exploring

VISUAL EFFECTS

Billy G. Woody II

THOMSON

DELMAR LEARNING Australia Canada Mexico Singapore Spain United Kingdom United States

Exploring Visual Effects
Billy G. Woody II

Vice President, Technology and Trades ABU:

David Garza

Director of Learning Solutions:

Sandy Clark

Senior Acquisitions Editor:

James Gish

Product Manager:

Jaimie Weiss

Marketing Director:

Deborah A. Yarnell

Channel Manager:

William Lawrensen

Marketing Coordinator:

Mark Pierro

Production Director:

Mary Ellen Black

Senior Production Manager:

Larry Main

Production Editor:

Benj Gleeksman

Art/Design Coordinator:

Nicole Stagg

Editorial Assistant:

Niamh Matthews

Library of Congress Cataloging-in-Publication Data:
Woody, Billy G.
 Exploring visual effects / Billy G. Wy II.
 p. cm
 ISBN: 1-4018-7987-X (alk. paper)
 1. Cinematography--Special effects. I. Title

TR858.W66 2006
778.5'345--dc22

 2006040186

NOTICE TO THE READER

Dedicated to my loving and caring wife, Jennifer, and
our soon-to-be-born daughter, Samantha Danielle.
I love you both and thanks
for making my life whole.

table of contents

TABLE OF CONTENTS

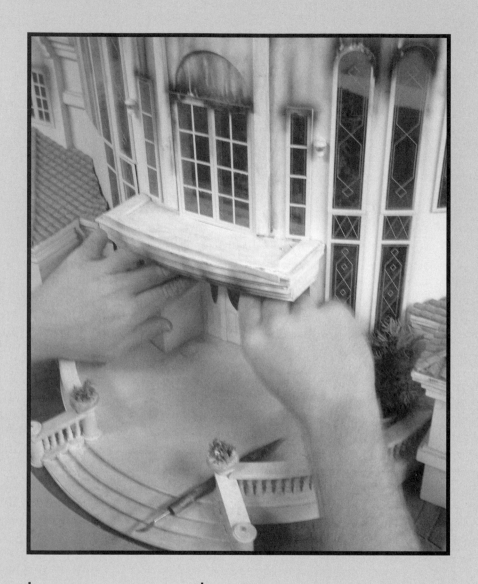

exploring visual effects

preface

INTENDED AUDIENCE

This text is intended for those who are new to and those with some experience in film-making. For both the student and independent filmmaker, this text is designed to introduce you to many aspects of filmmaking from the visual effects point of view. Those interested in both digital and traditional effects will learn a great deal about the future and past of their craft.

EMERGING TRENDS

With the emergence of high-quality, low-cost video equipment, the tools needed to create quality films and effects are no longer the province of large studios and well-funded post houses. For what amounts to pennies on the dollar compared with just five years ago, a person can set up a post-production facility in a spare bedroom or garage and still create amazing imagery.

BACKGROUND OF THIS TEXT

I decided to write this book after eating breakfast with a friend of mine. He was an instructor at a film school and I asked him what he used for a textbook because I personally could not recall any textbooks on visual effects. He said he did it all himself; he created the lesson plans and exercises. It seemed like an oversight that there were no texts available for such a growing curriculum, one that is on almost every campus in the United States. Thus the research began. I found many wonderful books on visual effects and some very informative books on digital visual effects, but nothing that captured real-world experience in a way to make it educational and not just fun to look at.

This book is designed to introduce the student or independent filmmaker to the tools and tricks needed to create big-budget Hollywood effects while still being able to afford to pay your rent and eat some lunch. I wanted to create a text that did not just list a bunch of information for you to figure out but to create something of a manual for visual effects.

The contents of this text are derived from my own personal experience as well as input from industry professionals whose expertise in some fields greatly surpasses my own. In fact, that is part of the foundation of this series of texts. With each future release I will concentrate more on single aspects of filmmaking by mining the knowledge of industry pros and putting it together in a format that is instructive and informative without being boring to read.

This text is designed for the novice and beginning filmmaker. While a basic knowledge of filmmaking will make some aspects of this text understandable much faster, it certainly is not required. It will introduce you to the beginning, middle, and end of the visual effects process.

TEXTBOOK ORGANIZATION

I have ordered this text in the manner by which you will probably approach your own productions. The opening chapters cover aspects of student and independent filmmaking that are both similar and dissimilar to commercial filmmaking. The second chapter touches on job descriptions, film budgeting, and script analysis.

Next the book takes you through previsualization, where you will learn about storyboards and study models. From here we move to shot design, shot composition, and 2-D and 3-D design.

The next chapters take you into hands-on construction of miniatures and models and demonstrate tips and techniques for creating your effects. The next step is to film your shots; thus the following two chapters take you though the production phase. Here we cover the types of camera used, both digital and film, as well as image formats used for post-production.

And of course, finally you are guided through the post-production phase of visual effects. You will learn some basic techniques and terms that will make you knowledgeable when speaking with the post-production crew.

Included with the text is an extensive glossary of terms as well as a DVD of instructional videos and loads of demo software from Apple Computer Inc. with plenty of content for you to work with. The instructional videos take you through the process of model making, weathering, tracking, and other aspects of visual effects. The DVD is designed to enhance your overall experience while working with this book.

FEATURES

The following list provides some of the salient features of the text:

- Provides a valuable introduction to traditional and contemporary visual effects techniques, information that is essential to making prudent design decisions.

- Describes both physical and digital approaches to creating visual effects, encompassing film and digital recording media in one valuable resource.

- Examines the professional use of all relevant tools, from an X-Acto knife to the duplication of elements by physical molding and digital cloning.

- Includes a back-of-book DVD of behind-the-scenes segments that illustrate important "how to" information—as well as the equally important "why not to" aspects of visual effects creation.

- Features interactive DVD content that supports time-related effects, such as animation and high-speed filming, inspiring readers to try the methods described.

SPECIAL FEATURES

▶ Objectives

Learning objectives start off each chapter. They describe the competencies the reader should achieve upon understanding the chapter material.

▶ Tips and Sidebars

Tips and sidebars appear throughout the text, offering additional valuable information on specific topics.

▶ Interviews

These profiles, located throughout the book, allow the reader to learn from the example of successful professionals in the field of visual effects.

▶ DVD Icons

These icons, appearing throughout the text, direct the
reader to the DVD for important additional information.

▶ Review Questions and Exercises

Review Questions and Exercises are located at the end
of each chapter and allow readers to assess their under-
standing of the chapter. Exercises are intended to rein-
force chapter materials through practical application.

E.RESOURCE

This guide on CD was developed to assist instructors in planning and implementing their instructional programs. It includes sample syllabi for using this book in an 11- or a 15-week semester. It also provides chapter review questions and answers, exercises, PowerPoint slides highlighting the main topics, and additional instructor resources.

ISBN: 1-4018-7988-8

ABOUT THE AUTHOR

Billy Woody has been in the industry of visual effects since leaving college in 1993. A graduate of the University of Central Florida with degrees in technical theatre and radio and television production, Billy moved to Chicago to begin his career in digital visual effects working for Electrogig, a 3-D animation software company. From there California called and he relocated to San Francisco, continuing to work for Electrogig while launching his freelance career.

Over the next decade Billy worked with or supported just about every major studio in the visual effects community, including such household names as Disney and Warner Bros. Studios, and has gained a vast knowledge of the visual effects industry. Billy has developed training classes for several visual effects software packages as well as taught 3-D animation classes at the American Film Institute in Hollywood.

Currently Billy works for Apple Computer Inc. supporting the award-winning visual effects software Shake.

ACKNOWLEDGMENTS

DION SCOPPETTUOLO OF APPLE COMPUTER INC. for inclusion of the Shake and Motion demos on the DVD.

DAVID LOWE AND UNIT 7 STUDIOS for his aid and support in supplying imagery for this book.

BILL TAYLOR, DAVID LOWERY, AND COLLIN GREEN for generously sharing their time and expertise for the interviews contained in this book.

JIM GISH AND JAIMIE WEISS OF THOMSON DELMAR LEARNING, you two have been a dream to work with and your support of this project has been amazing.

HUNT MANUFACTURING for the donation of foam products for this book.

X-ACTO for donating great tools.

ADOBE for the donation of its studio bundle.

FRAMEFORGE3D for its software donation.

THE DPL for their support over the last two years. 1-2-3 Drop!

MARK DASCOLI for his time and effort in reviewing this book.

My family back home in Florida: **MOM, DAVID, AND MARIA,** thanks for all your support.

MY NEW FAMILY here in California, the Ponds, thanks for everything.

PAM FERNANDEZ for being a wonderful human being.

. . .and of course, all of my dogs.

Thomson Delmar Learning and the author would also like to thank the following reviewers for their valuable suggestions and expertise:

Dane Krogman
Film Art Department
North Carolina School of the Arts
Winston-Salem, North Carolina

Thomas Mahoney
Visual Effects Supervisor

Billy Woody
2006

QUESTIONS AND FEEDBACK

Thomson Delmar Learning and the author welcome your questions and feedback. If you have suggestions that you think others would benefit from, please let us know and we will try to include them in the next edition.

To send us your questions and/or feedback, you can contact the publisher at:

Thomson Delmar Learning
Executive Woods
5 Maxwell Drive
Clifton Park, NY 12065
Attn: Media Arts & Design Team
800-998-7498

Or the author at:

Billy.woody@forcesunseen.com

exploring

VISUAL EFFECTS

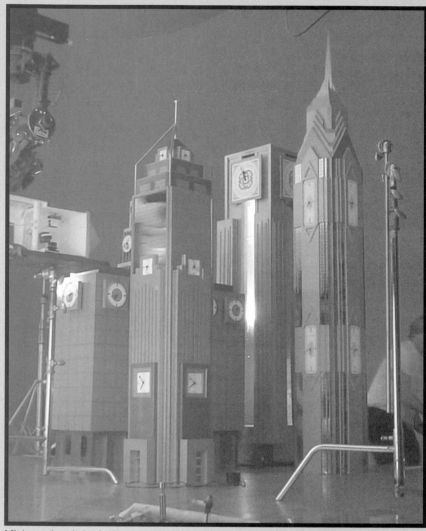

Miniature futuristic city for a commercial spot.

| student and independent productions, budgeting, and script analysis |

Section 1

SECTION INTRODUCTION

The working environment of the student or independent film production is both similar to and different from that of the big-budget film. While core elements such as continuity, quality of shots, and budgets are basically identical in all forms of production, student productions and independents usually meet many more obstacles and speed bumps. Crews on smaller productions receive less pay (or none at all) and share the workload among fewer people, and so are often less reliable than crews on large films.

Because of these dynamics, planning early is essential not only to getting your production completed but also to getting it completed on time and looking as good as possible. This section deals with the specific issues often encountered with smaller productions and then continues on to analyzing your script while using your budget and resources as a guide.

Don't forget, as a student your main agenda is to learn. You will make mistakes and you will get frustrated; it is the nature of the beast. But mistakes you encounter and correct now will keep you from making the same or larger mistakes when you are dealing with major studios and multimillion-dollar budgets.

STUDENT AND INDEPENDENT PRODUCTIONS, BUDGETING AND SCRIPT ANALYSIS

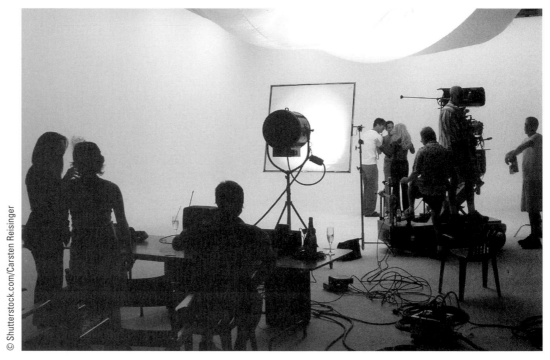

A film crew on set.

CHAPTER

1

Chapter Objectives

- Understand the dynamics of the film school crew
- Meet the expectations of your executive producer
- Learn to think within the box
- Understand the importance of planning early
- Be able to put together a crew for independent productions

Introduction

This chapter focuses on the obstacles and problems that you, the student or independent filmmaker, are likely to encounter during the process of making films. While this book concentrates on the visual effects side of the production, you will face obstacles in all aspects of making your film. Issues such as crew members, budgets, and materials become even a greater focus within a student production because they are usually very limited. This is the basic theme in smaller productions: limited.

The major difference between student and independent film productions is the role of the producer. This chapter will also cover issues and potential problems an independent producer may encounter in regard to visual effects. Many of them are the same problems students face. As an independent producer, you will continue to run into crews that are not as reliable because of lack of pay and time. Your budgets will usually be low, and you will be required to stretch your effects dollar further and further. And instead of meeting a deadline to get your film in to the class on time to get your grade, you will instead be meeting deadlines of events like film festivals and competitions, and of course arbitrary dates set up by those who have given you money to produce your film.

DYNAMICS OF THE FILM SCHOOL CREW

The dynamics of a film school crew are certainly different from those in the industry, in part because the degree of experience is so different. Another more practical problem is a lack of paid crews for your production. More often than not your film will be staffed by your fellow students, who of course are making their own student films. Thus, not only are you dealing with school schedules and production schedules, but you will also be running into your lighting guy not being able to shoot on Saturday because he has to baby-sit his kid sister. Or your miniatures girl is unable to finish the mock-up radio tower because she cannot take off from her pizza-delivery job. Given numerous distractions and possible showstoppers, it is imperative that you foresee any potential problems, plan and schedule early, and be prepared with alternative shooting dates and times.

INTERVIEW

Visual Effects Veteran Bill Taylor

© Adam Kowalski

Bill Taylor of Illusion Arts.

Bill Taylor is cofounder of Illusion Arts, a company originally dealing in glass matte paintings and miniature work and now mostly involved with digital matte painting and compositing. Bill began his feature film career in 1975 as Albert Whitlock's cameraman on *The Hindenburg.* Recent credits include *Bruce Almighty* and Lasse Hallström's *Casanova;* Bill was the visual effects supervisor for both films.

Understanding Effects

Most people coming in these days have a more realistic view than I did in the 1960s. I knew I wanted to work with visual effects, and had heard about optical printers, but I had only enthusiasm and a little general knowledge. There is greater understanding now because of trade magazines like *Cinefex* and *American Cinematographer,* and even TV shows like *20/20* that do exposes on movie effects. Today, anyone who brings actual skills to the table [such as painting or computer graphics] and really wants to work in the field has an idea of the difficulties of effects work. The rest of the world hears about CGI [computer generated images] and thinks there's a magic push-button that takes care of everything.

Often [filmmakers] know what they *don't* want. They don't want anything done with bluescreen because it looks fake, or miniatures look bad, or they don't want it to "look digital." It's a backlash effect. Digital effects have a bit of a bad rap. It's like going to a carpenter and saying, "Don't use any hammers, because they can hurt your hand." There is a wider panorama of tools available now than ever before. The trick as always is choosing the right tool for the job.

Illusion Arts' tradition started in the non-digital era. Plenty of Albert Whitlock's original negative matte painting shots fooled me, and I believe many people have had that same experience without realizing it. My favorite analogy is that a visual effect that is intended to be invisible is like a toupee—you only notice the bad ones. The 1956 movie *The Ten Commandments* used the best technology of the day, presumably in the wigs as well as the effects. And look how those stand out now. The believability bar is being raised constantly. It's possible the public is being overeducated about effects tools if they come out of the theater saying something looked too digital. What does digital look like? Generally, it's too clean, not atmospheric enough, doesn't move realistically, and doesn't look like real material [textures]. ∎

The following list offers some practical suggestions gathered together to help you keep your focus on the end product of your efforts:

1. If you have nothing to *show*, you have nothing to *discuss*.

Why? Conversation is vaporous. Images are negotiable currency. The best verbal description you can give is still mostly hot air. Always provide a photo or drawing.

2. Don't skip the storyboards.

Why not just say "make storyboards"? Because that's too easy to take for granted, like the boards themselves. They are so basic, so elementary, they may seem like an unnecessary use of time. Don't fall into this trap!

3. Discussions aren't decisions.

Simply talking about issues doesn't necessarily resolve them. In production meetings, individuals should be given specific tasks before moving on. This way each person leaves the meeting with goals and a schedule. If you leave a meeting without new (or revised) goals, you're already behind on the next task.

4. Give yourself the chance to improve.

Picture any step of a process, whether it's the scenic treatment of a set wall or the final composite of a visual effects (VFX) shot. If it's not something you have experience with, start practicing right away. It may sound easy to do, but it is usually harder to do well than you think.

5. Get approval first.

If you've made a decision, such as using **bluescreen** within your set, communicate it to the next level up so it can be shared. Proceeding without approval is sneaky (which isn't always bad) and could derail the plans of other crews (which is always bad).

6. Choosing to remember is choosing to forget.

Expect a lot from your brain, but take notes during meetings. Ideas and plans are tossed around in quantity, and notes are your best tools for sorting out and regrouping.

© Shutterstock.com/Dimitrios Kaisaris

figure |1-1|

A sketch of a miniature to be built.

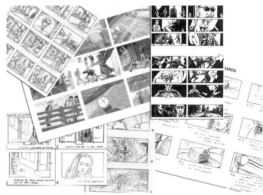

figure |1-2|

A storyboard can be as elaborate as colored panels or as simple as a pencil sketch.

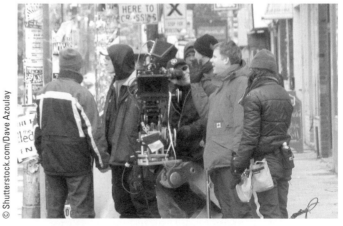

© Shutterstock.com/Dave Azoulay

figure |1-3|

Don't waste time discussing on set what should have been discussed the day before.

7. Don't take "yes" for an answer.

If you ask broad questions, like "Do you have everything you need?" you may get a simple "yes" in response. If you ask more pointed questions, you're likely to find a more accurate answer just under the surface. Try something like "Do you have the gels you need for that scene? What are they?"

8. Have a backup plan.

If you've made an educated decision about a procedure, then you have already considered other possibilities. Keep the next best one in mind, or better yet, on paper. Locations fall through at the last minute, actors get sick, and miniatures get run over.

9. Network.

Familiarize yourself with the local talent pool. Your school or community very likely includes other individuals like yourself, who would show their talent if they only had an outlet. Your film projects can provide that and help establish long working relationships.

10. Do quality work.

An old Hollywood saying goes, "You're only as good as your last job." All film students have invested money in their degrees, and their projects are the evidence of that. One of your goals is to leave with a portfolio that shows your skill. If that's not what you leave the school with, see point number 1.

While there are many other aspects of student and independent production, this text is designed to concentrate only on the visual effects element of filmmaking. Factors dealing with items such as on-screen talent, rights, and many other issues are dealt with in other texts and classes. As a student you will find yourself trying to do more than you can possibly handle. Not that you do not have the intellect to complete a shot or a project, but as a student film-maker, the variables out of your control can be excessive at times. The same holds true for independent producers. It is easy to get overwhelmed and to cut corners on quality. Delegate and manage wherever you can.

Lastly, let us not forget, the best effects shots are ones that no one ever recognizes as an effects shot. Taking the time to plan accordingly and making sure not to bite off more than you can chew will afford you the opportunity to create stellar effects shots that rival major Hollywood studios and at a fraction of the costs.

THE EXECUTIVE PRODUCER

One element of independent production that is not usually seen in student films is the **executive producer (EP)**. The EP is the person who puts up the money to get your film produced. If you are putting up your own money, you only have to answer to yourself. But if you are accepting funds from a third party to produce your project, you will have another creative influence that will have to be worked into your process.

> ## ▶ Thinking within the Walls of the Box
>
> We have all heard the statement "Think outside the box." Here's a new one: "Think within the walls of your box." While it is all good and wonderful to think of elaborate and amazing ideas and effects to create for your project, we often forget there are limitations to what we can and will be able to complete. Constraints on time and money, and not to mention labor, will more often than not be the driving force behind what actually gets created. By thinking within the walls of your box, you are aware of your limitations. By knowing in advance what is available to you in terms of time, equipment, and money, you give your project "walls" that will keep you from getting lost in the whirlwind of the production.
>
> Imagine you have been asked to be the contractor for the construction of a new home. You have looked over your budget and your supplies. You have a few guys to help you out. After analyzing the supplies, budget, and labor you realize you can probably create a nice but modest single-story home. The homeowners then tell you, "We want a house with two stories and with twice the number of rooms." You have three options. One, you ask for more money, buy more supplies, and give them what they asked for. Two, wanting to look good to the clients, you just say, "Sure, we can do that, no problem"—thus setting yourself up for failure. And three, you restate to the homeowners that you have a plan already, you have a budget, and that's all you can handle.
>
> By knowing your limitations, you are forced into thinking more creatively in your approach to solving problems.

This is where clear pre-production and previsualization techniques are very important. Conveying your ideas using a number of different methods will help put your EPs at ease because they will understand your vision of the shots and the film as a whole.

Not all EPs are artistic duds with no clues on filmmaking who need their hands held through the process, but there are a good number of them out there. Identify the level of involvement of your producers and learn early what you will need to do to make them feel comfortable with the fact that they are giving you money to produce your film.

PLANNING EARLY

As with any project, planning early is the key. This sounds like a simple statement, but it cannot be overstressed. You cannot plan "too much" in making films and creating visual effects shots. Early planning of not only how to do a shot but also which shots to do will go a long way toward making your project advance more smoothly and rapidly.

GETTING A CREW TOGETHER FOR INDEPENDENT PRODUCTIONS

One of the toughest tasks when creating any shot in the setting of an independent or low-budget film is the gathering of a crew. Just as with the student productions, you are often

dealing with well-meaning amateurs who cannot always be counted on to show up or do exactly what you say. Beyond that, even finding a crew can be difficult to do.

There are several resources you can use to locate crew members for your production. **Craig's List** is a Web site based in almost every major city in the United States. The list contains everything from people selling cameras and cars to openings for makeup artists and costumers. Many newly minted film techs can be found through this site. Most realize that the pay is little or none; they are looking for projects to boost their resumes and hone their skills. Their eagerness to work on any film project makes them a great resource for your crew.

Other possibilities can be found, of course, at your local college. With the film industry becoming a nearly $100 billion-a-year industry, most colleges now offer some programs in film production or in post-production graphics and effects. Not all schools offer the opportunity to work on larger projects; thus the students will be looking for opportunities to put into practice the skills they have learned in the classroom and lab. Planning your shooting schedule to coincide with semester breaks of your local college is a smart way to go, because you will not be competing with school projects that will take up your crew's time. And speaking of time, be sure to do your best to keep on schedule. If you plan on shooting only until 4 PM, do not keep your crew around until 9 PM and then expect them to show up to work again. Do not forget that for the most part you are not paying these people and they do have their own lives. Be up front and clear about schedules. Yes, sometimes things happen and you run over on time, but do not make it a common practice.

Compensation for your crew can range from minimum pay to merely providing lunch. But be up front; don't tell your crew they will be paid but then not follow through. The fastest way to lose your crew is to promise more than you can deliver. If you can only provide fast-food sandwiches and diet cola, tell them up front. The hungry and thirsty will line up to work for you.

SUMMARY

Plan ahead and be prepared for anything. Don't take on too much: Create a few first-class effects instead of dozens of third-class ones. Recognize that you do have some limitations as to what you will be able to do but also recognize that there are no engraved-in-stone rules. Experimentation and trying out new ideas and techniques may help you create a process that will save time and money while creating a wonderful effects shot.

It is easy to get caught up in the excitement of making a film, and this can often lead you to try to do more than you and your crew are prepared for. While it is great to have that "gung ho" attitude that you can do anything, be realistic. List the effects that are essential to conveying the story and then create a second list with effects that will make conveying that story even better. If you get the first ones completed in a timely fashion, you can start to add shots from your second list.

1. According to Bill Taylor, how do digital effects often look?

2. What are some of the obstacles you can run into with your film crews?

3. Considering the list of ten practical suggestions, where do you see problems popping up by skipping just one of the items on the list?

4. What is meant by "thinking within the box"?

5. How does having an executive producer change your production?

6. Why must we plan early and what must we plan for?

7. What is important to convey to your crew?

A Hollywood back lot movie set.

CHAPTER

Chapter Objectives

- **Understand the roles of the film's department heads**
- **Identify how your budget drives the analysis of your script**
- **Know how to analyze a script in regard to effects**
- **Recognize when or when not to use visual effects for a shot**

Introduction

This chapter covers the roles of some of the people you will encounter on a larger-budget film set and their parts in the production of visual effects. It then takes you through the process of analyzing a script for effects. While each department (props, costume, set) will have its own analysis of the script, I will deal mainly with pointing out obvious effects shots. The visual effects supervisor (described shortly) is responsible not only for going through the script and finding all the effects shots but also for deciding how the shots will be done and which ones take budgetary priority.

JOB DESCRIPTIONS

Visual Effects Producer

The **visual effects (VFX) producer** works alongside the VFX supervisor, taking responsibility for the budget, scheduling, and overall management of the effects crew and facilities. The VFX producer is also responsible for procuring the crew and facilities. Because VFX producers are responsible for delivering the project on time and on budget, they answer directly to the financiers and producers.

figure |2-1|

The VFX supervisor is also in charge of the digital visual effects.

Visual Effects Supervisor

The **visual effects (VFX) supervisor** has the overall responsibility for all the effects for the entire production and must, considering budgetary constraints, provide the most effective solutions available to complete the work required. Working hand in

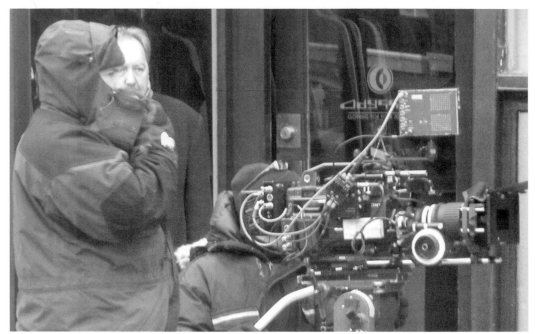

figure |2-2|

The DP (far left) needs to be knowledgeable about the different types of cameras, lenses, and mediums for shooting.

hand with the entire production team, including the director, the director of photography, and the camera department, the VFX supervisor designs, creates, and supervises every aspect of the film that requires a visual effect to be generated. This can include everything from live action, model, and miniature shooting to post-production digital effects.

Art Director

The **art director (AD)** is sometimes referred to as the **set designer** or **production designer**. The task of the AD is to analyze the cosmetic or visual requirements of a script in regard to the set. This includes both the construction and decoration of the set. The AD is commissioned to create visual representations of this analysis through sketches, drawings, or miniatures. These are presented to the director for selection and approval. It is then the role of the AD to plan, budget, arrange, and locate the proper setting for the script.

Director of Photography

The **director of photography (DP)** has the task of capturing the director's creative ideas onto film or video. Unlike some of the other members of the filmmaking process, the DP is both

INTERVIEW

Visual Effects Veteran Bill Taylor

Choosing the Right Effect

You start by thinking, "What would I do if it were real?" That guides your composition and shooting style. Sometimes [in older films] the cameras would be locked down for a matte shot, in the midst of a scene with moving cameras, and that would make it stand out [even if the painting was perfect]. Sometimes people go for what Whitlock warned about: the "oracle shot." This is when budget or time or availability of resources crams too many ideas within one shot, and you try to show too much. You see the town and the people, the gold mine, the gathering storm and the mountains, and so on. Maybe the matte painting shot is clear to the horizon, so you get all the information, but the other shots in the sequence are hazy. There's basic continuity to consider when designing the effects to help them blend in.

It used to be that 3-D characters could only be brought to life with stop-motion. But artistic use of a technique can overcome its limitations, and also careful introduction of a character, good design, and good direction. There are few actual limitations now, but filmmakers should be careful not to "stick their finger in the eye of the audience" with careless usage.

Directors can be handcuffed by imagined limitations, but making the fantastic believable is a challenge to even the best directors. "Hulk" was a tough sell because he's 15 feet tall and hurls a 68-ton tank through the air like a hammer. Suspension of disbelief was attacked every second he was onscreen because he was so out of context with his ordinary, contemporary surroundings, and because he was green. ■

an artist and an engineer: the DP must have the capability to understand the artistic vision of the director and then be able to use the tools at his or her disposal—cameras, lens, film stock, video, lighting, and more—to create that image within the camera.

Technical Director

The **technical director (TD)** manages all material shot by the VFX supervisor. The TD is generally in charge of the post-production crew that adds any required computer-generated images (CGI) and digital compositing. Working closely with the digital artist and the VFX supervisor, the TD manages the seamless integration of these effects to produce the final shot.

figure |2-3|

A budget is essential to smooth production.

BUDGETING

A large part of choosing the right effects depends not only on what you are trying to convey to your audience in terms of the visual imagery but also on what can you afford to create without making that image seem amateurish and fake. While film, at its core, is an art, it is also a business. It takes money to create your art; without proper budgeting, your art piece may never get finished.

 The first thing you will want to do is get organized. Creating a record of your budget using an Excel spreadsheet or software like ProductionPro Budget will help you plan your expenditures. On the DVD are examples of an Excel spreadsheet and Indie Budget Pro, and a demo copy of ProductionPro Budget donated by the manufacturer for you to try out.

PRODUCTION	Days *	Rental Fee (Per Day)	Quantity (35mm)	Total (35mm)	Quantity (16mm)	Total (16mm)	Quantity (HD)	Total (HD)	Quantity (SD)	Total (SD)	Alt Days *	↓	Total Alt. (35mm)
Camera													
Arriflex 535B - 35mm Camera		$550.00	1	$9,900.00									$4,950.00
Arri SR3 PL - 16mm Camera		$300.00			1	$5,400.00							
Sony HDW-F900 CineAlta Camera package (includes Video Zoom Lens, 4 batteries, Sachtler Head and Tripod, Arri Bridge Plate)		$1,100.00						$0.00					
Panasonic AJ-HDC27F VariCam Package (includes Zoom Lens, 4 batteries, Head and Tripod)		$800.00					1	$14,400.00					
Panasonic SDX-900 DVCPro 24p Package (includes lens, batteries, tripod)		$375.00							1	$6,750.00			
Panasonic AG-DVX100A 24p Package (includes 3 batteries, tripod)		$175.00								$0.00			
Panasonic AG-DVX100A (Purchase)		$3,700.00								$0.00			
Accessories													
1000-ft. Magazine		$75.00	2	$2,700.00									$1,350.00
400-ft Magazine		$65.00	2	$2,340.00	2	$2,340.00							$1,170.00
AC Power Supply		$25.00	1	$450.00	1	$450.00							$225.00
24v On-Board Battery		$25.00	5	$2,250.00	5	$2,250.00							$1,125.00
Sony BVM-D9H5U 9" HD Monitor		$175.00	1	$3,150.00		$0.00	1	$3,150.00		$0.00			$0.00
Other Rental		$10.00		$0.00		$0.00		$0.00		$0.00			$0.00
Lenses													
Zeiss 14mm Prime		$125.00	1	$2,250.00	1	$2,250.00							$1,125.00
Angenieux 25-250 T3.7 Zoom		$190.00	1	$3,420.00		$0.00							$1,710.00
Angenieux 11.5-138 Zoom		$150.00		$0.00	1	$2,700.00							$0.00

figure |2-4|

Indie Budget Pro for film budgeting.

SCRIPT ANALYSIS

In simple terms, **script analysis** is the task of breaking down your script into elements that deal with potential effects. Typically the VFX supervisor goes through the script and marks each potential effect to be created within the film. After variables such as budget, time, manpower, and difficulty are taken into account, shots are either kept or removed from the list of elements to be created.

Finding Deals and Stretching Your Budget

As a creator and facilitator of visual effects for your production, you will have to work within allotted and limited budgets. Don't think of this as a setback, but as an opportunity to be creative. Back in my college days we needed more lumber than we could afford to build a set for a play we were performing. I located all the lumberyards in the area and visited each one. At many of them I found piles of scrap lumber and gallons of mismatched paint that I was able to buy for pennies on the dollar. Don't forget, you are not really building a space ship or a brick wall or a dungeon of doom—it just has to look like it on film.

Make a list of businesses in the area that may carry supplies you will eventually need. Visit often and create a relationship with them. Soon you will find them calling you up to tell you about some extra lumber that is lying around.

For example, let us say a script calls for a shot of a 50-car pileup in the middle of a Los Angeles freeway during daylight hours. Your budget for effects is only $100,000 and you still have dozens of other shots to create. As the VFX supervisor you may recommend that this shot be adjusted or rethought in order to fit into the budget available.

Let us say that after you tell the writer and director the problems with creating this shot within the budget available, they tell you that the shot is essential to the film and must be created somehow. You then must come up with another creative way to create the same shot without actually closing the freeway for a day. You may decide that instead of shooting a large scene with 50 cars crashing together, you will shoot smaller scenes and use creative compositing and editing to create the look of a large accident.

While breaking down your script, determine what equipment is available to you to create the effects you need. If a scene calls for smoke, do you have access to a smoke machine? Or can the scene be shot clean first and then have smoke added in post-production? If you have both options, which one is cheaper and puts less strain on the project?

You will also be checking the script for location shots that may need to

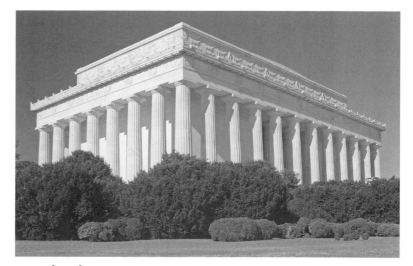

figure | 2-5 |

Stock photo of Lincoln Memorial.

> ### Another Reason to Save Money
>
> Saving time and money is stressed throughout this text, but it is not for the sole purpose of pleasing the people who may have put up that money. It is also a way of opening up more opportunity to create more of the kinds of shots you want to create for your film. By planning ahead and saving money, you may be able to do 20 effects shots, whereas before you were only going to get away with 15.

be created as a visual effect. Let's take, for example, a shot that requires the actors to be in front of the Lincoln Memorial in Washington, D.C. The problem is that you don't have the budget to send everyone to Washington. Instead of blowing your entire budget on one shot, you can list this as a shot that needs to have a background created. The actors can be shot on a bluescreen and composited into a background plate created from stills or stock footage of the Lincoln Memorial. Not only can you now have the shot required by the script, but you can save the production a lot of money and time.

There is no real formula for script analysis when it comes to visual effects. Every time you analyze a script it will be a bit different from the last one. When you are going through the script, it is a good idea to partner up with someone to bounce ideas around with. Often we pigeonhole ourselves into certain ideas or concepts and we don't see other options that may be available to us.

SUMMARY

During production of your independent or student film you will wear many hats. Keep the tasks and duties of each role separate because each is vitally important. If you do have different individuals in each role, make sure to always be clear about what you expect from each person.

The script review is the all-important first step in the process of creating your visual effects. Here you will decide which shots need to be created by artificial means (i.e., visual effects) and which shots do not. Part of this process is also deciding how the effects required for the film fit within your budget. You may be required to state that some effects just cannot be done because the budget does not allow for it; if the shot is required, you must be creative in finding solutions that allow you to create the shot while remaining within budget. Be thorough—taking your time to go through each page of the script is essential. Making notes and researching ideas and concepts are good ways to start the process. Don't feel you have to decide the means and the method of each shot during your first analysis of the script. Talk to the director, get feedback from others, and then when you feel comfortable with the decisions you have made, present them back to the director and the creative team.

1. What are the roles of the positions discussed in this chapter?

2. What does Bill Taylor say you should do first when starting to decide your visual effects?

3. What are some ways to stretch your production's budget dollar in terms of materials and supplies?

4. Why is it important to do a complete script analysis?

exercises

1. Choose a film script and analyze it for effects.

2. Using that analysis, create two effects budgets: one of $50 million and one of $5,000.

3. Put together a proposal for effects according to your budgets and present them to your classmates as if they were the film's producers.

Research materials can be found anywhere, from your local library, a bookstore, or CD collections of areas around the world.

| Previsualization |

Section 2

CHAPTERS IN THIS SECTION

- Preparing Your Project

- Shot Design and Composition

- 2-D and 3-D Design

SECTION INTRODUCTION

Now that you have prepared a budget and gone through the script to decide which shots you will do, next is the planning, or **previsualization (pre-viz)**, stage of your production. Taking the added time to thoroughly go through each visual effect shot and planning that shot will save you both time and money. You will hear over and over again about time and money. This is not an accident. Because budgets in student and independent productions are generally smaller than in big productions, the old adage of "time equals money" is even more important. Learning now how to work within time and budget constraints will prepare you for working within the same constraints as a professional, but with a few more zeros at the end of your budget total.

As you will learn, not only are there many methods of creating your effects, there are also many methods of planning them. Today's film teams use everything from drawing on napkins at a Bob's Big Boy to creating elaborate 3-D animated scenes as done by Pixel Liberation Front for *The Matrix Revolutions.* You can view some of the fascinating work done by Pixel Liberation Front on its Web site at http://www.thefront.com.

This section will take you through several of the processes used in pre-viz and discuss the advantages of each. Not only will you use your pre-viz techniques to save money and time, you will also use them to design shots and composition.

You would not go into battle without a plan. Think of pre-viz as your battle plan for your film. How do you attack each shot? How many men or women will be needed to complete the mission? What kind of equipment will be required to get the job done? For every hour of planning, you will save days of production. And of course, the more time you save, the more money you save.

PREVISUALIZATION

A sketch of a miniature extension for a full-size set.

CHAPTER

3

Chapter Objectives

- **Discover the three basic habits that promote successful effects planning**
- **Understand why research is a vital step in creating visual effects**
- **Know the importance of finding and collecting research materials**

Introduction

Organizing your shoot will be at times exciting, confusing, tense, and yes, probably boring. You will find yourself fixated on your immediate task, or daydreaming while you wait. There are countless opportunities for distraction.

Your experiments with visual effects will offer those same opportunities. Make the end results worth your investment of time and energy. You can keep the big picture in mind by making a habit of the following three practices:

1. Collect and keep reference material.
2. Create and use storyboards.
3. Focus on the finished composition.

WHY FIND AND COLLECT REFERENCE MATERIAL?

In most cases where an environment or architecture is being created for a film, it is either duplicating something that exists or is a fantasy based on existing elements. It must contain design elements that make it believable, so the audience can accept it. We all share, to some degree, a visual library in our minds of things we have seen. Design elements will ring true or false to most of the audience because of this.

Think of a song you like. Now sing it, or play it on the piano. Does it come out the same way you heard it in your head? If you've ever been to a karaoke bar, you know that many people don't deliver a song the same way you're used to hearing it, even if they think they do. The same is true with visuals. If you try to reconstruct something that people are familiar with, and don't work from adequate reference material, your audience will spot the forgery right away and that moment will suffer rather than succeed.

figure | 3-1 |

Magazines from different eras and genres are a great research resource for your projects.

23

All materials that you accumulate as reference can continue to give you new ideas and information throughout production. Just because you don't use a photo in its entirety doesn't make it useless. All reference is worth keeping, and keeping organized. The following examples are only a few of the many locations for gathering reference material for your pre-viz.

On Location

The best way to understand a location or building is to go to it and take still pictures and video. This places you in the environment in a way that you become most familiar with it. Any other photo reference is going to be limited or affected by that photographer's artistic choices. By going to a location you can spot the details that will be significant to you, and bring more authenticity to the design you will create.

Books and Magazines

What if you don't have convenient access to the actual location? A trip to your local library or bookstore will reveal all kinds of subjects that are closely related:

- Larger pictorial or coffee-table books frequently contain dramatic, panoramic images.
- Travel books illustrate many of the popular sites in a given country, often with closer photos of the details.

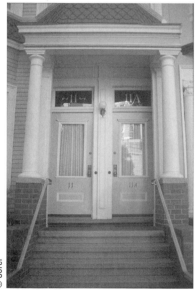

© Corel

figure | 3-2 |

Exterior location shot of a home in San Francisco.

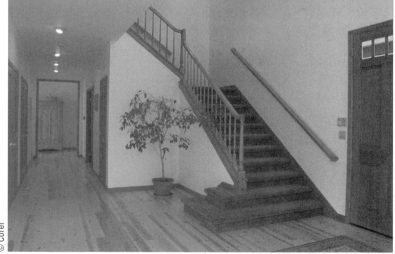

© Corel

figure | 3-3 |

Interior location shot.

- Architecture books are categorized by region, by style, and by architect. You can even find books that are just about European hotels, or bungalow-style houses, or staircases.

- Magazines are published to promote hundreds of travel destinations, to cover architectural trends and styles, and even to report on historical recreations. For almost any reference need you have, someone is printing a related periodical.

Internet

The Internet provides access to a wide range of specialized pages and other resources, such as newsgroups and university libraries. Search engines can return dozens or hundreds of sites based on the key words you use.

figure |3-4|

Keeping a library of resource materials ranging from books on art to magazines about home décor is essential to the design process.

But the Web does have its limitations. For example, you may find a nice image on a Web site, but when you print it you find it is only an inch or two wide. At that size it doesn't do you much good. Those low-resolution stills don't respond well to enlargement either, because they are made up of only a few blocky pixels. For this reason, it is better to use more than one source for your reference material.

figure |3-5|

Notice the degradation of this image created for use on a Web site. While it may look nice on your computer screen, once this is blown up large for a background image, the flaws will show through.

| TIPS |

Maintaining a Database

After you have been doing this for even a short time you will begin to collect images and ideas. Rather than just discarding these after each project or leaving them in the trunk of your car to get ruined by the beach chair you tossed in there, create a database to store this information. This can be something simple like a small filing cabinet or something more elaborate like a computerized database that you can use to reference images easily. Bottom line, don't do the work twice. Research for one project may find goodies that will be perfect for your next project.

Combining Your Resources

Combining your resources is always a good idea. For example, you could look through the broad categories of a bookstore to find pictures of what you're trying to duplicate. Suppose it's a Mayan temple location. You might buy a book or borrow one from the library. You may find that certain ruins have a look you like and others don't. If you find that the look that best suits your project is the ruins at Tikal, you can do an Internet search for Tikal and find more focused information than if you simply browsed Mayan civilization from the start.

Pulling elements from these various sources enables you to be creative in your designs while drawing from established styles. Whichever your preferred research method, it is vital that you provide hard-copy versions such as photos and drawings to your crew and directors.

figure |3-6|

CD image libraries can be obtained from companies like Corel. Usually the images are high resolution and can be saved in several formats.

CD Libraries

If you prefer, or need, high-resolution digital images, many kinds of CD image libraries are available. They contain bold, dramatic, and diverse subject matter. Their high quality also allows them to be used as elements in your final composite.

WHY CREATE AND USE STORYBOARDS?

Why trust a map instead of verbal directions?

A storyboard panel is the simplest, fastest, cheapest way to communicate in the medium of your film. That medium is visual, not spoken; therefore an image is superior to a word as description (although both are necessary). Just as verbal communication forms the skeleton of teamwork, these pictures form the basis for understanding the many important visual elements. They are the baby steps necessary to a successful stride in production.

From shot **composition** to set design to lens selection to **continuity**, the storyboard establishes the ground rules for creativity and budgeting.

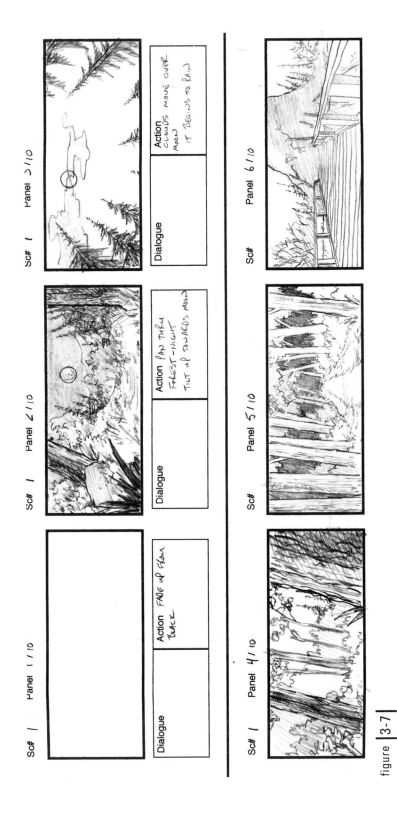

figure | 3-7 |

An example of a storyboard sequence from the animated film *It's Alive*. Notice the sequence setting up the establishing shot and open of the film.

INTERVIEW

David Lowery, Storyboards and Visual Effects

© David Lowery

David Lowery, storyboard artist, illustrator, and art director.

David Lowery has worked as a live-action and FX illustrator on numerous blockbuster films, including several Steven Spielberg features. He was cohead of story for *Shrek* and storyboard artist on *War of the Worlds*. As this book went to press he was storyboarding *Spider-Man 3,* due in 2007.

Storyboards are peripherally attached to the art department, [which] is the first thing brought onto a film after the director's been hired. The producer or studio picks a director whose work will complement or elevate their project. The director picks his crew, and among the first is the production designer. The production designer shares and enhances the director's vision of the world that the film takes place in. The production designer and his art department will then design, find, and build that movie's world, [whether it be] an alien planet in a parallel universe or the suburbs next door.

Concurrent with the design of these places, the storyboard artist designs the action of the story as it plays out. Using the script as a manual and guide for what happens from scene to scene, the director and the storyboard artist will produce a comic-strip blueprint of the story, the words reborn as pictures. The style of a director at this stage of the process, and the amount of interaction and/or free rein given to the story artist, vary

FOCUS ON THE FINISHED COMPOSITION

The characters in your shot wear costumes. Are they detailed and authentic or not? The characters are standing next to a brick building that you have created in miniature. Are you close enough to the brick wall where you should be able to see all of the textures of the bricks and

as widely as there are directors directing. In general the director will lay out the flow and beats of a scene, either verbally, with his own sketches, written as a shot list, or a combination of all of the above.

No matter how the ball gets rolling, I feel my job is to draw a scene at the highest level possible, specifically as that director might shoot it. Though the sequence might be spelled out for you, the challenge is to come back with a great new bit of business for the character to do or some cool angles and transitions.

Even with the scene visualized to its utmost, I've noticed that the best directors are all great "toppers." They'll add that little button to an action or a great bookend to a scene that will make the moment perfect—and it will also make your idea their own! I look at this co-opting as part of the collaboration between the "brain trust" assembled for the project. I also believe that storyboarding is an insurance policy to assure that the shooting has been thought about and solutions arrived at before the huge, expensive machinery of production starts rolling. Between the director and his DP, as well as the producers and production designer, when the time came, they [should] be able to shoot the movie—storyboards or not!

Though the main collaborator for the board artist is the director, [the board artist] must always be in contact with other departments as well. He must meet with the art department to make sure the action being boarded can happen in the space that they're providing. Also while storyboarding we must anticipate the special FX needs of a sequence. The board artist must have a working knowledge of the how-to of VFX, including CG animation and CG mattes, puppeteering and practical/mechanical FX, also traditional bluescreen and compositing. It's not that you have to have the answer in your boards, but you should be able to suggest a solution!

Each illustrator approaches the process of drawing and storyboarding differently. Some are research fanatics, and studying the exact things in the scene helps them visualize how to shoot it. To a certain degree, this is a smart approach to shooting small films, etc. The more accurate your boards are to the specifics of your shoot, the more useful they'll be when you're standing there with your actors and crew. I can appreciate a good reference when specific elements are in the shots I'm drawing, but I try to draw very fast and I've found that after 22 years in the biz and a lifetime of observing and drawing, whatever it is, I've probably drawn it three times before! ■

mortar, or can you get away with using a photo of the brick wall? The closer and clearer your subject is, the more attention must be paid to detail. To help budget your time and money, consider distance from camera, focal depth, lighting, atmospheric elements (fog, rain, etc.), and anything else that might limit clarity.

SUMMARY

Research and the gathering of materials is essential in the preparation of making your film and creating your effects. Keeping collections of materials on hand not only will aid you in creating elements but also can be used to inspire you during the creative process. Even if you are creating a structure completely designed in your head, you will eventually need to convey that image to the people who are going to help you realize that image. The best way to do that is through sketches, photos, and detailed descriptions.

in review

1. What are the three habits of pre-viz?

2. Where can you find images for research?

3. What can be saved by using storyboards or pre-viz?

4. Why is it important to storyboard your shots?

exercises

1. Choose a location to film an imaginary effects shot far away from where you live and find research material for that area.

2. Create a book of research material from your findings and present it to the class.

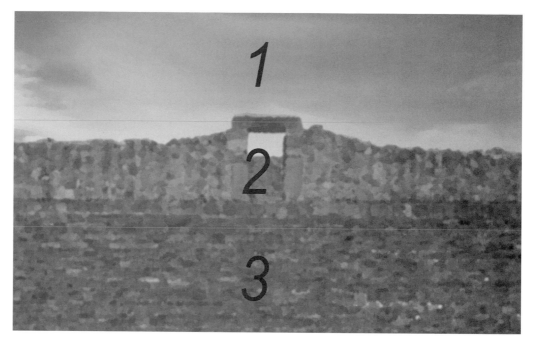

An image divided by using the rule of thirds.

CHAPTER

4

Chapter Objectives

- **Understand how composition of shots affects design and integrating**
- **Learn the practical and creative functions of previsualization**
- **Know the basic steps in the development of ideas**
- **Create storyboard images**
- **Turn storyboarded shots into moving images**

Introduction

"A picture is worth a thousand words." You have probably heard that plenty of times, and it's just a catchphrase now. But what if the line were "A picture is worth a thousand dollars"? It can be, if it makes the difference between buying permits for a location and shooting in the soundstage, or spending money on set walls that will never be seen. Pictures are absolutely worth dollars and hours, the two most valuable commodities to a crew.

Whether the pre-viz image is still or moving, it is a basic and critical step in the development of the film.

QUALITIES OF GOOD COMPOSITION

A principal design element of cinematography is the composition of shots. Any time an image is recorded or created, it contains composition. Objects are arranged within the frame to greater or lesser effect, even if you shoot with your eyes closed. Ideally you would not only keep your eyes open, but also try on purpose to arrange an appealing composition. In visual effects there are several practical reasons, in addition to the aesthetic ones, that guide shot design.

The purpose of shot composition is to direct the viewer's attention. In general, as a director or cinematographer you will design shots that maximize the effect of that moment in the narrative. A static wide shot emphasizes the location of the action, while a tilted-down point of view (POV) adds dramatic tension. There are general qualities attributed to good composition, such as **rule of thirds** (**balance**)**, contrast,** and **depth cues.** There are also some basic rules such as keeping it simple, framing your shot, and using open space.

figure |4-1a|

figure |4-2|

By composing a wide shot, or establishing shot, you quickly set the location, time of day, and mood.

figure |4-1b|

Compare these two examples. Which shot is poorly composed and which is more balanced?

figure |4-3|

Point of view (POV) looking down from space.

Balance

Balance refers to the distribution of visual "weight" in the shot. A common measure for this is to divide the frame in thirds, so there is a center and two opposing sides. When this is done both horizontally and vertically, you have a total of nine sections of interest. The intersections of the guidelines mark the positions of the greatest visual impact, because of the balance of focal and peripheral space.

	1	
	2	
	3	

figure |4-4|

Use the rule of thirds to break your composition up into three equal horizontal sections.

1	2	3
4	5	6
7	8	9

figure |4-5|

Add two vertical lines to break up your composition into nine areas of interest.

Contrast

Contrast can be created between light and dark values, sharp and soft focus, stillness and motion, and so on. The degree of contrast within the shot contributes to its balance. The eye is drawn instinctively to areas of contrast. This shot from a nature documentary contains these elements. The forest base in Figure 4-6 divides the frame horizontally, the only moving element (the buck) draws attention to itself, and the soft-focus background establishes distance.

© Corel Stock

figure |4-6|

Focus and depth of field direct the viewer's attention to the buck and away from the background.

Depth Cues

In simple terms, a depth cue is a trick played on the eye to make the mind think it is seeing depth where there is none. Film is a two-dimensional medium capturing three-dimensional space. One of the inherent problems in working with miniatures and models is the lack of depth between objects. Without this depth the models do not take on the size or weight of real-world objects. To compensate for this the effects team will use depth cues to create a sense of reality. There are eight basic concepts for creating depth cues.

Linear Perspective

Linear perspective is a depth cue based on the concept of apparent convergence. Apparent convergence is the visual "coming together" of two parallel lines as they fade off into the distance. Take for example the railroad track. As illustrated in Figure 4-7, if you stand between railroad tracks and look as far as you can see, you will see the apparent convergence of the track beams as they fade off in the distance. By recreating this convergence of parallel lines you can fool the human eye into thinking it is seeing something farther away than it really is.

figure | 4-7 |

While we know that train tracks never really do meet in the distance, the perceived convergence of these parallel lines creates the illusion of great depth.

Forced Perspective

In simplest terms, **forced perspective** is cheating the eye into perceiving something as larger, smaller, closer, or further away than it really is. *The Lord of the Rings* used this technique in many of the shots that combined Gandalf and Frodo.

figure | 4-8a |

Image of car and background before the camera is moved into place.

figure | 4-8b |

With the camera and the miniature in position, forced perspective makes the car appear full-size.

Relative Size

Another method of creating great distance is to recreate the **relative size** of objects in relation to one another. For example, in films like *Star Wars* and *Return of the Jedi,* altering the sizes of planets, starships, space stations, and structures within the scenes created illusions of depth. Objects in the distance appear smaller to the human eye and thus convey that distance. In order to repeat this in models or miniatures you often will scale down the size of objects farther away or scale up those objects closer to the camera in order to create the illusion of more depth than is really there.

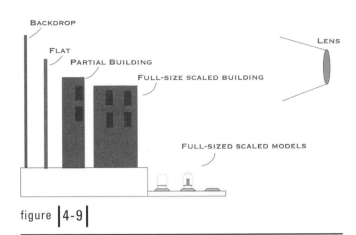

figure |4-9|

Typical layers of a miniature. If the trains closest to the lens are 100% of the original scale size, the full-size building would also be 100%, the partial building would be 90–100%, the flat would be about 80–90%, and the backdrop would be around 30–50%.

Light and Shadow

Another great method for creating the illusion of depth is using light and shadow. In reality all objects react with the light around them. They create consistent patterns of light and shadow. By recreating these patterns within your scene you can fool the eye into perceiving more depth than what is really there.

figure |4-10a|

These three cylinders have no directional light source and cast no shadows. Discerning the depth of each is difficult.

figure |4-10b|

The same three cylinders after adding three light sources from different angles. Notice how the image now "pops" from the screen, showing the depth of the cylinders.

Overlap

In simple terms, **overlap** is the placement of one element in front of or behind another. Let's say you have two cars coming down the road toward the camera and you wish to illustrate that one is closer than the other. Having the car in front slightly overlap the one behind it will give the illusion of depth. This combined with relative size can be a strong method of creating depth cues.

figure |4-11|

The fading of texture detail in the distance intensifies the illusion of depth.

Texture Gradients

If you look at the sidewalk under your feet you will see great detail in the cement. The textures are clear and stand out. As you look farther down the sidewalk the textures become more muddied or blended together. By using the **texture gradients** concept in your miniatures, you can create a greater illusion of depth.

Aerial Perspective

While the name **aerial perspective** may be a bit deceiving, its execution is quite simple. Objects viewed from a great distance are usually blurred or obscured by smog, dust, fog, or **haze**. These atmospheric conditions wash out color, remove detail, and create a hazy, blurred look for objects in the distance. By adding these elements to your shot in either the production or post-production phase, you help create the illusion of greater depth.

Relative Motion

Relative motion is defined simply as the perceived motion of an object in relation to the viewing source. A quick way to demonstrate this is to look out of your window and move your head rapidly left and right. You will notice that objects closer to your eyes become blurry and move by more quickly. While objects in the distance, say for example, a mountain or a large building, seem to move more slowly and stay a little sharper in focus.

Designing a successful visual effect shot relies heavily on the principles of composition. It becomes just as important to divert focus through composition as it is to attract it. The presence

figure |4-12a|

This composite of a jet over a background plate has no added atmosphere and thus the depth or distance of the aircraft looks fake.

figure |4-12b|

Adding just a bit of haze to the foreground image of the plane gives the perception of more depth to the image and makes the viewer feel as if the plane is actually farther away.

of a miniature, computer graphic, or composite is likely to draw the eye of your audience. If there is relevant action to watch, the viewer is more likely to take the effect element for granted.

Keeping It Simple

Just as a pop song can be overproduced or a painting can have one too many strokes, it is easy to overcompose a shot. Sometimes the best solution is the simplest one. By using **depth of field** to direct your focus, you can use less detail in the shot while guiding the viewers' eyes to the point of focus. Keeping the background out of focus creates a "veil of realism" that allows you to get away with less detail in your background plate or miniature. This is demonstrated quite easily in Figure 4-14.

Framing Your Shot

As the name suggests, **framing** your shot is creating a subtle, and sometimes not-so-subtle, frame around your shot in order to keep the focus and attention of the viewer on the area you desire. Research has shown that the attention span of the average viewer is getting shorter and shorter. Humans are more easily distracted. Thus, it is easy for important elements in your shot to get upstaged by something going on in the background. This is not to say that you should create a frame and shoot through it—that would be the non-subtle version. Rather, finding elements within your shot to use as a frame will help direct the viewers where you want them to look.

Using Open Spaces

Using open spaces may seem like the opposite of framing your shot. It is, but the open space actually works as a frame for the area of interest in your shot. With no action going on within the remaining space in your frame, the human eye is automatically directed toward the only movement in the screen.

figure |4-13|

The same composite with motion blur added to the plane but not to the background plate. The perceived relative motion makes the aircraft appear closer to the camera and separate from the background.

figure |4-14|

The composite with the background plate blurred. The blurring allows us to have a background with less detail and directs the viewer to the aircraft even more.

figure |4-15|

Using four aircraft to frame the sun.

© Corel Stock

figure |4-16|

The vastness of the ocean directs the viewer's attention right to the pirate ship as the only moving object on the screen.

STORYBOARDS

A storyboard image can be drawn by hand, photographed, or assembled with graphics software. The idea of drawing may be scary if you aren't used to doing it. But sketching is still the quickest way to produce a useful storyboard panel. A few lines to show whether something is on the left or right of frame can be all you need.

A storyboard is the illustrated equivalent of the script breakdown. It is primarily an instrument for communication, not an artistic achievement. Professional storyboards are generally done artistically and are high quality drawings. But production doesn't spend money on art for art's sake—it has to serve a useful function for the project. The functions of a storyboard are numerous and include composition, continuity, set design, visual effects, and equipment rentals.

figure |4-17|

An over-the-shoulder (OTS) storyboard.

Good News about Your Drawings

If you're concerned about your drawing ability, as most people are, there is some relief for you. Your earliest boards had better not be art. Why not? Because art takes time and looks finished, and your first storyboards should have neither of those qualities. Their only purpose is to give you a starting point to refine

your vision. Quality can improve once your crew has an actual image to base their opinions on. It's possible that few to none of your finished shots will look like the earliest boards, and that's fine. However, by not doing them, you commit your least-informed ideas to the final product.

Better News about Your Drawings

There is a worst-case scenario if you're still self-conscious about the drawing. If your shot is rejected, for whatever reason, it has served as a point of reference of what not to do. Having that example helps you get to what you do want, by process of elimination. In other words, whether the drawing falls into the good or bad end of the spectrum, it helps production move toward the better options.

Functions of the Storyboard
Composition

For the director and the director of photography (DP), the arrangement and choreography of talent and set pieces in a shot is their primary visual contribution. The audience's attention is directed through focus, perspective, and motion. Designing before you

© Brian Lemay

figure |4-18|

Storyboards from the animated film *It's Alive.*

shoot allows you the most opportunity to select the best compositions. Even "**guerilla-style**" filmmakers get better shots if they plan them first. Planning helps get the most bang for your buck, which you need even more when you have fewer bucks to throw in.

Continuity

Sequential shots are typically staged as if seen from a single point of view, as in an audience seeing the action of a play. For example, if a character exits to camera right, he should enter from camera left in the following shot. This is referred to as the "line of action." Maintaining continuity of lighting, direction of action, set dressing, and so on between those shots is a basic concern of filmmaking. Because the takes may be done days or weeks apart, some diagram of the necessary elements is a benefit. Continuity photos taken on the set are common during production, but having the storyboard ahead of time helps to lay the groundwork. The same attention to continuity is needed when you shoot separate elements to composite as a visual effect shot.

Set Design

A common misconception is that sets need to be fully realized, meaning that any implied four-wall room needs four walls and a ceiling built. Another notion that goes hand in hand with that is that it's worth building the full set just in case you need it.

Production designers can plan their sets based on the desired shots within a location. This includes not only how many standing walls are needed, but also which set elements can be partial and which ones need to be full. With accurate plans for the use of the set, resourceful designers can create double-sided walls and scenery to make the setting as versatile as possible, while saving money on unnecessary construction and set dressing.

Visual Effects

The use of any kind of effect depends on knowing first what you want to see, and then figuring out how to make it happen. The storyboard image can contain important information, such as the kind of depth cues that will sell the shot, areas of action, and notation for the various kinds of effects and where they are to be used. Seeing the intended shot influences your selection of techniques, and helps you make choices to fit your budget.

Equipment Rentals

By figuring out choreography of talent and action in advance, you have a distinct advantage when it comes to booking equipment. In some situations you may only have a **tripod**, or "sticks," available. You may prefer a **dolly** or a **Steadicam** for more rapid moves between takes or for more interesting-looking shots. There might even be cause for a **crane**. These items tend to be in demand from rental houses, so the earlier you can book them, the better.

Creating Storyboards

Drawings

You can draw. No, really—you're better at it than you think. The image you scrawl onto your paper might not be photo-realistic, but because people can see it, that image communicates in a way your words cannot. Even if you have to explain what is on the page, it is the fact that others can look and evaluate that makes all the difference. The visual language of illustration is as universal as mathematics, and potentially a lot funnier!

One of the suggestions made in Chapter 1 was to network. This is as good a time as any to start. If you've exhausted your options for artists within your class, check with other students of the program. There is always someone in the student body who can draw. This kind of challenge is appealing, especially to those interested in comic books, given the

Storyboards and Visual Effects

Imagine your story calls for a large house, but you don't have access to one that you like. The inactive area of the property could be realized with a foreground miniature making the house appear larger. Action in the background catches your attention and allows the viewer to take the house for granted as a full-size element. If you choose to create an over-the-shoulder (OTS) shot, which can't be done in-camera with a foreground miniature, the foreground talent can be shot against a greenscreen and added in post-production. This involves extra steps, but costs much less than building a functioning house set. You will always have to balance the cost with time for any given approach, based on your situation.

Shot of the back of a small house.

With a miniature set extension placed in front of the camera, the house appears much larger.

similarities. Advertise to film students as well as to those in fine arts and even students in general. Artists' work helps make your project better and gives them experience and material for their portfolios. This is the spirit of cooperation that you will be hoping to find when you go on to make your own independent features, so give it a chance.

Preproduction artwork goes through three basic stages: thumbnails, sketches, and renderings.

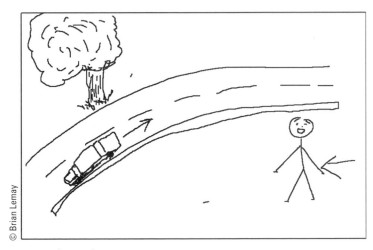

figure |4-19|

Even stick drawings can convey the actions needed to complete the shot.

© Brian Lemay

figure | 4-20a |

An initial thumbnail board from the animated movie *It's Alive*.

© Brian Lemay

figure | 4-20b |

The same board sketched with a little more detail.

© Brian Lemay

figure | 4-20c |

Final board after its final rendering and added detail.

Thumbnails. Scribbles, smudges, and stick figures. Sound familiar? A **thumbnail** is a first-pass attempt to visualize your shot. It takes your hazy, rough idea and makes it into a hazy, rough image. This way, you can block out compositions to establish the flow of scenes. You can also get a sense of where visual effects might be suited to the project. Are there wide shots? Do you want to see big interiors or geographic features like mountains or forests? The thumbnail shows what you think should be seen, before you limit yourself to your actual surroundings.

Sketches. Once you have sorted out the scribbled drawings that didn't work and come up with better ideas, the next step is to make a drawing that other people can understand. The **sketch** is typically larger (three to six sketches to a page), and contains such information as proper aspect ratio, character details, and approximate perspective. This is the storyboard stage used for most feature films. Sketches are almost always revised as ideas continue to evolve; only now they're improvements on already improved ideas. To get to this point, you could spend as little as zero dollars. Do sketches still sound like a waste of time?

Renderings. When your better storyboards don't give enough specific or aesthetic information, you may want to develop a few key shots into **renderings.** These tend to be full-page images. There may be color and scale drawing involved, but in either case there must be detail. Renderings may be conceptual (as in storyboards) or

architectural (meaning illustrations of the set). Very often, renderings are used as part of the pitch process, to sell investors on the "vision" for the film. Remember, your vision is just black text on white paper until you can present something that resembles it more closely. This effort could even convince a hesitant instructor that you are up to the challenge of VFX.

Photos

Because you will eventually compose your shots through a camera, you may find it useful to plan them with one. The use of three-dimensional representations of the set, along with toys or people, will provide a more accurate estimate of those shots than drawing can.

Toys. If you have ever played with action figures or dolls, this should come fairly naturally. Reenacting dramatic situations (and more than likely some combat) with toy people is part of how we learn to exercise our imagination. If you can forget the toy is a soldier or supermodel, it can be a valuable part of your preproduction. (Unless, of course, your movie is about a soldier and a supermodel, in which case you've lucked out.)

Access to toys and a camera makes you a one-person pre-viz crew. Any object can represent set pieces, from cardboard boxes to pieces of furniture. If you can create scaled models of your set to match the toys, you're that much closer to the real thing. Larger toys, in the 12-inch range, are typically easier to work with for close-ups and focusing. Smaller figures are great for wide shots and showing depth, because their surroundings can be smaller also. With your camera's macro lens, you can stage close action with the smaller figures as well.

Inexpensive craft supplies can be used for mock bluescreens if you'll be trying to composite photos. Fluorescent poster board and certain types of foam sheets make effectively **keyable** backgrounds.

People. Photographing people can create the most accurate live-action storyboard. If your set's framing is up, or you have access to the location, it benefits you immensely to block the action and take stills and video (see the Animatics section). Even without the actual setting, moving around and capturing the action of your scene brings you close to the shooting conditions.

If this sounds like making the same movie over and over, it's not. Each time it should be a better movie. Think of it as your insurance against feeling it should have turned out much, much better when you show the final result to people.

Digital Illustration and Photo Collage

The variety of tools available in software like Adobe **Photoshop** enables you to create simple or elaborate collages, meaning still composites. Pictures of toys or people can be worked into an all-digital painting and manipulated as needed.

figure |4-21|

Using software like Storyboard Quick means no drawing talent is required to create an informative storyboard.

figure |4-22|

Storyboarding software packages come equipped with libraries of objects, sets, and actors for ease of creation.

Computer Storyboarding

As with all aspects of filmmaking, computers are playing a role in traditional storyboarding. One example of this is the Storyboard Quick software by Power Production. Storyboard Quick allows the storyboard artist to work with a library of images to piece together frames for the storyboard panel. Because it is done in a digital format, changes are quick, thus allowing more time for experimenting and creating.

Another software that takes computer storyboards to the next level is **FrameForge 3D Studio**. With software like FrameForge the user cannot only generate the storyboards but can do so in full 3-D space. Advanced software like this not only allows the filmmaking team to get an accurate look of a shot long before it is done, but it actually allows the user to set limits in the scene. For example, the built-in camera can be set to a real-world lens and the size of the room can be input into the 3-D model. The software is smart enough to not allow you to design a shot that cannot be created in real life.

This option can save tens or hundreds of thousands of dollars in production cost by avoiding mistakes and miscalculations of an area you plan on shooting.

To summarize, the storyboard has several advantages:

- Quick and inexpensive to create.
- Easy to change—draw a new one and paste it in.
- Easily copied, distributed, and referenced by the crew.
- Easily inserted into the script breakdown for continuity.

Now that you are sold on storyboards, let's see what is behind curtain number two!

ANIMATICS

What is an animatic? In the simplest of terms, it is an animated storyboard. Some of the advantages of animatics are:

- Able to show motion.
- Uses pacing and timing cues.
- Includes sound (dialogue, music, effects).
- Features animation and visual effects.

Why create the storyboard at all, if the animatic is so much more descriptive? The answer is the same motive as for anything else—time and money. Animatics are more expensive and more time-consuming than plain storyboards. Remember, the important thing is that you create pre-viz. Whichever method is most available should be used, and improved as soon as it can be.

figure | 4-23 |

FrameForge 3D allows you to plan your composite and the placement of equipment, such as your camera rig, in full 3-D space.

Just as there are degrees of complexity for storyboards, so there are for animatics as well. With an eye on available resources and cost, here are some of your options.

Videotaping Storyboards

Once you have the boards and your video camera, you are again a pre-viz commando. If the board shows a **zoom**, you zoom while recording it. Pan across the board if that's described. Speak the dialogue if there is any. Shake the video camera. Fade in and out. As much as you can, mimic the camera action as it is described, and add to it if it's motivated. All this is within your grasp for the cost of videotape.

Scanning and Animating Storyboards

Digital software ups the ante again with 2-D animation. Drawings and photos can be scanned and manipulated completely. Adobe **After Effects** is a popular tool for this, and uses similar approaches to Photoshop. Pan and zoom speeds can be changed at any time, color and focus can be shifted, and layers can be individually controlled for maximum versatility. It is possible to create a virtual rough cut of the movie in this fashion.

Videotaping Toys

Fundamentally, this progression is the same as for storyboards. To better understand your shooting conditions, move from 2-D art to 3-D environments.

Your set designs, commonly between 1/4" scale and 1/2" scale foamboard models, work well with smaller video cameras, including Webcams and lipstick cameras. Their distorted wide-angle lenses and deep focal distance actually complement the tiny shooting space. The toy figures described earlier can be used to similar effect in video, down to shooting against bluescreen backgrounds and compositing into the set.

Videotaping People

As you might expect, recording people on video as they perform scenes is your closest comparison to the actual shoot. You get the most accurate framing, talent blocking, and set visibility. If your plan involves placing talent in a miniature set in post-production, shoot them against bluescreen and practice lining up perspective with the miniature. This is one of the most basic, and underestimated, challenges in compositing.

SUMMARY

The planning and the preparation of your shots is of vital importance not just because of the time and money equation, but also, of course, for the artistic vision of your shot. Using the tools and the tricks explained in this chapter will aid you in creating reality where there is none. But don't stop there. Experiment, try different techniques, and combine multiple options.

in review

1. What are the qualities of good composition?

2. Describe the rule of thirds.

3. What are the different types of depth cues?

4. What are the different methods for creating storyboards?

5. What is an animatic?

exercises

1. Find examples of framing, depth cues, balance, and contrast. Display them on a foam board and describe them to the class.

2. Create simple storyboards or thumbnail sketches from any effects shot from your favorite film.

3. Create final presentation storyboards from your thumbnails.

4. Recreate the same sequence using one of the alternative storyboard techniques (photos, videotaped toys, etc.).

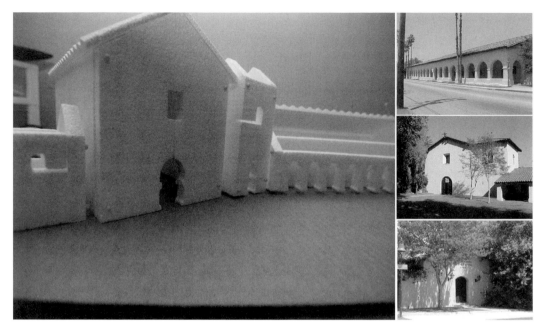

A study model of the San Fernando mission in Mission Hills, CA.

CHAPTER

5

Chapter Objectives

- **The meaning and use of scale in design**
- **2-D floor plans and elevations in planning a set**
- **Practical 3-D study models**
- **Creating digital 3-D study models**

Introduction

You've analyzed your script. You've thought about the story action and how it would look. You even found a great excuse for making a movie with toys. Now, with your photo reference and a rough idea of how the sets should look, the question is before you: "How do we make this happen with no budget?"

Welcome to the bottom line. That dilemma faces every film crew. In fact, it is the very reason you did all the previsualizing: to get the best movie for your budget, whatever it is. Whether you're building full-size sets or scale miniatures, the objective is to build only the amount that will be seen.

Think back to the discussion in Chapter 3 of the development of ideas . The thumbnail represents the most basic presentation, followed by the more detailed sketch, and finally the finished rendering. As that pattern was echoed in the transition from drawings to animatics to the final feature, so does design progress from 2-D plans to 3-D study models to the finished set.

DESIGNING THE ENVIRONMENT BEFORE THE SET

In order to know what segment of your environment needs to be built, you must know what else would exist there in the world of the story. How do you do that? You look at what the production designer gives you as visual reference, for starters. You think about the whole location first, and then pick the best ways to see or imply it within your means.

The limited soundstage space you have been allotted is your window to the story's setting. Are there hallways leading to that room? Is there scenery beyond the window? Is there a visible level above or below? Designing only the portion that would fit in the shooting space is a restrictive habit to adopt. It rules out the available options of forced perspective construction, foreground miniatures, and bluescreen for set extension. There are many ways to imply a larger environment, but they all rely on the use of one quality: scale.

figure | 5-1 |

Scale models, like this 1:18 scale model jeep, allow the film-maker to manipulate and film objects and scenes that would otherwise be impossible or cost-prohibitive.

SCALE

Scale can refer to two qualities, both related to size. **Mechanical scale** is a measured comparison of an object to a duplicate of itself, including small set models and oversized props. Mechanical scale is a mathematical relationship used in design to realistically plan the space at a comfortable size to work with. The set dimensions are reduced by the same proportions, as described next, so they will be the same shape. **Apparent scale** refers to the size relationships of objects within a picture. This is often achieved by using a person's perceived idea of the size of an object to define the scale of another. For example, if you place a quarter next to a miniature, it will instantly give you an idea of the apparent scale of the model because you now have a reference to work from. But if you want to fool the viewer into thinking something is larger than it is, you create a scaled down version of that quarter, thus your miniature now looks bigger.

Notation of Measurement

Set designs commonly use the architectural notation for feet and inches. Measurements in feet are denoted with a single straight quotation mark, as in 6'. Measurements in inches use a double quote, as in 6". An object that is six feet and six inches long would be labeled 6'-6". It is easy to confuse single and double marks if the writing is small or smudged, so for the sake of clarity, any foot measurement without remaining inches is written with a zero in place of the inches, as in 6'-0" for six feet.

To describe the scale comparison being used, you may see it written as 1" = 1'-0", which means that one inch on the model equals (represents) one foot of set space.

You may have seen that written a different way, without the quotes. Since a foot is made up of 12 inches, the 1" scale compares a foot of set space to a fraction of that, 1/12 to be exact. That may be written as 1:12 or 1/12th scale. A model half that size would be 1/24th scale or 1:24.

To recap: A design model of a set, built so that one inch on the model represents one foot of set space, can be written the following ways: 1" = 1'-0" or 1:12 or 1/12th scale. A design

| TIP |

Filming in Meters
While this text is directed toward students in the United States, where the standard of measurement is feet and inches, the rest of the world measures in meters—and at some point you may need to as well. The conversion formula is simple:

1 meter = 39.3700787 inches

and

1 foot = 0.3048 meters

 A conversion spreadsheet is included on the DVD that is packaged with this book.

model half that size, so that one half-inch on the model represents one foot of set space, can be written the following ways: 1/2" = 1'-0" or 1:24 or 1/24th scale.

When labeling the dimensions on a design, it is best to stay consistent, using the foot and inch marks.

Choosing Which Scale to Work In

Why use a certain scale for your plans? Normally you will use the largest scale that will fit on the paper you have available to draw on. A standard-size sheet of drafting paper is 24" × 36". If your set is a living room that is smaller than 24' × 36', it will fit at a 1" scale.

figure |5-2|

A 1/250 scale drawing of a castle model.

KINDS OF PLANS

2-D Plans

Any drawing or scribble of a set design is two-dimensional. It is flat and has only width and length. Even a perspective drawing is only 2-D because the depth is an illusion formed by converging lines and shrinking shapes. They help to convey what the space will look like, so are considered conceptual artwork. In order to be considered plans, they must be laid out in such a way that they can be measured. There are a handful of basic views that are useful for planning a set's dimensions.

Two-dimensional plans, as used in miniatures, serve largely the same functions as those used for full-scale sets. Let's understand what those are before moving on.

Set designs must fit within an existing soundstage, and it has definite limits (the walls). The **ground plan**, or floor plan, is typically the first drawing to be made. It is a view looking straight down onto the floor. It shows the spatial relationship of objects to each other, and how they fit within the length and width of the space. Because the view is straight down, height cannot be illustrated, but is noted wherever it is significant.

figure |5-3|

This ground plan of a soundstage shows dimensions and height for each area. It is essential to know the space you will be working in so that you can plan accordingly.

Room may be needed between the set and soundstage walls for safety or equipment, which further limits the available set space. Laying out the stage ground plan is the first step to arranging the set walls. Ground plans are also used to block camera and lighting positions within a set, as well as **sight lines**. Movement of wild scenery, layout of dolly track, and lens selection by focal distance can all be planned with this, the most important of the 2-D plans.

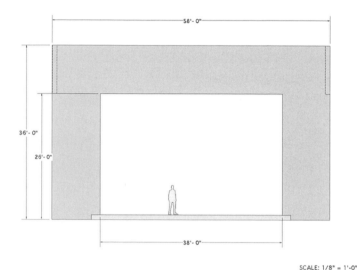

SCALE: 1/8" = 1'-0"

figure |5-4|

The front elevation.

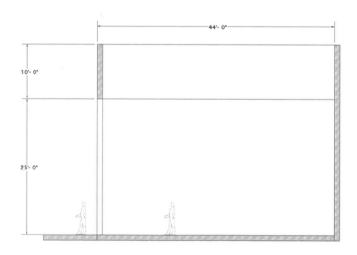

SCALE: 1/8"=1'-0"

figure |5-5|

The side elevation, or section view.

Elevations are also straight-on views without perspective. They are significant because they illustrate the height of the space, but only either the length or width, not both. They contain views of the walls as if seen from eye level, within the set instead of above. There are three common elevations: front, side, and rear.

A **front elevation** shows the arrangement of scenic detail, including texture and set dressing, on a wall that will be seen by the camera. The height and length of the wall are visible.

A **side elevation**, or section, shows the edge, or profile, of a wall, including its support in back and set dressing in front. It is important to plan a support system that allows safe maximizing of the space.

A **rear elevation** shows none of what the camera should see. Why does it matter then? It shows how the set is to be constructed and any areas that may have camera ports or **breakaway** sections. If someone will be thrown through one of the set walls, it's advisable to avoid putting wooden supports in that spot.

2-D Plans for Miniatures

In the case of shooting foreground miniatures, a ground plan can be used to first design the implied set, then to isolate the portion to be built in smaller scale. You can also plot distance from the full-scale **partial set**, based on the miniature scale and lens angle. If that sounds a little abstract, it will be easier to visualize when you've made a 3-D study model.

figure |5-6|

A full-size house that needs a foreground miniature.

figure |5-7|

Sketch of the foreground miniature to be added to the full-size set.

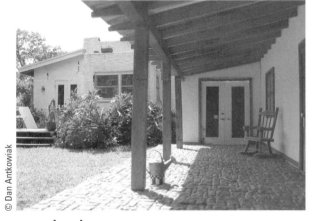

figure |5-8|

The final image with the miniature placed in front of the full-size set.

3-D Study Models

The next step in understanding your design and the space it occupies is to build a three-dimensional study model of it. This model can be very simple because details like base molding and light switches don't affect the overall composition for our purpose. This is true whether you're using the study model for a set or miniature. Shape and depth are the qualities you're trying to get a handle on.

One consideration when building a model is how much material you want to use. The model needs to be large enough to convey some depth, without wasting useful materials. If you can plan all your walls to be cut from a single sheet of foamboard, you're doing well. That habit will

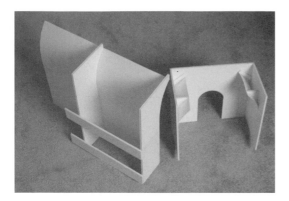

figure |5-9|

A 3-D foam study model of an Egyptian tomb.

figure |5-10|

Camera test for placement of the foreground miniature of the Egyptian tomb.

| TIP |

The Difference between Model and Miniature

At this point, a distinction must be made between "models" and "miniatures." Models are used as part of the design process and are not seen on camera. They are usually made to aid in the process of planning shots and action within a particular scene. Miniatures, on the other hand, are scenic pieces that are simply smaller than they appear to the viewer. Miniatures are the final elements that will be pieced together for the final shot.

figure |5-11|

A variety of foamboards for building both pre-viz and final models.

come in very handy when you try to get the most value from your more expensive sheet materials, like plywood or medium-density fiberboard (**MDF**). The careful planning of your cuts prior to ever breaking out the saw is imperative.

Materials

The most common materials for building design models are foam-core and illustration board. **Foamboard** has a core of **Styrofoam** and a paper coating on both sides. It is lightweight and easy to cut and glue. Moisture through contact or humidity will cause the paper to weaken and warp the board, especially at larger sizes. This is rarely an issue for small study models, but it would be a reason to use a different material for a miniature. Other foam-core boards, such as **Gatorfoam** and plastic-coated **Ultraboard**, are sturdier and possibly more expensive.

Ground plans and elevations can be drawn directly on the board or spray-mounted on to save that step.

Straight pins can be used to temporarily hold foam-core together. White tacky glue or even hot glue will hold it more permanently. Using just the amount needed to bond it will produce a cleaner model, and help to conserve supplies.

Illustration board is much thinner than foamboard and is made of layers of paper. It can be bent easily and can be used with the foam-core boards to represent curved surfaces.

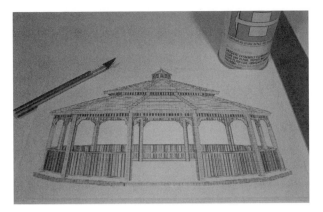

figure |5-12a|

A sketch of a gazebo spray-mounted on a piece of foamboard.

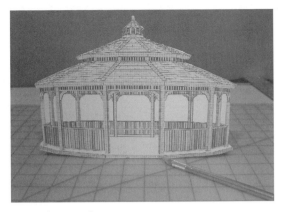

figure |5-12b|

Once the image has been mounted to the board you can then use your X-Acto blade to cut out the shape.

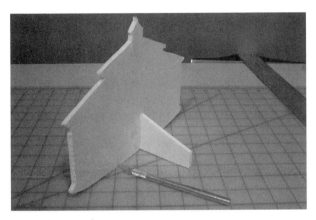

figure |5-12c|

A simple support can be taped or glued onto the back of your cutout to allow it to stand on its own.

figure |5-13|

There are several options of mounts for your foamboard. Spray mount is perfect for pasting drawings onto foamboard. Rubber and contact cement are great for building models.

Remember, your model merely represents what you are going to build; detail is not that important yet. The idea is to create a working model that can be used to plan shots and action around your set.

Digital 3-D Study Models

Computers, of course, continue to change and alter all facets of just about every industry. Film pre-viz is no different. As mentioned earlier, computer software has allowed the nonartist the ability to create very clear and descriptive storyboards. Simple 3-D applications also allow you to create study models that you work on virtually.

Most colleges have a department that teaches 3-D animation. You should be able to easily find a resource there. One of the great aspects of creating your pre-viz in 3-D is that you have the ability to then animate your virtual camera and truly plan your shots.

Shaping Foam-Core Boards

Foam-core boards are not flexible but can be shaped into curves with this trick. Using your blade, make a series of close, parallel cuts along the back of your foam. Make sure you do not cut all the way through.

After several cuts you can begin to bend the foam into the needed curve.

From the front you get a nice smooth curve.

figure |5-14|

With software like Maya you can create a digital study model and test the placement of the foreground miniature.

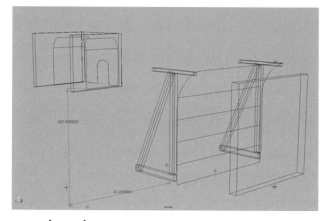

figure |5-15|

After creating the model, you can prepare technical drawings for the construction and placement of your set pieces.

SUMMARY

This will begin to sound like a broken record before long, but it is so important with such restricted budgets: plan, plan and plan again. You do not need to be Monet or Frank Lloyd Wright when creating your storyboards or your models. They just need to convey your message accurately and clearly. Where accuracy is very important is with the floor plans and layouts. If you deliver a floor plan that is the wrong scale and then your set pieces are built and you show up on site and now nothing fits…well, remember that your reputation is all you have in an industry like film. If you do good work, people will know. If you do bad work, they will know much faster.

in review

1. What does scale mean?

2. Why would you choose to work in a particular scale?

3. What are the different types of 2-D plans?

4. What is a 3-D study model?

5. What materials are used for creating study models?

exercises

1. Using a 1" = 1' scale, draw a floor plan of your classroom or lab.

2. Create a front elevation of your building.

3. Create a cutting plan for the front elevation in exercise 2.

4. Create a foamboard 3-D study model of a building of your choice.

5. Create storyboards of a sequence of shots of that building and then shoot that storyboard using the study model.

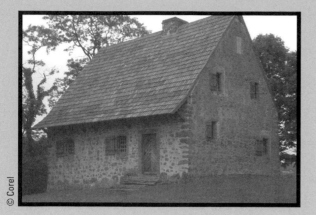

© Corel

© Corel Stock

While one home seems much more elaborate than the other, when broken down into simple shapes you can see that the basic underlying structure is not that different.

| miniatures |

Section 3

CHAPTERS IN THIS SECTION

- Foreground Miniatures

- Building Miniatures

- The Layered Miniature

SECTION INTRODUCTION

One area of creative expression we all have experimented with is miniatures. As children, we stage dialogue and action between toy people. Have you ever orchestrated a car crash, an aerial dogfight, or a derailing train with toys? Using smaller versions of familiar objects is a basic way to make them more controllable. With such models, suggestions and creative ideas can be converted into realistic shapes for accurate planning. But that is only the beginning of their potential.

Using a camera to fool the eye has been a part of photography since its beginning. With a variety of lenses and lighting, you can manipulate depth, size relationships, and other visual cues to trick the viewer. The use of miniatures in feature films dropped off with the advent of detailed 3-D computer graphics (CG). CG promised greater versatility and superior quality, and miniatures were seen as old-fashioned. There has been a tendency to include more practical models, though, due in part to the low cost and fast turnaround of creating them.

Realistic proportions, colors, and textures are the key ingredients to successful model-building. This section will explore ways to create models with these qualities, using common materials and basic scenic detailing techniques.

Let's say you've made it to this point in your life without ever assembling a model kit. That's okay—model kits are rarely used out-of-the-box for effects. What if you've never tried to build a dollhouse or fort for your action figures? Still okay. What if you can't even draw a stick figure? Not a problem. Fortunately, you'll probably never have to put your stick figures on screen.

MINIATURES

A miniature used in front of a camera to represent a deck and pool in a backyard too small to have one.

CHAPTER

Chapter Objectives

- Illustrate the versatility of foreground models in improving the look of low-budget films

- Create foreground miniatures, even with little or no prior experience

- Explain how good composition helps make these shots work

- Use foreground miniatures both on stage and on location

- Understand the photographic principles of foreground miniatures

- Design and create convincing miniatures from scratch

- Understand good shot composition and how to disguise the use of miniatures

Introduction

The amount of full-size set that can be built for a film, particularly one with little financing, is normally determined by the budget, time available, or skill level of those involved. Small sets are restrictive to shoot in and can feel claustrophobic to an audience. Careful use of foreground miniatures can either subtly or dramatically expand the visual space of the setting. Pre-production planning with storyboards and reference photos can produce a minimal set that is designed specifically for wider shots with a foreground model. With this strategy, you would build only enough of the set to accommodate medium and close-up shots. Alternatively, a miniature can be taken on location and framed to enhance the existing scenery using the forced perspective method mentioned before.

LENS SELECTION

Generally speaking, the use of a miniature near the lens, with action staged in the background, will require a long **depth of field**, meaning both the foreground and the background will be in focus despite the distance. Not all lenses are capable of both focusing on an item three feet from the lens and keeping the background sharp at the same time.

If the miniature represents an upper floor of a building, and the set is the bottom floor, they are supposedly equal distance from the lens. Any difference in focus is an immediate giveaway that the shot is a fake. For this reason, wider angle lenses are typically used when shooting miniatures. These lenses provide greater depth of field by supplying more light to the film. Because they have a pronounced curvature, they will also bend and distort the lines of the foreground miniature. The distortion of these lines creates a greater apparent depth within the model and ties it in with the more distant lines of the background.

© Dan Antkowiak

figure |6-1|

Using a lens with a short depth of field will leave the background out of focus with the foreground in focus. This makes the foreground set extension look like the miniature that it is.

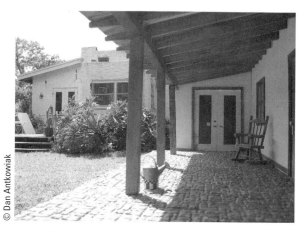

© Dan Antkowiak

figure |6-2|

Shooting the same shot with a lens with a longer depth of field brings everything into focus together, thus removing the hint that the foreground is much closer than the back and removing some of the telltale signs that this is a miniature set extension.

figure |6-3|

This set extension is placed directly in front of the camera. It is scaled to match the proportions of the real set, seen in the background behind the staircase. Figure 6–4 demonstrates the setup for this shot.

figure |6-4|

Pre-viz setup for Figure 6-3. Notice the placement of the camera in relation to the set extension and the smaller light (represented by the cones) placed toward the window of the miniature to match the main light's direction.

EXTERIORS

Exterior establishing shots provide valuable information by giving a greater sense of setting to a film. This is especially true when the film is shot entirely within a soundstage. Seeing a character enter or leave a building, or simply showing the building or landscape, introduces an audience to the setting more thoroughly than simply editing from one interior to another. Even showing someone at a window from an external point of view expands the viewer's sense of environment. Many student-made films feel smaller or more amateurish

The Dividing Line

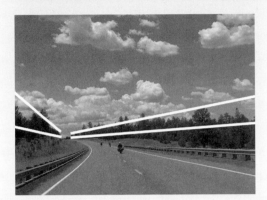

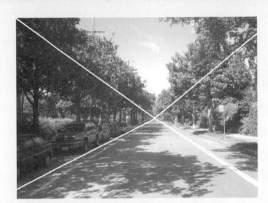

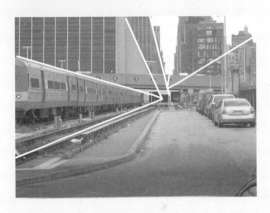

Visible edges of a foreground miniature frequently correspond to similar edges in the background. They may be clean architectural lines that align with distant structures, or softer and more organic edges that blend, rather than intersect. These collectively form the dividing line. It appears as a line in the viewfinder and recorded image because it is two-dimensional, but in reality the line is formed by the contours of the miniature. The visibility of the dividing line is significant because it either sells or betrays the illusion of a continuous environment. Notice by following the natural lines within the next three shots, you can easily find the vanishing points of each scene. In the first two, the road and the trees work to guide the eyes' focus. In the third, the railroad tracks and the tops of the buildings serve the same purpose.

because they lack exterior establishing shots. This may be due to the expense of permits or the unavailability of such locations. There are several ways to create establishing shots without transporting a whole crew to some distant location.

Miniatures on Location

Because of the available space outdoors, exterior foreground miniatures shot on location are inherently easier to use. Individual buildings or entire streets can be placed at whatever distance from the camera is most appropriate. This also allows building in larger scale, which provides an opportunity for greater detailing.

figure |6-5|

Here the actor moves behind the railing lending more to the illusion of a real full-size patio.

Continuous, Split-Scale, and Forced-Perspective Environments

Continuous environments are sets that exist in a single scale throughout. Split-scale environments are built in more than one scale, including the full-size background and a foreground miniature setup. Forced-perspective environments are sets or miniatures that gradually reduce in scale to imply a much greater distance within the location.

Staging a shot that uses foreground miniatures has to be done carefully to avoid revealing the lack of depth between the lens and miniature. With specific blocking, the talent can appear to move within the set without breaking the line. For example, an actor who walks too close to the lens will become partially obscured by the miniature. If a ceiling is hanging in front of the camera, a person walking toward it will be cut off head first behind the model. On the other hand, if the foreground element is a railing, or a row of windows or columns, the actor can naturally move behind what appears to be normal foreground set elements.

© Dan Antkowiak

figure |6-6|

This board shows the placement of the tree house miniature in front of the grove in the background.

| TIP |

The Point of Contact

The point of contact is where the talent or subject physically touches its environment. You will typically see some evidence of real contact between an object and its environment. There may be shadows cast or dust stirred on the ground or ripples in the water. The absence of such a reaction will cause the shot to look unrealistic. A reaction that is inappropriate or exaggerated will also draw attention to the "fakeness" of the shot. Evidence of appropriate contact might be seen **in-camera**, but may also be added during digital editing. You should know that it would be there, so you can be sure to add it wherever appropriate.

Set Insertion

In some cases, you may need to place an entire structure into an existing location. Ideally, the location would contain an open area, free of obstacles that interrupt the dividing line.

In the case of the tree house in Figure 6-6, an open area within the grove provides a perfect location to place the miniature. To convincingly see the miniature trees and house in their entirety, part of the ground is included in the miniature. A knoll in the foreground blocks the actors' **point of contact**, so they appears to stand between the foreground tree and the tree house. A simple ramp for the actors to walk up ties them even more into the terrain. To further add to the sense of depth, some close foreground leaves would be added.

Miniature foliage doesn't sway like real foliage, so the leaves would be shot full-scale in front of a white board. They then would be blurred and added onto the top layer of the composite.

For example, a miniature boat in water can easily look out of place or silly. Instead of crashing waves and spray around the hull, you instead have one smooth ripple that rides along the boat. The ship's point of contact with the water is the dead giveaway. In Figure 6-8, a dog that was filmed sitting against bluescreen does not have any visible shadows. Amid the harsh shadows in the environment, the composite is noticeable.

figure | 6-7 |

A model of a speedboat looks just like that, a model.

figure | 6-8 |

Notice the lack of shadows on the foreground image. This image looks fake.

The solution may be simply to frame out, or not show, the point of contact. Or you may add foreground scenery, shadows, or any number of things to help obscure it.

Set Extension

It may be that a building you find on location looks good but is smaller than the story requires. Maybe the property it's on is too small or is too cluttered with objects you don't want to see. Here, a foreground miniature can both extend the structure for design reasons and cover up unwanted scenery at the same time.

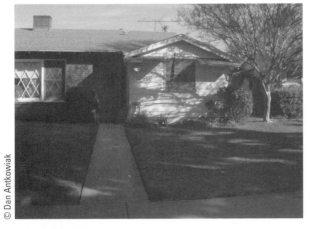

© Dan Antkowiak

figure | 6-9 |

A shot of a full-size house in need of a set extension.

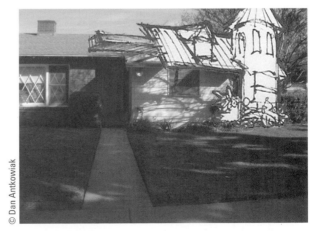

© Dan Antkowiak

figure | 6-10 |

Sketch showing the placement of the set extension relative to the camera placement.

© Dan Antkowiak

figure |6-11|

Miniature set pieces add realism to the final composite.

This house represents the kind of location that may be available to your student film project. It is fairly small, and sits on a small plot of land. The objective here is to make it appear more elaborate while still staging action freely around it.

Design and home magazines were consulted first. The final design for the set extension includes a new gable and a two-story tall rotunda. The wall hides the property line, while the upper level further increases the building's apparent size. Notice, in Figure 6-11, the effect of converging perspective lines of the wall and covered walkway. While the eye is naturally drawn to the actions on the left, it is also being guided to a specific area on the right. These opposing focal points pull attention away from the dividing line, which is formed by the awning, its supports, and the hedge.

Exteriors on Soundstage

If the soundstage has sufficient available space, exterior shots can be accomplished indoors. The larger the stage space is, the wider the possible framing becomes. Anything from windows and balconies to more revealing facades can be staged in-camera.

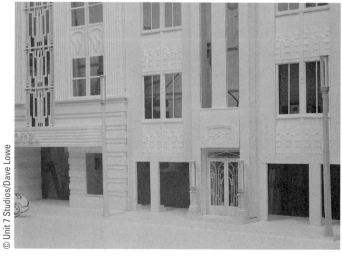

© Unit 7 Studios/Dave Lowe

figure |6-12|

A street-level facade under construction.

Some amount of partial set may be appropriate to supply a backdrop for the talent. As few as one or two walls can achieve the necessary background. Through the lens, the perspective lines of both set and miniature need to appear continuous, meaning they appear to physically exist as one. Careful placement of the model requires extra time to set up. Plan to spend anywhere from one to three hours setting up, depending on the complexity of your shot.

Higher camera angles may require tilting of the model to match perspective. Distant background elements, like other buildings and the horizon, may be included in the miniature or composited later during post-production.

The street-level facade in Figure 6-12 is accomplished by placing the facade miniature

> ## Building to Match Scale Cars
>
> Imagine you would like to dress your miniature set with realistic cars. There's no need to build cars to match the scale of the miniature set. A common scale for realistic die-cast metal cars is 1:18, which is the same as 3/4" scale. That is a decent scale for an exterior set of a building.
>
> For texture, you can find various plastic molds at hobby and dollhouse stores. The most common scales are one inch to the foot (1" = 1'-0"), and one half-inch to the foot (1/2" = 1'-0"). Though they aren't quite the same scale as your cars, these molded textures can still be used, as long as they look appropriate. For example, if you have a sheet in a scale of 1" = 1'-0", representing 4" wide bricks, it will also work as 6" bricks in 3/4" scale, and 8" bricks in 1/2" scale. Try not to fixate on exactly the scale and measurement of the texture as it is labeled. Remember— it's your creation, and in the end it only has to look believable. The audience won't be measuring the siding, but they will recognize if it is out of proportion with other elements.

in front of an exterior set wall with a door. The point of contact can be masked to a degree by compositing in full-size cars in the foreground moving from left to right and right to left.

INTERIORS

Ceilings

One of the simplest and most versatile illusions is the hanging ceiling miniature. Unlike a practical ceiling built over a set, which can be expensive and interfere with lighting, the hanging ceiling miniature may be only a few feet across and sell the idea cheaply. A key advantage of this type of foreground piece is that the dividing line is above the heads of the talent, meaning the actors are less likely to disappear behind the model. What the false ceiling effect does for a set is to enable wide establishing shots of the space before cutting to close-ups. Once the room is seen in its entirety, tighter shots can be cut in without feeling so limited or claustrophobic.

For the cleanest dividing line, keep the contour of the set walls simple, as in a three-wall, right-angled plan. If all walls are of equal height, the ceiling will align evenly. Keeping the line simple can mean less time setting up the shot as well.

Once a dividing line is in place, cleanly separating the set and miniature, you may wish to disguise that line. A dividing line that is too clean can cause the shot to read as fake, especially if one portion of the frame has movement and the other does not. In some cases the line can be broken purposely to help hide the line between the miniature and the real set. For this reason,

figure |6-13|

A three-wall set minus the ceiling for ease of lighting and for shooting overhead shots.

figure |6-14|

The same set with a false ceiling slid in. Notice the addition of lights in the false ceiling that match the lights on the wall and the shadows painted onto the drop-in ceiling that help to cast the illusion that the ceiling is actually there.

appropriate scenic elements may be added to break the line. For example, a chandelier or fan that is attached to the ceiling, but hangs low enough to obscure part of the distant set wall, interrupts the otherwise clean line and helps to blend the room elements.

Levels

Single-floor sets can also be extended to include upper or lower levels. Try to imagine how you would frame within the room if the other level actually existed there. This might mean choosing a lower camera height to show the upper floor, or a higher one to see the lower floor. Visual interaction of talent between floors is not always necessary, but can help sell this effect, which may mean shooting one of them against a bluescreen.

The more complicated a floor plan becomes, the more difficult it is to match a foreground model. As the set walls protrude and recede, the miniature must also.

Staircases

It may be helpful to show a staircase connecting two floors, whether or not it is actually used. Including a staircase within the miniature provides a more varied dividing line, offsetting the break in the same way as the ceiling fan would. The decision to show step surfaces depends on whether anyone uses them. As with other foreground elements, the point of supposed contact with the actor instantly sells or ruins the effect. Stagings of action around the staircase, and the continuity of shadows in the room, are important factors to keep in

> ## Simplifying the Process
>
> As with all efforts that appear complicated, one way to approach them is to simplify. Simplify each part of the process. The concept, the designs, and the execution can all be reduced to basic shapes and steps.
>
> For example, imagine a house. Whether your mental image is of a simple house or an elaborate one, there are features common to both. Each includes simple shapes, such as squares and triangles. Each one also shows other qualities that can be simplified. There is symmetry of window placement and repetition of window shapes and architectural details. A tracing of the more complicated house reveals an arrangement of rectangles. Notice how much simpler it looks in this form. If you were to make a model of this house, you might begin with something like this. Surface textures can make a building appear more difficult to reproduce than it necessarily is. Techniques for applying texture and other details will be covered in this section.

mind. For example, if railings would cast shadows, a wall may be added to the miniature or shadows can be positioned on the set, depending on where the dividing line is. Using movement in the background takes advantage of the implied depth and takes scrutiny away from the miniature.

DEPTH CUES

One of the depth cues covered in Chapter 12 is **atmospheric haze**. That effect is described as moisture and particles suspended in the air that creates an increasing diffusion of light reflected from distant objects. This causes them to appear less distinct to the eye as well as the camera. The extreme proximity of a foreground miniature to the lens does not allow such a buildup of diffusion, so the model naturally appears much sharper and more boldly colored than the background. The difference can quickly reveal a shot as fake, but there is an assortment of ways to correct for this.

Diffusion

Typical methods of diffusing foreground models involve cutting bridal veil or other tight netting to place between the model and camera. This creates a softening of the model, but also further diffuses the background. To reduce that overall diffusion, the netting can be cut in the shape of the model's silhouette. This method is similar in principle to building mattes in Photoshop to make adjustments to only sections of a frame. A variety of material can be used, anything from silk to nylon stockings.

figure |6-15|

Wedding veil material can be used as a diffusion filter for a miniature shot.

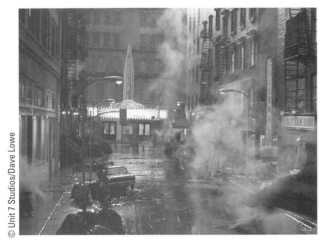

figure | 6-16 |

A miniature enhanced with hanging fog.

figure | 6-17 |

A typical stage fogger and controller

Fog

Scenic fog machines can be used under controlled circumstances to create hanging atmospheric diffusion. Left to its own devices, fog wants to roll and tumble in a way that is not realistic in miniature scales. Allowed to build up in an area free of air circulation, it can be visually effective. It does further diffuse the background, however, like the netting technique. It may be worth experimenting if a fogger is readily available, but in general the cost isn't reflected in the finished picture.

Controlled Lighting

Because the basic visual difference between objects' distances from camera includes contrast and clarity, the quality of light used on the foreground model can be adjusted to match the background, or vice versa. More saturated or brighter light could be used in the background, whereas diffuse, paler light might even out the foreground.

MATTE BUILDING

Among the most significant contributions of digital technology is image editing. If a shot using a foreground model suffers one of the depth cue issues, corrections can be made fairly easily. For a stationary shot that requires an area of adjustment, a limiting border can be drawn around that area to isolate it for editing. This is called a **mask**, or **matte**. These can be drawn with straight lines, or hand-drawn to follow a more organic line.

Any adjustments to blur, contrast, brightness, and so on, contained within the mask can be repeatedly applied to each frame of the stationary shot. This allows a foreground model to

be adjusted to match exactly to the background. Matte building will be covered more in Section 6.

DROP-IN BLUESCREEN

There is an alternative to hand-drawing masks around the foreground miniature in a shot. Think of the principle of **keying** out colors that allows compositing of bluescreen elements. A smaller bluescreen card or material can be placed behind the foreground model to obscure the background. The compositor or colorist can then grab and remove the color, instead of hand-drawing a mask. This is true for traveling mattes as well, because the non-keyed element of the shot will distort and change on its own.

Just as master wide shots are recorded before close-ups in filmmaking, to be sure all necessary information is captured, so should the combination of foreground miniature and background be shot first. Even though a second pass of the model is being shot without the background, this is still considered a foreground miniature setup. The model is photographed with the background for cleaner matching of lines than shooting them separately. Use of the drop-in bluescreen produces an instant matte for easier compositing.

There are many different options for creating blue or green screens. You can of course spend hundreds or thousands of dollars on materials designed to be blue screen or greenscreen, or you can try some of the following options:

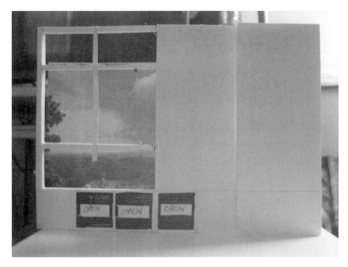

figure |6-18|

A working miniature with just a backdrop representing where a new background element will be composited in later in post.

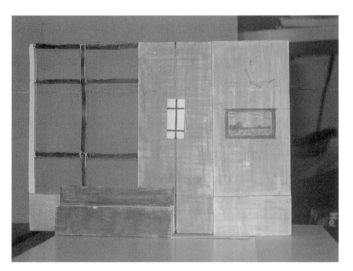

figure |6-19|

The same working miniature with a drop-in screen placed behind the window.

- Check out your local fabric store for materials that are rich in color and matte finished. You want the fabric to be smooth so that it will be lit evenly. If you can find a fabric that stretches, like a **Lycra**, you can stretch it around a frame for a nice smooth surface

INTERVIEW

John Goodson of ILM, freelance artist Greg Jein, freelancer Mark Stetson, Tony Meininger of Disney's Secret Lab, and Brick Price of Wonderworks

The stereotype surrounding modern effects films suggests their dazzling imagery is largely the result of computer-generated artistry. In truth, of course, the effects in such films as *Pearl Harbor, Planet of the Apes, Jurassic Park 3, A.I.,* and others are actually mixed-media affairs, and virtually all of those films relied on model and miniature work in combination with CG effects.

"Our [model] shop has never been busier," says John Goodson, ILM's model project supervisor for *Planet of the Apes.* "All recent big films used miniatures. The reason these films use miniatures combined with CG is that you would run into cost issues doing just CG because of outlandish render times. Plus, some shots still look better with real-world interaction, like explosions. For this reason, it's hard for me to see miniatures becoming extinct, even though CG is obviously improving at a rapid rate."

This does not alter the reality, however, that there clearly has been a sea change in the role of miniatures in film and TV production. The rapid rise of CG in the '90s led to the closing of several independent model shops in Hollywood, with well-known artists from such shops either transitioning into freelance work, becoming computer animators, or moving into other entertainment-related venues, such as theme parks, museums, and the toy industry.

Most of the remaining miniature shops, with a few exceptions, are affiliated with major studios or are part of larger effects houses, like ILM, Digital Domain, and Disney's Secret Lab.

Has CG changed your industry as much as people think?

Mark Stetson: I'd say the total volume of miniature effects used in films and TV shows has been reduced somewhat from a few years ago, but at the same time, mixed-media approaches to specific shots, especially in films, are definitely on the increase. Combining digital and miniature solutions has actually been beneficial to our industry. For instance, in *Fifth Element,* take a look at that well-known shot of flying cars maneuvering through flying traffic. The flying cars were digital cars, but they were maneuvering through a miniature, futuristic cityscape—a perfect combination.

Digital compositing has improved our ability to add miniatures to the mix, and that has actually led to more ambitious miniature shots in certain films.

Brick Price: We use computers every day, but we use them as an adjunct to our main stock in trade—building and shooting miniatures. In many ways, computers have been a blessing. We can do more ambitious designs; we can more faithfully rig models now without having to limit ourselves to extremely fine monofilament wire. Now, we can use heavier gauge wire because it's so easy to erase wires digitally. Since we've built almost full-size spacecraft and other models, requiring thick cables, this has been a godsend.

What about the texture issue? Is there a business building maquettes to provide CG animators with real-world textures?

Tony Meininger: Models are the best direct way to get textural information for computer animation, and productions often ask us for models that can

provide that information for their digital work. I'm seeing more of that work than ever before.

Greg Jein: Not just for textures. There is less miniature business overall for me than a few years ago, but a great deal of my work now is to create reference models for CG work.

Why are physical models so useful for CG effects?
John Goodson: It's really hard to interpret little things in the computer without a physical reference. With a real-world object, you can move and examine it relative to light and get a priceless reference. [When] our CG guys were animating a small spaceship crashing for *Planet of the Apes,* [the film's visual effects supervisor] Bill George asked me to build him a heavy, wooden model, shaped like the pod spaceship. I built one, and he spent time throwing it around our back lot and taping it with a video camera, trying to see how it flips and falls. This helped them figure out movements for the ship during the crash sequence.

Price: Another area we have gotten into is the art of metal etching to add unique textures to computer models. It's based on the idea of making printed circuit boards, but we use sheet brass instead, etch letters or symbols on them, and then filmmakers scan them in and use them on CG models. The concept works both ways, in fact. We recently built a Taj Mahal model, and it has lots of fine art and lettering and mosaic tile patterns on it. We created those unique patterns entirely in a computer, came up with a special printer that used special ink, and printed out the images and added them to our physical model.

What are some of the areas where miniatures can still provide filmmakers with superior effects?
Jein: The way debris fans out when you blow up a model can't exactly be replicated by the computer yet. Also, you usually aren't allowed to blow up real buildings. Other factors can make a model preferable over

CG. For instance, for TNT's *Mists of Avalon* TV movie, I built a miniature landscape featuring the Avalon temple. The reason the producer asked for a miniature was that they had so many angles to shoot of the temple, and it was so large, that it was easier for him to digitally photograph the 360-degree model rather than building the temple from scratch in the computer.

Stetson: There is still something to be said for filmmaking in a physical environment, like a regular movie set or a miniature set. When a group of artists working together can sit down with the same piece of art in front of them and discuss it, they are likely to have a more fruitful collaboration when they can see and touch it. The immediacy of that is important and valuable in the collaborative world. On the business side, there is the assessment of resources issue. If you build big environments in the computer, you will have to deal with heavy renders, which can be very time consuming. Render time is improving, so that problem may eventually go away, but it is an area where models can currently be more practical for a project's budget. On the other hand, of course, shooting motion control on a stage can be very expensive, especially if you need to do retakes. So it just depends on what is right for your particular project.

Meininger: We tend to use models whenever there is major physical interaction going on—fire, explosions, water on an object, etc.—even if we later enhance it with CG. Close-ups are another area where miniatures often tend to be favored. With models, you can often achieve superior lighting of an object, relative to other objects. That's harder to do in CG, though the technology is improving. *Titanic* is remembered as a groundbreaking CG show, but people forget that film featured tons of miniatures. That's largely because of the interaction issue. Whenever water was spreading through the ship or around the ship, it made sense to use physical models. ■

- If you need a small amount of screen area, you can find colored foamboards at most art supply stores and hobby shops. Make sure the board looks evenly colored. Some colors can be splotchy and can hinder the compositing process.

- You can also get a can of paint from your local hardware store. Just as with the fabric, you want paint that is flat or matte finish. Ideally you should paint with a roller with a very smooth nap or finish.

SUMMARY

The use of foreground miniatures is as viable as it ever has been, and possibly more so. Professional as well as student filmmakers can now utilize digital technology to clean up original photography and add effects that integrate miniatures into a shot. In the end, a foreground model will cost less than the same environment built at its full size, and take less time. If you want to add visual interest to a location or set, you don't have to rely on specialized computer graphic artists or surrender the idea because of cost. You can combine the skills of the art director and cinematographer to produce a timeless movie illusion.

in review

1. What are some of the visual giveaways that a foreground model is being used?

2. What is a dividing line, and why is it significant?

3. In what ways can the dividing line be disguised?

4. How does good shot composition help keep attention away from the miniature usage?

5. How does using a foreground miniature affect the type of lens you shoot with and the depth of field required?

6. What benefits are there in using a drop-in screen?

7. What is the significance of atmospheric diffusion, and how can you simulate it in a miniature set?

exercises

1. Using a camera (still or video), practice using forced perspective with miniatures.

2. Find examples of the different depth cues in film or photographs and explain them.

3. Find examples of images using different depths of field and describe them.

4. Create a sketch of a miniature set extension you wish to create for a class project.

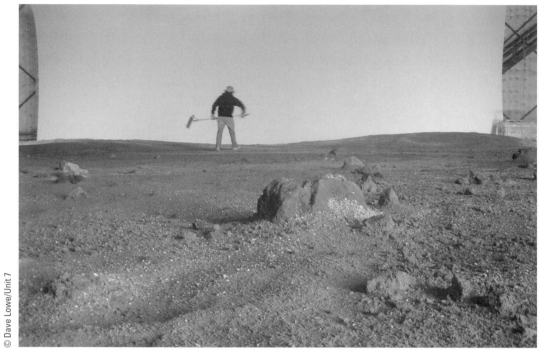

© Dave Lowe/Unit 7

Final preparations for a miniature set of Mars' surface.

CHAPTER

7

Chapter Objectives

- Become more resourceful by associating shapes

- Find and use all kinds of materials

- Integrate kit-bashing and scratch-building techniques

- Stretch your art department budget

- Mold and cast duplicate textures for surfacing miniatures

Introduction

Learning to recognize and use shapes out of context is a key step in the development of a scenic miniatures artist. For a full-size set you can use a lampshade as a lampshade, but at 1-1/2" scale, you may be in a little bind. Dollhouse and hobby stores carry an assortment of such set dressing, but often only in a single scale, and they're not cheap. It would not be financially sound to construct and dress a miniature set entirely with dollhouse supplies. For certain intricate furniture or rugs, that might just be the best solution. The rest of it wants to be done on the cheap, which means you have to be more resourceful.

THIS LOOKS LIKE...

Remember these words. Try to use them. They help you to appreciate more of what's around you, and see more possibilities as well. For example: "This coarse sandpaper looks like miniature pavement. This mustard bottle looks like a jet engine. This small interior dentil molding looks like the exterior trim of an old building." Okay, that last one was a stretch, but it's still true. Training your eyes to make these comparisons will enable you to use cheap materials and found items (and even salvaged trash) to pull sets together within a budget. Likewise, understanding the need for depth and detail, or lack thereof, will help you focus your concentrated effort where it will actually pay off. Miniature sets are often a collage of materials that have nothing to do with the items they represent.

| TIP |

Flip That Marble!
The random items you find to place in your miniature may not look right in their normal condition. Try physically turning them upside down, combining unlike pieces, cutting down, and rearranging them. In Photoshop you can mirror-flip, reverse color values, and otherwise distort original images like scans of marble or brick to create new varieties. Free your mind.

BUILDING MINIATURES

KIT-BASHING AND SCRATCH-BUILDING

These odd-sounding terms are actually two basic approaches to miniature construction. Using various parts from a scale-model kit or other toy, separated from the rest of the kit, is known as **bashing**. It might involve using the wheels from a model car for your own vehicle design, or using the spoiler as a small-scale plane wing. These parts may be smooth and polished or intricately detailed, but the important quality is that they're already made, which saves you time creating them. Building from scratch involves any other construction from raw materials like wood, **PVC** (polyvinyl chloride) hardware, craft or office supplies, or even kitchen items. The relatively high cost of model kits and dollhouse items make scratch-building a valuable skill to learn. It will also come in very handy on your full-size sets.

figure |7-1|

The basic plastic model that you used to put together as a kid can be "recommissioned" into a new model.

MOLDING AND CASTING

A common feature of architecture, and by extension street scenes, is repetition. At some point, after cutting and gluing numerous duplicate window frames, trim moldings, or railings, you might wonder if there's a more streamlined method. This is where **molding** and **casting** play a part in your model making. Molding is the process by which you create a negative copy of your texture or object you wish to replicate. Casting is the act of actually pouring the material you will use into the mold. By creating a mold of your often used

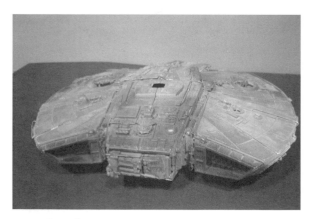

figure |7-2|

A spaceship model built mostly from kit-bashing.

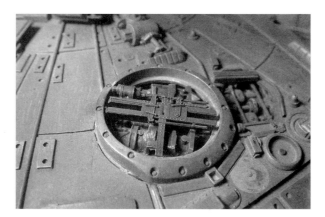

figure |7-3|

A close-up view of the pieces that make up the model in Figure 7-2.

texture or model, and then casting it over and over, it is possible to take such simple shapes and create several duplicates using basic mold-making materials. Anything from **plaster** and **latex** to **silicone** and **urethane** can be used, depending on the functional needs of the duplicates. There are books that address this process in detail, so in this text we will cover one of the more introductory level (and cheap) methods.

DUPLICATING HOBBY TEXTURES

One of the most useful supplies for dollhouse and model train sets are Vacuform sheet textures in various scales. They are very thin plastic sheets, with contours that catch light and shadow and therefore show depth. They are manufactured from original sculptures by companies like Precision Products, and are available in a number of brick, wood plank, stone, and shingle designs. The sheets can be cut and painted, then applied to your basic construction.

These sheets tend to cost around $10 or more, which is fine for a limited amount of space but cost-prohibitive over large areas. A simple solution to getting more for your dollar is to mold a sheet and duplicate it several times with cheaper materials. In fact, you could create your own reference library of reusable molds to cover a number of future modeling needs. This is a typical practice in many shops.

THE INGREDIENTS: PLASTER

The most common plaster found in hardware stores is **plaster of Paris.** It is a light grey to white powder that, when mixed with water, will set to a rigid solid mass. Typically it is useful for repairing flat patches of wall that are not subject to bending. Although solid, it will crack if twisted or impacted. In thicker quantities, it can be very durable and dense. If it is applied as, or used as, a thin layer, you will want to reinforce it by laying strips of cheesecloth in the plaster while it is wet. This makes it slightly less delicate.

figure |7-4|

Some of the textured pieces available from Precision Products.

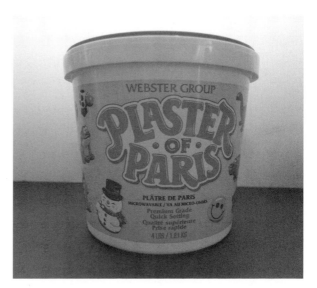

figure |7-5|

Plaster of Paris is cheap and can be found at almost any hardware store in premixed or powder form.

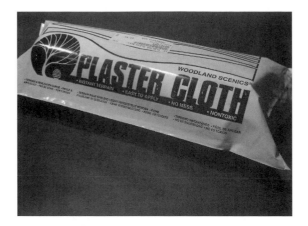

figure | 7-6 |

For added strength you can add cloth to your plaster models or you can buy the plaster already on a roll. This can be found at hobby shops, medical supply stores (cast bandages), and some hardware stores. Since each manufacturer is different, follow the prep instructions on each package.

figure | 7-7 |

There are several versions of Hydrocal, each with varying properties. Some expand more than others; some are easier to paint and are more durable.

If you need a sturdier mold, you can use **Ultracal,** which is common for taking life-casts of heads in the makeup field. For mold making, depending on the quality of detail you require in the finished item, you may prefer to use a finer plaster called **Hydrocal.** It has a smoother finish when dry, and often sets bright white. Look for Hydrocal and Ultracal at hobby and makeup supply stores.

figure | 7-8 |

Using supplies found at home, like Pam spray or diluted soap, you can prepare your mold for pouring.

Instructions for Hydrocal

Casting Hydrocal is rather simple. There are some important items to remember. The primary one is to make sure you keep out air bubbles, which have a tendency to stick to the edges of the mold. This can of course create problems and wasted time and materials, as you may have to fix or recast your mold.

Preparing the Mold

The first thing you want to do in preparing your mold is to wet it down. A 1:1 mixture of laundry detergent (not dish soap, it foams too much) should be brushed throughout the entire mold. Only a small amount is needed. You can use a toothbrush or something similar to get into the curves and corners of your mold. Make sure you do not miss the corners; they are notorious for trapping pockets of air.

If the mixture is still a little rich and there is some foaming on the mold from the detergent, try using a spray bottle filled with plain water and

very lightly mist the area and brush away the bubbles. You do not want to wash away the soap, just the pockets of air.

When pouring your molds, you will want to make sure you are using a tabletop surface that is not porous. A surface such as wood, over time, will begin to warp and wobble and can create uneven pours in your molds.

Mixing the Hydrocal

The instructions on the boxes or bags of Hydrocal recommend adding the powder to the water. This can sometimes cause clumping of the powder that can be difficult to break up later. Adding the water to the already poured powder usually works out better. While specific water-to-mix ratios are supplied with the Hydrocal instructions, usually trial and error work best. Like a chef, you will find over time what ratios work best for you.

Mix your plaster in simple plastic pails from your local dollar store. Once you have started mixing, if you begin to notice clumps forming, just toss the mixture. With Hydrocal costing about $20 for 100 pounds, you can afford to make a few trials early on.

When you begin to mix the ingredients together, make sure you are using a clean pail and a clean tool to stir with. Remnants of past mixes may chip off and create problems with your new mixture. As for the types of tools to use to stir with, you can use a simple wooden stick, a potato masher from your kitchen drawer, or, if you have a few extra dollars, find a drill attachment at your local hardware store for stirring plasters. Another option is a handheld mixer used for making shakes.

It is best to add all the water at once and then begin to stir. Stirring while pouring it may create lumps. Add water until it just covers the powder mixture, then stir to a consistency of a thick soup. While stirring, tap the bottom of the pail with a stick or solid object to help any trapped air bubbles escape to the surface.

A final trick is to determine how much time you need for the mixture to set. If you are in a hurry, use warm water as this will speed up the setting time. If you need a little more time, cool water will retard the process slightly. If you need even more time, add some vinegar to the mixture.

Pouring the Hydrocal

Have your stirring stick or a spatula handy. Pour the mixture gently into your mold to avoid splashing and the trapping of more air in the

figure | 7-9 |

First the powder, then the water.

figure | 7-10 |

Items like a potato masher can be a good tool for mixing your plaster.

figure |7-11|

Pouring your mixture into the mold before it starts to set.

mixture. Pour a little more mixture than the mold can hold. This is because there will be air bubbles trapped that we are going to try to remove next.

Use a metal rod or small pipe to tap the sides of your mold to help release any trapped air pockets in your pour. You will want to tap strongly and often to release the bubbles, just don't break your mold.

Place the molds on a flat, even surface and drag a metal straightedge or yardstick along the back of the mold to even out the pour and remove any excess mixture. Usually in about 15 to 20 minutes, depending on the size of the pour, the pour is ready to be removed from the mold. See the DVD for more information on Hydrocal.

| TIP |

A Safety Note about Plasters
All plasters will become irritating to breathe or have in your eyes, since moisture is the catalyst for the thermal curing process. Always wear eye protection and work in a ventilated area.

| TIP |

A Safety Note about Latex
All latex contains ammonia, which can easily overpower your eyes and lungs if the room you are working in has poor air circulation and ventilation. Be sure to wear adequate protection and give yourself plenty of ventilating space to work in. Also, many people have latex allergies; be sure to test yourself first.

THE INGREDIENTS: LATEX

There are various kinds of latex available. Thinner liquid latex is used in makeup applications for its flexibility and ease of detailing. There is also thicker casting latex, which, as the name implies, sets as a denser and sturdier product. Both will dry to a light tan color, or translucent if a thin layer. To save yourself some scenic painting time, try mixing in some interior acrylic latex paint from a hardware store. This will allow the latex to dry with a tinted base and put you ahead of the game scenically. For example, if you mix black and white interior acrylic into the casting latex, it will dry grey. Some scenic **washes** and paint spattering will quickly complete the look once it dries.

A benefit of duplicating your texture in latex is that it can be wrapped around curved walls or other forms, which is not true of the plaster duplicates. Alternately, you might wrap the Vacuform over a curved surface and then mold it.

This is more complicated to do, but may be more appropriate. If you would like to investigate the process, there are many books on casting techniques.

TEXTURE-DUPLICATING

Here is a procedure for creating copies of a single sheet of scaled texture. This will enable you to buy five different **sheets of textures** and open up your options, as opposed to five of the same for just one effect. In addition to your texture sheet, you will use the following materials, which

figure |7-12|

An example of a commercial Vacuform.

figure |7-13|

A cheap homemade version of a Vacuform made of plywood, a steel pipe, and a vacuum cleaner.

should be available at any hardware or craft store: plaster, cheesecloth, 1" × 2" lumber, acrylic latex paint, casting latex, a very cheap staining brush, talcum powder, and masking tape.

1. Assemble a frame from the lumber, with the same dimensions as your texture sheet. (This may be 15" square.) Staple the lumber for permanence, or tape it to take apart and reuse.

2. Tape the texture sheet in place, with the raised texture within the lumber frame. The hollow backside of the sheet should be facing out.

3. Mix enough plaster to brush over the raised texture entirely. (The staining brushes are cheap, but they're even cheaper if you rinse them each time and reuse them.)

4. Mix and pour a thicker quantity of plaster into the lumber frame, to about 1/2" or thicker. Be sure to brush it thoroughly, so it sinks into all the texture detail.

5. Lay sheets or strips of cheesecloth into the wet plaster.

6. Allow the plaster to set someplace dry, such as in front of a fan. Avoid blowing hot air across it, as that may cause it to crack.

7. Remove the texture sheet and frame, if it was taped together. You now have a solid negative mold of your original texture. This mold can be used repeatedly, if you're careful with it, to produce positives in different materials.

8. For a solid positive, brush a release agent such as petroleum jelly into the mold. This will prevent the new plaster from bonding with the mold and allow you to remove it more easily. For a flexible positive, sprinkle talcum powder into the negative and brush in a mix of casting latex and acrylic paint. It is good to work in thin layers to be sure the detail is being captured. Allow some drying time between applications, to avoid pulling up the previous layer before it sets.

| TIP |

Flexible Molds

When making a flexible mold, allow the latex to build up beyond the edges of the texture. This will give you a leading edge for pulling the latex out of the mold. Pull slowly from the corners to avoid tearing the sides. If it is too thin to remove in one sheet, add another layer and try again when it sets. Hair dryers can be used to accelerate drying time for latex, unlike plaster.

figure | 7-14 |

A piece of styrene plastic.

figure | 7-15 |

Hobby shops carry styrene in premolded shapes.

figure | 7-16 |

One of the many kits available from X-Acto.

STYRENE

Styrene is a plastic that comes in everything from sheets to rods. It is relatively lightweight but also very sturdy. Styrene is pieced together using liquid cements, so care is required. You can find styrene at most hobby stores or you can order it online from stores that support the model railroader.

Selecting the Thickness

Since styrene comes in several thicknesses you need to determine what you need. Styrene is usually measured in inches and ranges in thickness from 1/8" to 4". The sheets of styrene can come as large as 4' × 8' or larger if you special order it. Typically, if you are building a facade, you can get away with the 1/2" sheet. If the model you are building is very tall, the base of the structure will be bearing the weight of the entire model, thus a thicker foam would be needed to keep the building sturdy.

Suggested Tools for Working with Styrene

Styrene is pretty simple to work with and use, thus you need only a few simple tools in your shop to begin to work with this material. The first items on the list are a selection of cutting tools or knives. There are many types available, like the many blades made by **X-Acto.**

Second, you should have a selection of tweezers with fine tips that allow you to reach places your fingers cannot. Tweezers also allow you to place glued pieces together without getting the excess glue on your fingers and thus transferring it to the faces of other pieces.

The third tool you need is a sturdy metal ruler or straightedge and a good cutting surface. You can either use a T square or metal ruler; some of the better ones come with a

figure |7-17|

A collection of tweezers.

figure |7-18|

An adjustable aluminum T square; aluminum is a great choice because it will resist dings and nicks.

rubber or foam strip on the back to keep them from slipping. If you have one without the no-slip backing, you can run some masking tape or glue on some sandpaper to keep it from slipping.

The cutting surface should be something that will not dull or damage the blades on your knives as you cut through the styrene. Hunt Manufacturing as well as several other companies produce a "self-healing" cutting pad. These pads are thick, soft, and somewhat gel-like. When your knife cuts through the surface, the slice seems to heal and disappear. If you do have a self-healing pad you can also use **masonite.** The next set of tools is sanding blocks and files. You will not need these to remove splintered pieces, as you would if you were cutting sheets of plywood or balsa, but rather for finishing surfaces or rounding finished edges. Emery boards are useful and cheap as well.

Cutting the Styrene

The first method of cutting styrene is not unlike cutting glass. Once you have marked out the lines you wish to cut, score them with a sharp blade, like an X-Acto knife, and then snap the piece in two.

This of course works best for straight lines. For cutting curves you may want a band saw or a handheld decorative saw. Both of these allow you to cut curves very easily. The preferred method is the powered hobby saw. The speed at which the blade moves makes for nice cuts and makes it easier to stay on track of your cutting line.

figure |7-19a|

Using your straightedge and your knife, cut a 1/8"
score along the backside of the styrene.

figure |7-19b|

Grab the two sides of the scored cut and snap the
styrene in two.

figure |7-20|

If you have a woodworking shop available
to you, use a band saw like this one to
make more difficult cuts.

figure |7-21|

A selection of handheld saws for more precise cutting.

Gluing the Styrene

As with most types of gluing of surfaces it is best to apply the cement to both pieces of the model. Each type of bonding material may have slightly different instructions, so be sure to carefully read the documents or instructions that come with the cements you plan on using. Two very common cements used for gluing styrene are **Hebco's Tenax 7R** and **Testors Liquid Plastic Cement.** However, these will not bond styrene to other materials such as wood or metal or to other pieces of painted styrene. In these cases you will want to use some a superglue or an **alpha cyanoacrylate.** Along with the superglue is a secondary product called an **accelerator.** An accelerator, once applied to the still uncured superglue, rapidly decreases the amount of time needed for the glue to cure, thus eliminating a lot of waiting time and excessive clamping.

figure |7-22a|

Apply the contact cement to both pieces that you wish to glue together.

figure |7-22b|

After applying the glue to both sides wait about 15 minutes and then bring them together. Times may vary, so read the directions on the particular type of cement you are using. If you want to be able to reuse the parts, try using rubber cement.

If you are gluing together two painted styrene surfaces, it is best to scrape or sand off the paint in the area of the joint.

For gluing wood to styrene, a gap-filling superglue is best used. A good example of this is cyanoacrylate glue.

For some of the larger pieces it may be necessary, and even advisable, to use a clamp of some sort to hold the bonds tightly together until they are dry. There are a large variety of clamps available at your local hardware store but if you are gluing a flat surface, placing a heavy object, like this book for example, on top of the bond helps keep pressure on the joint for a tighter and cleaner connection.

figure |7-22c|

Press and hold the contact points. After a few minutes the bond will be strong enough to set aside. Follow the instructions on your particular brand of cement for full curing time.

Painting the Styrene

To get a good coat of paint on your styrene model, you must first thoroughly clean it. A good start is a mild detergent and water. Wipe down the model, removing any dust and particles that remain from the construction phase. After this cleaning, give it a quick wipe with alcohol before painting. It is best to begin painting right after cleaning and drying. As for the types of paints to use, enamel paints are the preferred type for painting plastic or styrene; if you are going to use an acrylic water-based paint you will need a couple of drops of a wetting agent. A wetting agent allows the paint to be applied more smoothly.

table |7-1|

Guidelines for Choosing Adhesives

The characteristics of the materials involved can vary: it is up to you to determine which adhesive does the job best. A good idea is to test adhesives on scraps of material before moving on to the final model. Some materials, for example polyolefins (polyethylene and polypropylene), cannot be bonded at all. 1= best, 5 = poorest, – means do not try it.

Application	Solvent cement	Plastic-weld	Superglue	Epoxy	Weld-bond	Fast Fix	Stick'm	Gloop
Plastic to plastic								
Styrene–styrene	1	2	4	3	4	–	–	–
Styrene–acrylic	1	2	3	4	4	–	–	–
Styrene–copolyester	–	–	1	2	4	–	–	–
Styrene–butyrate	2	1	4	3	4	–	–	–
Styrene–ABS	1	2	3	4	–	–	–	–
Acrylic–acrylic	1	2	3	4	–	–	–	–
Acrylic–copolyester	–	–	1	2	–	–	–	–
Acrylic–butyrate	2	1	4	3	–	–	–	–
Acrylic–ABS	1	2	3	4	–	–	–	–
ABS–ABS	1	2	4	3	4	–	–	–
ABS–copolyester	–	–	1	2	–	–	–	–
ABS–butyrate	2	1	4	3	–	–	–	–
Copoly–copoly	1	2	3	4	–	–	–	–
Other materials								
Wood–wood	–	–	3	2	1	–	–	–
Wood–plastic	–	–	1	3	2	–	–	–
Wood–metal	–	–	1	3	2	–	–	–
Wood–glass	–	–	1	3	2	–	–	–
Plastic–metal	–	–	1	2	3	–	–	–
Plastic–glass	–	–	1	2	3	–	–	–
Foams								
Gatorfoam	1	3	4	2	–	–	–	–
Patterned sheets								
Almost flat	3	–	–	–	4	2	1	5
Moderate draw	2	–	–	–	–	–	3	1
Deep draw	–	–	–	–	–	–	–	1
Scenic applications								
Flocking/grasses	–	–	–	2	1	–	–	–
Tree foliage	–	–	–	–	–	1	–	2
Ground cover	–	–	–	–	2	1	–	3
Grass mat	–	–	–	–	3	2	1	–

BALSA AND BASSWOOD

Before there were polymers and petroleum-based foam-boards, there was wood, the old standby. You may remember balsa airplanes, lightweight planes made out of wood that were cheap yet durable enough to stand being thrown in the air and crashing to the ground, over and over again. The wings may pop off, but they usually didn't break and you could slide them right back on the plane.

That same balsa wood can be used in your model building. What is unique about balsa is the process by which is it prepared. Balsa is primarily grown in South America. The wood is dried in special kilns that reduce the moisture in the wood. This leaves it strong but removes much of the weight of the wood. Also, because it is wood, it paints and stains nicely and is easy to work with. Basic modeling tools such as an X-Acto knife or hobby saw will be just about all you need to cut this wood.

Basswood is popular because of its abundance, which makes it a very cost-effective solution. It has a very tight grain structure that makes it ideal for things like models and miniatures. Basswood is also great for **subtractive**

figure |7-23|

Balsa wood can be found at most hobby or arts and crafts stores. You can usually find it in sheets, rods, and blocks.

figure |7-24|

Balsa grain.

figure |7-25a|

A lamppost miniature created out of balsa wood.

figure |7-25b|

A close-up of the top of the lamppost reveals that it is made of simple geometric shapes glued together and painted.

figure | 7-26 |

Basswood grain.

modeling, or carving. Basswood also paints and stains very nicely and can be cut with an X-Acto knife or hobby saw.

STYROFOAM

You are probably familiar with the Styrofoam cooler and perhaps the old Styrofoam Big Mac containers. The foams used today can be quite different. Let's first, however, discuss the cheap route.

Your basic white foam, or packing foam, is made up of thousands of small beads or balls of foam. This is usually the cheapest foam you can buy—or find in the trash. As long as your project doesn't require huge sheets, you can scavenge together foam scraps and piece them together to create your models. One of the problems with using this type of foam is cutting it. Because of the small beads it can be messy and sometimes imperfect. If you are using a blade to cut your foam you will want something very thin and with small teeth to give you a cleaner cut. Also, it is a good idea to coat your knife in wax first. Rubbing the blade on a candle, for example, will help you get a smoother cut. Ideally you would want to use a **hot wire blade.** A hot wire blade is just what it sounds like, a blade that is heated so it not so much cuts the foam as melts through it.

If your job calls for a more rugged, durable board that resists dents and punctures, you'll want to use Gatorfoam. Gatorfoam has an exceptionally hard and smooth surface. It is uniform and blemish free, and this makes this foam very reliable to use for your miniatures. Gatorfoam also is

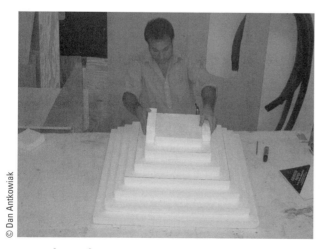

© Dan Antkowiak

figure | 7-27 |

The beginnings of a Mayan temple built on a base of Styrofoam.

figure | 7-28 |

A hot wire tool can be used not only to cut your foam but also as a sculpting tool to create textures like this brick texture.

very resistant to warping. It is a dense material while still remaining lightweight.

Another great feature of this foam is that it takes paints very well. Anything from oil to acrylic or latex can be used to paint this surface; in fact, you could even screenprint onto it if you had access to the machine to do it.

Cutting and shaping Gatorfoam is also easy. Your basic woodworking tools will work perfectly with this board. You can also use routers or shapers to cut and design your Gatorfoam.

figure | 7-29 |

A sheet of Gatorfoam with a close-up view of the core. These sheets come in several colors but are easily painted.

FOLIAGE

If you are making any outdoor scenes you may be required to create some foliage: trees, shrubs, plants, etc. You can find some of these items premade at your hobby store, but why spend all that money when you can make your own? The process takes some practice, but it is simple enough.

How to Make Trees

Tools you will need to make trees in three days:

- Scissors
- Small paintbrush
- Wire cutters
- Clothespins

Materials for your trees:

- Metal wire (steel or copper are fine)
- Cotton thread in any earth-tone color (1 to 1.5 mm)
- Contact cement
- Foliage material, various colors, available real cheap from the hobby store
- Water-based paints in browns and grays
- Ground bark, either from a hobby store or just grind up some bark yourself
- Polyvinyl acetate–based glue, also known as white glue, for adhering the leaves
- A can of hairspray

To make the trees:

1. Cut 15 to 20, five-inch-long pieces of wire.

2. Twist the wires into the basic shape of a tree trunk and its branches. Use your research to help guide you. Make several trees.

3. Add cement to the trunk and branches.

4. Before the cement dries, wrap the thread around the trunks and branches. Let your trees dry overnight.

5. Paint the tree trunks and branches. Let them dry.

6. Apply the white glue to the trunks only and attach the ground bark. Allow to dry overnight again.

7. Add the leaves: Apply the white glue to the branches and attach clumps of foliage to each branch. Allow to dry.

8. Lightly spray the trees once over with the hairspray to set them.

This method is designed for trees that are not heavy in detail but are for establishing or far-away shots. This is a classic example of faraway and close textures. If this tree were right in front of the camera, it would be a dead giveaway as a fake. But far away as part of a large scene, it may just make the shot.

Poor Man's Foliage

Homemade clump foliage will save you even more money. The process involves the grinding of foam and coloring it to resemble the clump foliage you buy in the hobby shop:

1. Cut a couple of small foam pads, like those you might see in a doggie bed, into cubes.

2. Load some of the cubes of foam into a blender. Do not stuff them in. Just fill it up.

3. Start the blender on the lowest setting. Have a wooden spoon handy to help push the cubes of foam back down as they try to escape the blades.

4. During the chopping process add a little water over time, no more than a quarter cup total.

5. Every minute or so turn the speed up until you get to the highest setting. The foam should be finely chopped by now.

6. Next add some paint, maybe an ounce or so. Use greens to make leaves and shrubs or browns to create dead leaves or shrubs.

7. Alter the color by adding more cubes to the mix and chopping them up as well. Continue this until you get a color you like.

8. After you are done chopping, spread the foam out on some cardboard or paper to dry.

9. After the foam has dried, you can run it through the blender one more time to create a finer material if you wish.

30-Second Trees Made with Ground Foam

Materials needed:

Gray primer spray paint
Brown spray paint
Spray adhesive
Two colors of ground foam (green and brown work nicely)
Some sprigs from a berry bush or similar shrub

Steps to make trees in 30 seconds:

1. Find sprigs that look similar to this:

2. Carefully remove the berries leaving even the smallest branches.

3. Lightly spray the twigs with the brown paint first and then a lighter coat of the gray.

4. Spray the twigs with the adhesive.

5. Dab the ends of the branches into the chopped foam.

6. Shake off the extra foam, spray again, and dip again. There is no need to wait between layers.

7. When you get the look you want, give it a final coat of spray adhesive to hold it in place.

figure | 7-30 |

A simple airbrush from Badger.

figure | 7-31 |

The airbrush allows thin, smooth layers of paint to be applied rather easily. Here a hammer is being aged and weathered.

BASIC PAINTING TECHNIQUES

No matter how detailed your model, the paint job will be the final step in creating a realistic-looking model. The best method, or tool, by far in painting models is the **airbrush.**

Because the details on miniatures are so small, the layer of paint must be as thin as possible so as to not muddle the detail. This is why an airbrush is preferred over bristle brushes. The best way to learn to use an airbrush is to practice, practice, practice. Airbrushes come with several types of tips and adjustments, depending on the type of airbrush you are using. Practice controlling the flow of the paint on scraps. You will make many mistakes at first; this is why it is best to practice on scraps and not your final project.

The very first thing you should get is a color wheel. It is a quick guide for those new to color. A good color wheel will show you what colors to mix to create the hues you need for your model. After a while this will become second nature.

Dulling

When you look at a life-size building in the distance you will notice that the colors begin to dull and fade. Creating the same effect with miniatures cannot be done by simply moving the camera back. You just don't have enough room to do so. You have to fake that dulling with paints.

To dull your colors you will need to add some neutral colors to your primary color. A neutral color is a white, gray, or something in that family of colors. Keep good records of the paint mixes and the amounts used in case you need to create more of the same color for use later.

Weathering

Weathering your models is vital to conveying the idea that the miniature is in fact a full-size model. Let's say you are building a model train for a visual effect of a train wreck. Your first step is to go look at real train cars. What is the one thing you notice, besides the graffiti? You will notice that the paints and surfaces of the train are weathered. Some paint may have peeled away, some surfaces may be rusted, and some may just be dusty and dirty. These small details go a long way to conveying the reality of your shot. While the viewer does not directly look for these elements,

the subconscious mind will notice right away if they are missing, and the miniatures will scream fake to the viewer of your film.

The first option for weathering is the dry-brush technique. Before you begin this step you must seal the base coat of paint on your model: cover the entire painted surface with a clear, flat finish and allow it to dry completely. This creates a protective coating for the weathering to be applied to. Next, dip the tip of your brush into an off-white paint. Before painting your model, run the bristles over a cloth or rag several times to remove most of the paint, leaving only a minute amount in the brush. Brush over your model lightly, leaving a thin layer of the white paint. You will want to use up-and-down strokes but only touch the model on the down strokes. This will help make the miniature detail stand out by collecting the whitewash just on one side of the detail. This method creates the effect of the model looking as if it is outside in the sun and aids in bringing out raised detail. You can use other colors, such as reds and browns, to create rust. Grays will create a more dusted look.

The second option for weathering is the use of simple chalk, the pastels found in art stores. You will want to get earth tones.

The first step is to grind the chalks up into a powder. You can do this by crushing them or by using sandpaper or a file. Next, using a soft brush, apply liberal amounts of the powder to the area of your model you wish to weather. Put on more than you think looks right. Just as with the dry brush, use an up-and-down motion with the brush. You may want to mix in a couple of colors but keep one color as your main base. If you feel you have gotten too much chalk dust on your model, simply brush away some of it with another clean brush.

figure | 7-32 |

Notice the stains and imperfections on the side of this real tanker car.

figure | 7-33 |

To create the dry brush, remove the excess paint by wiping it on a rag, paper towel, or a sponge.

figure | 7-34 |

A cheap chalk set can go a long way toward creating more realism for your models.

| TIP |

Working with Clear-Coat Paints
Although your clear-coat paint is flat, there will always be some shine created by the clear coat. To dull this out, brush on some crushed gray chalk very lightly.

figure | 7-35 |

Here the styrene is painted with a lighter undercoat and the overcoat is darker. The outer coat was rubbed with paint thinner and cotton balls to give it the weathered look. An added pass of stain wash was used to bring out the cracks in the wood.

Now that you have brushed on the chalk, you need to secure it to the model. Do this by coating the model again in a clear-flat coat. This will make much of the chalk seem to disappear, thus the need for liberal amounts of chalk in the initial application. Allow this to dry and take a look at the model. If you feel you need a little more, repeat the steps as another layer. The layering may actually aid in the realism of the model.

The third option in weathering is staining. This works basically the same way as the whitewash, but with darker stains to accentuate grooves and crevices. Ideally you should mix your darker-color paint with a paint thinner. This will allow for smooth, thin, translucent coats. The paint will gather more in grooved areas, making them seem more shadowed and creating the greater illusion of a full-size model.

The last technique for weathering is **underpainting.** The technique of underpainting is to apply one coat of paint that represents the "natural" color of the object. For example, if you are creating a barn, your undercoat may be the color of wood. After this first coat dries, paint a second coat of a different color on top of the first coat of paint. Using some paint thinner and a stiff brush, remove some of the top coat of paint by brushing lightly in random areas. This will remove some of the top layer of paint, revealing the undercoat and giving it the look of a weathered paint.

SUMMARY

The one thing about the art of building miniatures is that there are truly no rules. Sure, there are guidelines and suggestions, but experimentation and trying new things are the keys to discovering that rocket engine in the mustard bottle or the laser gun for your spaceship on a '68 Camaro model kit. Much of the time your miniatures need only to suggest the object you wish to convey as large. The combination of the camera lens, the human eye, and the movement of the camera masks many imperfections in your models.

In those models that will be in the forefront of your shot, your attention to detail will be key. As with the set extension for the backyard swimming pool, adding the tiki lamps and the potted plants distracts from the rest of the model and lends believability to the eye that this is in fact a full-size patio.

Bottom line, have some fun. This is a great chance to be a kid again and have fun getting your hands dirty playing with tools and toys. While there have been great advances in computer technology to create many of these same types of scenes digitally, the ability to actually touch and create with your own hands a model of the building you are about to blow up, is pretty special.

in review

1. What is kit-bashing?

2. What are two liquids discussed for mold making?

3. Why is it important to remove air bubbles from your mold?

4. What are the safety notes to remember when dealing with plasters and latex?

5. What are the raw materials discussed and how do they differ?

6. When is attention to detail important?

exercises

1. Using random parts from models you can buy at the hobby shop, build your own model.

2. Create plaster molds of existing textures.

3. Using the molds you made, create both plaster and latex textures.

4. Build a miniature using some of the materials suggested in this chapter.

5. Using the technique in this chapter, make several trees and shrubs for your miniature.

6. Find an existing realistic-looking toy and use the dulling and weathering techniques to make it look even more real.

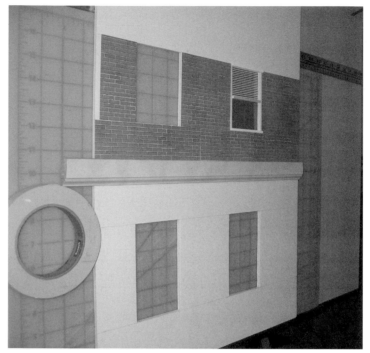

The start of a layered miniature facade.

CHAPTER

8

Chapter Objective

- **Assemble building exteriors in a very simple fashion**

Introduction

This description will serve as a template for many different kinds of buildings that you might want to create in miniature. The goal of this chapter is to teach you how to build the best-looking finished product with the least amount of actual construction. Because the surface textures in this method will be two-dimensional prints instead of relief textures, it is intended to cover your wide-angle establishing needs more than close-ups. That means if you see more than two stories of the building, you're probably far enough away to get away with this approach.

Here are the basic materials that will suffice for many establishing-shot miniatures:

- 1/2" medium-density fiberboard (MDF) or other wood for base
- Foamboard for the facade
- Computer and printer
- Drafting tools
- Acetate sheets
- Balsa wood strips
- Molding and trim strips from a hardware store
- Masking tape
- Spray adhesive
- Standard painting supplies

THE LAYERED BUILDING

The concept behind the layered building is to create a relatively 2-D model that looks 3-D on camera. By layering textures and some 3-D elements, you can create a very real-looking structure without all the back-breaking work. The layered buildings work best for backgrounds that are not designed to come in contact with the talent.

The Base

One of the complicating factors of miniature architecture is how to build the support for it. In some cases it's important to have framing construction or supports, notably when it will be seen on-camera. Starting out, you may not want anything that intricate. If your need is only to supply an exterior as a foreground miniature or as part of a composited environment, you can work with solid, flat shapes as your supports.

Weather and Location as a Factor in Materials

An issue to take into consideration is the weather and atmosphere in the location where your models will be used. If you are shooting at a windy beach, miniatures built out of foam or thin wood won't work because they will bend in the wind.

And consider the atmospheric conditions. How do the materials you are using perform in, say, the heat and humidity of a Florida summer?

One way to allow for poor atmospheric conditions is to avoid any kind of carpentry in favor of simply stacking thin, flat materials. A good base material that is sturdy, fairly light, and unlikely to warp is medium-density fiberboard (MDF). All you need to cut out is one rectangle the size of each visible facade. MDF is particularly useful if you're going to shoot on location, since wind is less likely to shake it. For soundstage use, you can substitute Gatorboard. The interior support joining the facades together can be a flat shape as well. For a two-sided miniature, triangular supports will secure them. For three or more sides, the appropriate shape to contact all sides should be used.

Facade Layout

A nice feature of architecture is that for all the variety of styles, there are some common characteristics. For example, the windows in a given room may start at a uniform height from the floor, may have a uniform width, or both. In many cases the height of the window frame is the same as the height of the doorframe. Windows on different floors often fall in direct line with those above and below. That means that without much designer's acumen, you can lay out a simple but convincing door-and-window pattern for your miniature building. Believe it or not, just having that pattern converts your board into a recognizable facade. This design

figure |8-1|

Medium-density fiberboard (MDF) is sturdy and cheap.

figure |8-2|

Outline of cutouts on a piece of foamboard.

> ## Cutting Technique
>
> The most common cause of bad cuts (besides dull blades) is improper handling of the knife. Remember, it's razor-sharp, not laser-sharp. Holding the knife straight up and trying to make one master cut is awkward and doesn't take advantage of the blade design. Instead, hold it at an angle toward yourself and make three to five scoring passes, meaning mild pressure to cut a little groove. Each groove will cut more smoothly than the last until you're through the board. This lets you use the whole length of the sharp edge, also. Best of all, you don't have to cut only within the shape! Cut a little past the corners to get the sharpest, cleanest right angle. The printed texture will cover up this "slop."

template can be adapted to houses, apartments, storefronts, and other typical structures that basically consist of a flat wall and door/window combinations.

Drawing the Plan

With a long straightedge and a ruler you can draw a set of guidelines to "snap" those shapes into. One long line sets the base for all your windows. A parallel line above sets the tops for those windows and the doorway. That's just two lines to draw in order to place all your windows. You can draw this design on paper and spray-mount it to your foam-core board, or draw it directly on the board. The beauty is that you will never see stray lines as you would in a design model, because this will be covered with a 2-D print of some texture. Try to work cleanly for your own benefit, though.

Cutting

To cut the window and door shapes out, use a razor blade in a handle, like the X-Acto knife, for precision. Under your foamboard should be a self-healing cutting mat or a scrap piece of foamboard or cardboard. This allows the X-Acto blade to move smoothly without being dulled by a hard table surface. (If you've ever shaved with a dull razor, you know how detrimental that can be.) It's also important to keep the cut lines clean for placing in window framing later.

Window Framing

Balsa strips come in many different thicknesses. Only a few will look appropriate to the scale of your particular model. It may help you to bring a scale ruler to pick out the ones that will look right. You can tell by looking at actual windows whether the framing protrudes out of the window space, and purchase your balsa accordingly.

When cutting the balsa, be careful to be sure your pieces will fit into the window. That means you can cut the bottom and top pieces to the exact width of the window, but the vertical sides have to be cut slightly smaller than the height. Why? Because the other pieces will reduce the

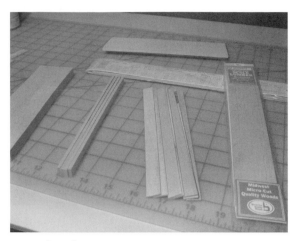

figure |8-3|

Balsa and basswood come in a variety of sizes and shapes.

figure |8-4|

Companies like Midwest sell pieces that are cut directly to scale.

| TIP |

Creating Custom Guides

When it comes time to build multiple copies of the same thing, as in the window sills of our model, it may be a good idea to build a custom guide or block to make your measurements quick and easy. After building the first window sill, you create a guide with the measurements of your object. Now instead of having to measure each time you can use the guide to piece together your models for quicker and more precise model making.

amount of height once they are in place. You can cut multiple strips of differing sizes to create beveled or contoured window frames, it's up to you. As always, it depends on how visible they are and the style of your architecture.

Creating the windowsills is pretty simple. Glue together a couple of pieces of your scaled lumber to make a long strip of material used for the windowsills. It is a good idea to paint the pieces before you begin to install them. You will want to make sure that you are using a paint that is made for wood and not for plastics. The balsa and basswood are

figure |8-5|

Measure twice, cut once.

figure |8-6|

Creating a guide that gives you the precise measurement needed for your windows will make the process of marking and cutting much quicker.

figure |8-7|

A cutting block or a miter box is essential for cutting a straight line in a small piece of wood.

figure |8-8|

Using a handheld blade and a cutting guide will make your life much easier.

very porous, so paints designed for plastics will sometimes just disappear into the wood. Since these pieces are a good distance from the camera, detailed painting is really not required, so there is no need to break out the mini brushes. Small cans of spray paint from your hobby store work great.

2-D Digital Texturing

Here's where we take advantage of the grain and compositional conditions of your shoot. Fine details like brick mortar and wood grain do not have any discernable depth once you back

| TIP |

Cutting Balsa

For cutting balsa, an X-Acto knife and metal edge are sufficient. To help you make cleaner, straighter cuts, you might prefer a miter box, which X-Acto also makes. It is a three-sided metal guide with cuts in the sides for inserting a fine-tooth saw blade. The cuts allow the blade to stay at a consistent angle to the balsa, either at a 90-degree or 45-degree angle.

figure |8-9|

Using your utility brush, layer on a thin coating of cement.

figure |8-10|

Using your guide, you can then place the bottom of the windowsill onto the cement. Allow this to dry the suggested amount of time according to your adhesive.

figure | 8-11 |

Laying out all the pieces to be painted makes it simple to lightly coat them with just a few passes of spray paint.

| TIP |

Painting Balsa Wood

Balsa wood is very lightweight and the strength of the spray from even a small spray paint can blow your pieces across your workbench. It is a good idea to take a scrap piece of foamboard and place it behind the items you are spraying so that they do not move across the table.

figure | 8-12 |

A library of textures, like this brick one, can go a long way toward helping you finish projects. Several textures are included on the DVD.

away from them. So, unless you're going to be very close, you don't need to have any actual depth in the texture. Printing out a photo of a surface texture will save you the agony of meticulous scenic efforts that might otherwise call attention to how shoddily they were done. That's not meant to reaffirm any lack of artistic confidence you might have; it just gives you a way to start strong.

As with all digital processes, you want to start with the highest resolution image available to you before adjusting it. This helps to avoid seeing blocky pixels in the final image. Start with a high-resolution image, meaning larger than the print size of 8.5" × 11" and greater than 100 dpi (dots per inch). Many digital cameras record images that are higher quality, and those are the best to use. The amounts of storage on flash cards, and the ease of downloading images for printing, make digital cameras the superior choice for this practice. Edit images at their full resolution, if the textures are far enough away from the camera you can reduce the DPI of the image to save print time and ink.

Photoshop

Although Photoshop will be addressed as a tool for backgrounds later in the text, it bears mentioning now as an adjunct to scenic dressing for miniatures. Only a few of the many tools available are required for this application, the primary ones being Scale, Invert, Mode, and Dodge/Burn.

Scale is used to stretch the object's width or height, or change its size proportionally. If the image does not match the scale of your miniature, you can enlarge or reduce with the scale tool until it meets your needs, and then change the resolution to maintain file size. This should not affect the quality as it appears on-camera.

Invert reverses the color values. For example, red inverts to blue-green, and light gray inverts to dark gray.

Mode refers to the range of color available. The image can be grayscale or one of several color options. Color can be converted to grayscale with this tool, but not the other way around.

Creating a Texture Assortment

Figure A is the original brick image as photographed. By **dodging** and **burning** the values, you add weathering effects. In Figure B they have been **scaled** horizontally to make longer, narrow ones. The colors are **inverted** in Figure C to produce a blue-green effect. By changing the **mode** to grayscale, all color is removed to leave a dirty white brick with black mortar lines. Adjusting the **contrast** produces a brighter, sharper range of values. From here, you could convert back to a color mode and add tint or color to the bricks. This will also work for marble, which is very forgiving in terms of its versatility in various color schemes.

Dodge lightens the value of areas you "paint" with it, while **burn** darkens those values. These also tend to reduce the contrast of the areas you paint with them.

Printing

To conserve ink, and prevent the paper from buckling, you can print on the "Draft" setting. This is found in your printer setup, usually with "Normal" and "Best" as your other options. Using the draft setting allows you to get the most use out of your ink cartridge.

However, printing with less ink often results in a muted look. To prevent this, adjustments must be made to the brightness and contrast of the image before printing. Adjustment for higher contrast darkens shadow areas so they will read better in the draft print. As a result, lighter colors may become too light, so bringing down the brightness will restore them to a more natural shade. The dodge and burn tools can then be used to add weathering overall and in detail.

Photo paper is too glossy or evenly matte, so regular multi-purpose printing paper is the best and cheapest option. Multipurpose paper is also more absorbent, so it will bond with the spray adhesive better than a thicker stock will. Keep in mind this isn't a document, but a piece of scenic art, so it will look better on camera than in your hand.

figure |8-13|

There are many brick and stone textures you can capture yourself by walking around your neighborhood with your digital camera. And the best part, it is royalty free!

Walls and Floors

Applying digital technology to physical model building can achieve a faster and better-looking product. Rather than use texture tiles, which are available in graphics software, photograph

► Polished Surfaces

To add a gloss finish to wooden floor or marble textures that you have printed, stay away from gloss sprays. They will dry unevenly and possibly warp the paper itself. Also, stay away from printing on glossy papers, because they don't translate the effect. Your best bet is to apply the printed texture to the base surface, and cover it with a sheet of clear acetate. This is the same material once used for animation cels. Acetates are usually available as a pad of sheets, and can be found in art supply stores. Simply tape the acetate to the non-camera side of the surface, rather than using any adhesive that will be clearly visible through the acetate. Particularly on floors, the reflectivity will increase the apparent size of the set.

buildings in your community. Tiles that are simply duplicated to fill a space create an immediately noticeable pattern, which is inconsistent with realistic surfaces. Find buildings with a textured area unbroken by windows and other details. Look for a variety of brick, cement block, and stucco surfaces to start your new digital texture library. Those images can then be retouched in any number of ways to create variations on the style.

In other cases, you may find a sample of usable textures at a store that sells dollhouse supplies. You can purchase a single sheet of wood-strip flooring, wallpaper pattern, bricks, shingles, and so on. Those sheets can then be scanned and used as you would any photograph.

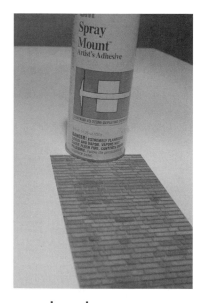

figure | 8-14 |

Use spray mount to adhere the printed texture to your model facade. Spray mount is not a permanent solution, so you may need to reapply. If you want something more permanent, brush the board with a thin layer of glue.

ASSEMBLING THE SCENIC LAYERS

Now it is time to start to bring together a few of the pieces we have built. Using a spray adhesive, apply the printed texture over the entire cutout of your building facade, even over the windows. Don't try to line up the edges of your printed textures; overlap just a bit and line up the brick mortar lines.

Next, cut out the holes where the windows have been covered by the texture. The best way to do this is to flip the facade onto its face and diagonally cut the texture through the windows. The texture can then be pulled through and wrapped around the cut window openings. This creates the illusion of the brick being three-dimensional. You can spray-mount the back of the facade to hold the folded pieces in place.

Next, add in all of your windowsills. It is best to apply the cement to hold these directly onto the windowsill itself so as to not get excess cement on your model.

The last part of this assembly section is the window frame. Measure out the frame pieces and build the entire window frame first, gluing it together. Allow all of your window frames to dry completely and then glue them into the open window spaces on your model.

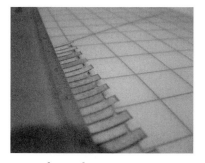

figure |8-15|

With an X-Acto knife, create an interlocking edge on the new piece you are going to place onto your bricks. This is not always a necessary step, but can sometimes help blend together the seams and make them disappear.

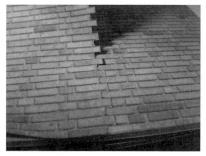

figure |8-16|

After spraying the adhesive on both the edge of the printed bricks and the facade, line up the second page of texture. The spray mount is not permanent and you can lift the sheet up to realign if need be.

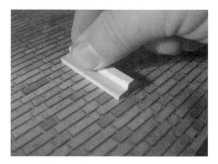

figure |8-17|

Flatten the seam with a simple tool made out of balsa wood. One trick is to spray a light coating of spray mount over the seam before you begin to flatten it out.

figure |8-18|

Cutting a diagonal to each corner will create four triangles that need to be folded over.

figure |8-19|

Spray-mount the back of your facade and fold over the triangular pieces.

figure |8-20|

Front view of cutout with the folded-over edges.

figure |8-21|

With windowsills added, the model begins to take shape.

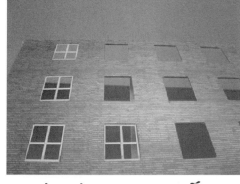

figure |8-22|

Window frames being installed.

figure |8-23|

Dura-Lar is a great acetate replacement and is a bit cheaper.

figure |8-24|

After cutting a piece of the plastic a little larger than your window frame, brush some glue on the window frame and place the plastic onto the frame.

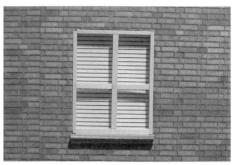

figure |8-25|

From the front the acetate looks like glass because of the reflection.

THE FINAL TOUCHES

Window Dressings

Acetate

Cutting out the windows will allow you to see through to the solid board base. Normally there would be a room on the other side, but for most occasions where you would use this layered building, the interior wouldn't be visible. In fact, much of what you would see would be reflections on the window glass, particularly if you view the building from street level. This is another application for the acetate, which will catch reflections and is cheap in pads. Tape the acetate on the back of the foamboard, and then tape a printed window dressing to that. Some indication of window dressing can be enough to fool the eye. Blinds and curtains are common dressing, and simple shapes to create.

figure |8-26|

Simple horizontal lines representing closed blinds.

figure |8-27|

The same image with the bottom portion replaced with about 80% gray.

Blinds

All you need to sell the illusion of blinds is a series of narrow black and white stripes. They can cover the whole window or appear partially open. For the "open" area, a mid-to-dark value grey will allow you to see reflections more clearly. Whether solid or a gradient of values, it will read as the darker interior room.

figure |8-28|

Adding the simple piece of printed horizontal lines makes for some pretty convincing blinds.

figure |8-29|

The same window with the blinds "pulled up."

figure |8-30|

The window dressing illusion revealed.

Curtains

If you have curtains available to photograph, you can print and apply them to the acetate. A window image scanned from a home-decorating catalog or magazine is also fine. If you don't need the detail, you can create the basic shapes in Photoshop just like the blinds. The difference is they may require some "folds," which can be streaks of gray you digitally paint on the flat graphic.

Surface Detail and Dressing

With your basic texture in place, and windows dressed sufficiently, all that remains is some amount of three-dimensional dressing to cast shadows and provide contour to the edges. This can include trim or molding, signs, lighting fixtures, etc. You can purchase balsa strips that are contoured to resemble some decorative moldings. They can be combined to create more decorative versions as well. For larger trim, like around the rooftop or between floors of a storefront, try the interior molding section of a home improvement or hardware store. There are assorted contoured wooden strips designed for interior room use, which double easily for miniature exteriors. A little scenic paint job will turn them from grained wood into distressed concrete.

Signs can easily be printed from Photoshop or other graphics software and applied to foamboard, balsa, or other rigid material. Lighting fixtures can be purchased from hobby stores or assembled from raw materials (see scratch-building in Chapter 7).

figure |8-31|

This curtain was created by copying the fabric on the left to the right and adding in 80% gray to the background.

| TIP |

Window Reflections
Use window reflections to your advantage. If you can supply foliage near the building or pictures of other buildings to reflect in the windows, you place it more convincingly in the real world.

figure |8-32|

Our layered model with window dressing, a printed doorway, and painted balsa wood for a gutter system. Notice the small bend in the gutter to make the image look less perfect, as if the gutter had been bent.

figure |8-33|

Lampposts and a bench add to the realism. If you are adventurous you can add practical lighting to your miniatures…but that is another book.

SUMMARY

In my days of teaching theatre crafts to college students, there was one rule I tried to instill: We are not creating reality on the stage, we are creating enough to make the audience *think* it is reality. If the scene called for a car to be on stage, we did not tear down walls and drive a car on stage, we got pieces and built them onto a wooden frame and rolled it out by hand. The same can be said for film, probably even more so. With theatre your audience is sometimes only a few feet away from your set piece, so attention to detail and realism are important. With film you have the advantage of many layers of **filters** and optical illusions to fool the eye. If you know the small building you are constructing will not be close to the camera, do not waste your time or your modeler's time creating a few thousand carved-out bricks. If only a portion of the model is close to the camera, building a second model of the close-up may save time and money. The best advice is to experiment. When you don't have a project to work on, try perfecting your trees or your ability to work with balsa. Make a replica of your house or apartment. Look for reality in places that you once thought it may not exist.

in review

1. What is the layered-building method?

2. When is it good to use the layered-building method?

3. What are some good places to find textures for your models?

4. How do you create polished surfaces?

5. What is surface detail and dressing?

6. What is the basic order of assembly of your layered model?

exercises

1. Create a photo library of building textures in your area.

2. Using the techniques in this chapter, create a layered miniature of a building in your area or of your choice.

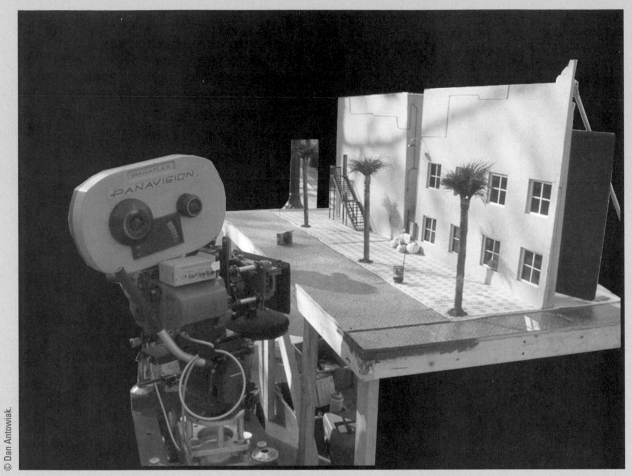

Miniature set with camera.

| production |

Section 4

CHAPTERS IN THIS SECTION

- Cameras and Lenses

- Lighting Sets and Models

- Blue/Green/Red/Black Screen Photography

SECTION INTRODUCTION

Now that you have gone through the script, decided which shots need to be created using visual effects, and decided how each shot should be created, it is time to move to the production phase of the process of making the film. In this section we will walk you through the types of cameras used in production as well as the positive and negative aspects of each.

You will also learn about the camera lens and how it works. While not all cameras we talk about in this section afford you the opportunity to change lenses, the ones that do open up a whole world of options in shooting your effects shots.

In Chapter 11 you will learn about the different types of lighting instruments commonly used on production sets as well as how to use them. In that chapter you will learn the proper lighting of colored screens for compositing, the type of lights that work best for each situation, and some basic lighting plans that can be used as guides for your individual sets or miniatures.

PRODUCTION

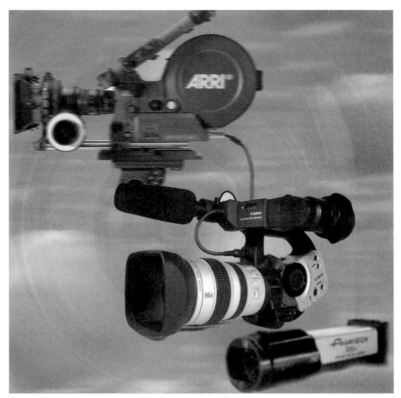

The equipment used to capture images ranges in cost and in format.

CHAPTER

Chapter Objectives

- **Understand the types of cameras used in production**

- **Choose the best shooting speeds for miniatures**

- **Know the different types of lenses available and how they work**

- **Know how and when to use blue/green/red/black screens**

Introduction

One of the wonderful aspects of art such as painting or sculpture is that you can capture the beauty, or lack of beauty as the case may be, of the art with your own two eyes: when you stand in front of the Mona Lisa, nothing impedes your view.

With movies, however, the camera and the lens must first capture the vision of the artist. The camera can be one of the most important tools in your entire production, not only because of the quality of the image captured but also because the type of camera you use will drive so much of the production and post-production. Your choice of camera will affect everything from lighting and costumes to editorial and compositing. This chapter gives you an overview of the different types of cameras and formats and explains the difference in each as well as the plusses and minuses of each.

CAMERAS

Choosing the type of camera and lens to use is an important first step in relaying the vision of your film to your audience. Granted, we know that not everyone has several cameras at hand, but hopefully you will find enough tools here to help you make the right decision among the pieces of equipment you do have available to you.

If this book were written ten years ago this section would primarily consist of information about film cameras and the latest film-stock technology. But thanks to some amazing breakthroughs in technology, digital cameras have taken over as the most-used cameras for students and independent filmmakers alike.

Digital cameras come in many different sizes, types, formats, and of course costs. We'll work our way through the cameras available at the time of this writing and try to give you, the artist, a good foundation for choosing the camera best for your production.

Before we get to the cameras themselves, we need to first understand the different storage formats that are available to you: National Television System Committee (NTSC), phase alteration line (PAL), and high definition (HD). **NTSC** is the standard used in the United States. NTSC works by combining lines of video images together to create a moving video image. Unlike film, which flashes a full image one at a time, NTSC

CAMERAS AND LENSES

117

INTERVIEW

Bill Taylor
Planning and Shooting

Mattes are Illusion Arts' principal business, so it's usually self-explanatory. But if there's a pan or tilt, you have to decide whether to do it on location or in post. Do you use a dolly or **Steadicam** on set? With a dolly you might see the track, which would have to be removed later. Some shots on *Van Helsing*, for example, [were] tougher than others. For one shot the time of day and weather condition was changed after principal photography and after editing had already started. A scene got cut for some reason, so the time of day had to be moved from afternoon to overcast dusk. That brings with it a major cost. They had to pull contrast from the actor and the scene, which could only be done with digital image processing. They call shots like these "special *defects*" because they are reparatory in nature. But there is no digital repair for using the wrong lens, or shooting in too much atmosphere, etc.

There's a shot in *Van Helsing* where the lead actors walk up a foreground hill and the camera follows behind them on a **Technocrane**, booming up to reveal Budapest in the distance. There the pre-production decisions were, shoot on stage or on location? If the latter, do you **roto** the foreground actors or put a blue or green screen behind them? What size screen do you need? In that case rotoing the foreground would have been very difficult, so they took a bluescreen to the location and set it just beyond the foreground hill where the actors finished their walk.

In general, you want to use the minimum bluescreen you need. Too much blocks the natural light, reflects more blue into the foreground, and outdoors it becomes a giant sail. And it's expensive to acquire and set up more than you need.

Camera data [height, lens, movement] has to be recorded properly, as well as lighting notation for angle, contrast, etc. You have to make sure the shot is being photographed the way it was visualized [for your bid]. Sometimes you have to reel them back to the storyboards, or if they want to rethink the shot on the set, you have to let them know the consequences. On *Bruce Almighty,* a planned lock-off was changed to a Steadicam tracking shot on the shoot day. Ideas come up in the moment, which is to be expected. The director should not feel like he is in handcuffs, but he also needs to know the consequences.

Some storyboard artists draw realistically enough for accuracy in planning effects, but many do not. It saves money on sets if you can, as well as locking down effects plans.

Way back in the thirties, for *The Private Lives of Henry VIII,* Alexander Korda was able to make a huge-looking picture for peanuts, because they storyboarded every shot and stuck to the plans they made. A cathedral was made with a glass shot, a forced-perspective set, and painted half-columns. The columns closer to the camera were built shorter! This limited their options on set, which kept them to their tight budget. Films can still be made that way, by putting yourself in a box that keeps you to your plans, but some people don't want to work that way. Hitchcock was the master of previsualizing, having come up through the art department. You commit to your pre-production plan to save expenses later. Visual FX can give directors freedom to improvise; if they've built a limited set and want a new shot where they see more, they can insert a bluescreen and extend the scenery in post. You hope they'll use that freedom with some discretion though, and not abandon *every* plan for improv on the set. ∎

When Does 30 = 29.97?

Frame rate is the rate at which video plays back frames. Black and white images can play back at a full 30 fps. Once color was added to the video spectrum, video engineers has to make concessions in the frame rate in order to get it to work properly with the video circuitry. This new rate was 29.97 frames per second instead of 30. While this difference is minute, over time it builds up and creates a noticeable gap between the real time and the time on the video playback.

An hour of video at a real 30 fps is 108,000 frames, but if that same 108,000 frames was broadcast out at the actual 29.97 fps, it would take an additional 3.6 seconds to play the video. To compensate for this discrepancy, a technique called **drop-frame** is used to compensate for the slight difference. In order for the video lengths to match up, 108 frames per hour need to be removed from the 30 fps source before they can be broadcast at 29.97. This is done by dropping two frames per minute.

Of course, dropping two frames per minute would cut 120 frames in an hour, not 108. In order to fix this, every tenth minute the dropping of the frames is skipped, leaving us with 108.

breaks each image down into lines or fields. These fields alternate on the screen in odd- and even-numbered lines on top of each other to build the full image.

The standard for NTSC is 525 lines of resolution. The amount varies somewhat depending on the equipment used. The images are created about one frame per 1/30 second, or 30 frames per second (30 fps).

While the number may seem arbitrary, in fact it is based on the cycles in electrical power in the United States. The United States is based on a 120 current, or 60 cycles or hertz. The fields refresh at 60 fields per second and thus 30 frames per second.

PAL, like NTSC, is based on the electrical currents in its native countries. Since PAL is a standard in places with electrical currents based on 50 cycles, its field-refresh rates are 50 fields per second or 25 frames per second (25 fps). Because PAL is 25 fps and film is 24 fps, many independent film makers will use PAL if they plan to eventually transfer to film. PAL's standard is 625 horizontal lines. Countries that use PAL as a standard include Australia, China, Germany, Israel, United Kingdom, Saudi Arabia, and many, many others.

The newest and most exciting standard is **HD**. HD is defined as any resolution 720 lines or above. Two standards are in use today: 720p and 1080i. 720p comprises 720 lines of resolution, each made up of 1280 pixels. The "p" in 720p stands for **progressive**. This means the lines of resolution are displayed all at once, similar to the way a film projector shows a film frame. This format can play in either 25 fps or 30 fps.

The 1080i comprises 1080 lines of resolution, each made up of 1920 pixels. The "i" in 1080i stands for **interlaced**. This displays images by interlacing the 1080 lines of resolution to build the final image, just like NTSC or PAL. The frame rates for 1080i are 50 fps or 60 fps.

Let's first deal with standard-definition (NTSC or PAL) cameras. There are basically two types that are readily available to students and independent filmmakers: DV and MiniDV cameras. (There are other digital formats available, but those cameras easily run into the hundreds of thousands of dollars, so we'll concentrate on the lower end of the monetary scale.)

The digital video (**DV**) format was born out of a meeting of the minds of ten different companies. DV was created as a format standard for consumer digital video. DV, or, as it was first known, digital video cassette, is recorded onto a metal tape. The video recorded on this format is captured at the same rate as the high-end digital formats such as **D-1** or **D-5** but because it is a smaller format, there is a sampling that takes place. This sampling reduces the color information by half compared to the high-end formats. This sampling is represented as 4:1:1 in NTSC or 4:2:0 in PAL. These numbers are representations of the color sampling used on each format. The first number, 4, means that the sampling rate of the **luma** of an image is basically about four times the amount of standard NTSC or PAL color frequencies. That would be 720 color samples, or pixels, per **scanline**. The remaining two numbers represent the sampling rates of the color signals of **R-Y** and **B-Y**. For example, in 4:2:2 systems (D-1, D-5, DigiBeta, etc.) the color values are sampled at about half the rate of the luma values. This gives the user about 360 color samples per scanline. In 4:1:1 systems we still have the full sampling of the luma channel at 720 pixels per scanline, but now we only have 180 samples per scanline for the color information.

Another very important aspect of the digital camera is the CCD. A **CCD** (charged coupled device) is the main type of image sensor used in digital cameras. A camera may have one or three of these chips. The lower-end cameras use one CCD. The single CCD processes all three colors—red, blue, and green—together into one data stream. The higher-end cameras, like the DV and some MiniDV formats, use three CCD chips. Each chip then handles the task of converting one of the primary colors into digital information for the tape. This of course captures more color information, which is vital to the **color correction** and keying processes. Not only do the number of CCD chips matter, but so does the size. The larger the chip, the better the quality of the image.

As mentioned above, the DV format is a 4:1:1 sampling scheme and is the better of the affordable formats for the cost-conscious filmmaker. The following tables list the different aspects of the digital format.

The current format of choice of most independent filmmakers right now is the **MiniDV**. The introduction of the MiniDV revolutionized the independent film market. MiniDV, a smaller version of the DV, is a 4:1:1 sampling format and can be found in both three-chip and one-chip cameras. By far the largest seller in this format is the Canon Xl series. The first iteration of this camera was the Canon XL-1. What was unique about this camera was its ability to change lenses. While this may not seem like much of a big deal, in fact it was the holy grail of cheap digital cameras. Now cinematographers and DPs have a greater ranger of possibilities to create the image they wish to convey to the viewer. Cameras like the XL-1 as well as Sonys and Panasonics are equipped with three CCDs. This gives a superior image quality compared with the one-chip camera available by the same companies.

table |9-1|

Digtal Cameras

Suppliers	Sony DVCAM series	Panasonic AJ series	JVC GY series
CCDs	3	3	3
Tape Type	ME (Metal Evaporate)	ME (Metal Evaporate)	ME (Metal Evaporate)
Media Type	MiniDV, DV, DVCAM	MiniDV, DV, DVCAM	MiniDV, DV, DVCAM
Tape Time	MiniDV: 80/120 min DV: 3.0/4.6 hrs DVCAM: 184 min	MiniDV: 80/120 min Std: 3.0/4.6 hrs DVCAM: 184 min	MiniDV: 80/120 min Std: 3.0/4.6 hrs DVCAM: 184 min
Audio	2 ch @ 48 khz. 16 bit 4 ch @ 32 khz. 12 bit	2 ch @ 48 khz. 16 bit 4 ch @ 32 khz. 12 bit Dual XLR	2 ch @ 48 khz. 16 bit 4 ch @ 32 khz. 12 bit Dual XLR
I/O	SDI, I-link (IEEE-1394)	Y/C & Composite	Y/C & Composite
16:9/4:3	Yes, switchable	Yes, switchable	Yes, switchable
Lens	Changeable	Changeable	Changeable

Information supplied by the respective suppliers. Different models by each supplier may have varied features.

table |9-2|

Acquisition-Organization

Formats	Bit Rate	Bit Depth	Sampling	Resolution	Product
HD	2.9 Gbps & 1.5 Gbs	12 Bit or 10 Bit	444	2K or 1920×1080	Viper Film Camera
HD-SDI	1.5 Gbps	10 Bit	422	1920×1080/1280×720p	
HDCAM SR	440 Mbps	10 Bit	444 RGB or YUV	1920×1080/1280×720p	Sony HDWF950
D5	235 Mbps	8 Bit & 10 Bit	422	1920×1080/1280×720p	Mastering format
DNxHD	220 Mbps	8 Bit or (x) = 10 Bit @ 220	422	1920×1080/1280×720p	Contribution format
HDCAM	140 Mbps	8 Bit	311	1440×1080	Sony HDWF900/750/730
DVCPro HD	100 Mbps	8 Bit	422	1280×1080	Panasonic Vericam HDC27F
DigiBeta	85 Mbps	10 Bit	422	720×486	Sony DVW730
IMX	50 Mbps	8 Bit	422	720×486	Sony PDW530/510
DVCPro 50	50 Mbps	8 Bit	422	720×486	Panasonic AJ-SDX900/905
DVCam	25 Mbps	8 Bit	411	720×486	Sony DSR570/PD170
DVCPro 25	25 Mbps	8 Bit	411	720×486	Panasonic AJ-D910
HDV	28 Mbps	8 Bit		1280×720p30	JVC GY-HD10
DV	25 Mbps	8 Bit	411	720×486	Panasonic DVX100A

The next sets of cameras we will discuss are the high definition (HD). HD, as its name basically states, is a higher definition camera capable of capturing near-film-quality images but in a digital format. As mentioned above, there are several formats or standards for HD cameras. Ideally, if you are going to shoot miniatures or talent that needs to eventually be keyed out or composited onto something else, using the progressive standard is the best. This is because the images are full images and not interlaced with odd and even lines of resolution.

While HD cameras are usually much more expensive, at the time of this writing several consumer HD cameras have started to hit the market. Hopefully by the time this text reaches your hands, there will be several HD cameras available to you at a reasonable cost.

While the digital video camera is certainly the wave of the future, the film camera is still used in the majority of all films produced today. While this format is more expensive and requires more steps in the process of moving images from the camera to the computer, the image quality is still superior in many ways. But that is quickly changing. The two most recent *Star Wars* movies were shot all in digital.

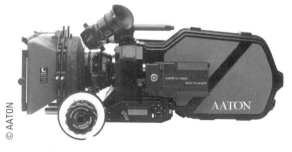

figure | 9-1 |

Aaton 35-III.

table | 9-3 |

However, not all film formats and cameras are created equal. Since this book is mainly concerned with the production of visual effects shots, we can eliminate 16 mm and 8 mm from your list of options. The quality and grain of these formats make it nearly impossible to work with in a post-production environment. Not to say that it has never been done, but save yourself and your post-production crew some big headaches. If you are going to shoot film, use 35 mm or higher.

The three most popular makers of 35 mm motion picture film cameras are **Aaton**, **Arri**, and **Panavision**.

Camera Manufacturers and Cameras

Manufacturer and Model	Weight	Magazine	Frame Rates	Power
Aaton 35-III	16 lbs	400 ft	24, 25, 29.97, 30, 1–40 fps	Battery or 12V DC supply
Arri Arriflex 435	14.3 lbs	400/1000 ft	23.976, 24, 25, 29.97, 30, 1–50 fps	24 or 26V DC
Arri Arriflex 535b	30.8 lbs	400 ft	24, 25, 29.97, 30, 3–60 fps	24V DC
Arri Arriflex BL4s	31.9 lbs	400 ft	24, 25, 30, 6–30 fps	12V DC
Arri Arriflex BL4	30.9 lbs	400 ft	24, 25, 6–40 fps	12V DC
Arri Arriflex BL3	28.5 lbs	400 ft	24, 25, 6–42 fps	12V DC
Arri Arriflex BL2	28 lbs	400 ft	24, 25, 5–50 fps	12V DC
Arri Arriflex BL1	28 lbs	400 ft	24, 25, 5–100 fps	12V DC
Arri Arricam Studio	18.19 lbs	400 ft	1–60 fps forward, 1–32 fps reverse	24V DC to 32V DC
Arri Arricam Lite	11.57 lbs	400 ft	1–40 fps forward, 1–32 fps reverse	24V DC to 32V DC
Panavision Millennium	17.2 lbs	400–1000 ft	3–50 fps forward or reverse	24 V DC
Panavision Panaflex	17.2 lbs	400–1000 ft	3–50 fps forward or reverse	24 V DC

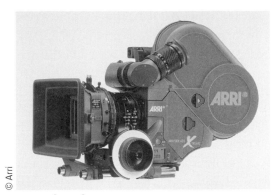

figure |9-2|

Arri Arriflex 435.

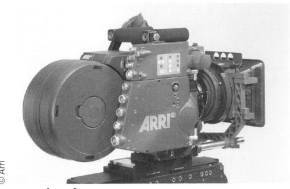

figure |9-3|

Arri Arriflex 535b.

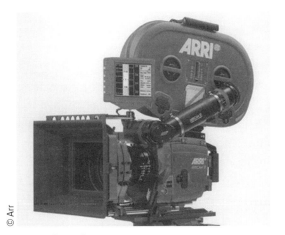

figure |9-4|

Arri Arricam Studio.

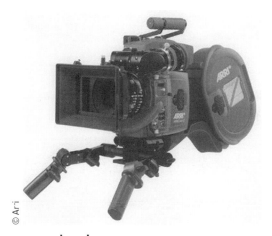

figure |9-5|

Arri Arricam Lite.

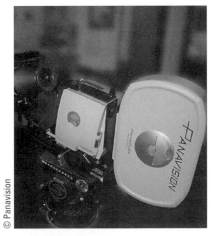

figure |9-6|

Panavision Millennium.

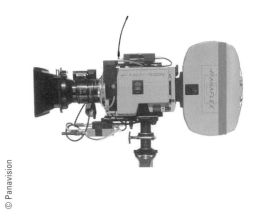

figure |9-7|

Panavision Panaflex.

After you have decided on your camera, the next order of business is film. This is crucial in the filming of effects shots. For example, **Kodak** has developed a film called Vision 2100T. It is a **color negative** film designed to work with digital compositing. The film has been optimized to allow for easier separation of colors for such things as green/blue screens.

Film types are labeled with what are called **ASA** ratings, or speed ratings. This system was originally developed by Kodak in the 1940s and later amended for international standards in 1960 to 1962. It is now known as **ASA/ISO**. The term "film speed" can be misleading, however. When we speak of film speed we are not talking about how fast the film moves through the camera, but rather how much light it takes to expose the film; that is, how sensitive the film is to light. While ASA ratings are not entirely useful for film work, the **exposure index**, or EI, is. The exposure index is calibrated to **light meters** or readers and corresponds to the ASA ratings for film. This allows cinematographers to create the correct exposure for the film they have chosen to use. In simple terms, the higher the EI–ASA/ISO value, the less light needed to expose your film. EI values are normally listed like this: EI 100/21°.

figure |9-8|

A film can.

Because of the variation in exposures compared to ASA/ISO speeds for film, an EI chart was developed to aid cinematographers in determining the correct exposure for the film they are using combined with the factor of light removed by lens filters. Remember, this is just a guideline. Over- or underexposing film can sometimes give very desired results.

Beyond working with various types of films, film cameras give the user the option of running the film through the camera at different frame rates. This is important for several reasons.

First, if you are shooting a miniature that has no movement, the speed of the film running through the camera is not a problem. But if your miniature has movement or you are moving your camera, adjustments need to be made to correctly simulate the movement of a life-size model.

figure |9-9|

A light meter.

table |9-4|

EI- ASA/ISO Exposure Index Reduction Table

	Filter Factor										
ASA	1.5	2	2.5	3	4	5	8	12	16	24	32
1000	640	500	400	320	250	200	125	80	64	40	32
800	500	400	320	250	200	160	100	64	50	32	25
640	400	320	250	200	160	125	80	50	40	25	20
500	320	250	200	160	125	100	64	40	32	20	16
400	250	200	160	125	100	80	50	32	25	16	12
320	200	160	125	100	80	64	40	24	20	12	10
250	160	125	100	80	64	50	32	20	16	10	8
200	125	100	80	64	50	40	25	16	12	8	6
160	100	80	64	50	40	32	20	12	10	6	5
125	80	64	50	40	32	25	16	10	8	5	4
100	64	50	40	32	25	20	12	8	6	4	3
80	50	40	32	25	20	16	10	6	5	3	2.5
64	40	32	25	20	16	12	8	5	4	2.5	2
50	32	25	20	16	12	10	6	4	3	2	1.6
40	25	20	16	12	10	8	5	3	2.5	1.6	1.2
32	20	16	12	10	8	6	4	2.5	2	1.2	1
25	16	12	10	8	6	5	3	2	1.6	1	
20	12	10	8	6	5	4	2.5	1.6	1.2		
16	10	8	6	5	4	3	2	1.2	1		
12	8	6	5	4	3	2.5	1.6	1			
10	6	5	4	3	2.5	2	1.2				
8	5	4	3	2.5	2	1.6	1				

Figures are rounded to the nearest exposure. Index example: ASA 200, factor of 4. New ASA is 50.

Let's take for example a 1/8-scale version of a locomotive that is barreling down the track toward a car stuck on the tracks. Not only is the model itself in scale, so is the motion. If you shot this scale model just moving at normal speed with a standard 24 fps, the model would look just like a model. It would seem to have almost no "weight" to it. The cinematographer needs to figure out the film speed that will allow the 1/8 model to look as if it is traveling at the full speed of 70 mph. Luckily, many charts have been developed to make this process simple. The chart in Table 9-5 lists the different film speeds, along with the speed of the model, to simulate real-world speeds.

table |9-5|

Miniatures: Camera Speed, Model Speed, Exposure vs. Miniature Scale

Scale: Inches per Foot	3	2	1.5	1	1.75	0.375	0.75	0.125
Fraction	1/4	1/6	1/8	1/12	1/16	1/32	1/48	1/96
Frames per Second	48	59	68	84	96	136	166	235
Exposure	2×	2.5×	2.8×	3.5×	4×	5.7×	6.9×	9.8×

PORTRAYED SPEED PER HOUR OF MODEL	MODEL SPEED: FEET PER SECOND							
60	44	36	31.1	25.4	22	15.6	12.7	9
40	29.3	24	20.7	16.9	14.7	10.4	8.5	6
30	22	18	15.6	12.7	11	7.8	6.4	4.5
20	14.7	12	10.4	8.5	7.3	5.2	4.2	3
10	7.3	6	5.2	4.2	3.7	2.6	2.1	1.5
5	3.7	3	2.6	2.1	1.8	1.3	1.1	0.7

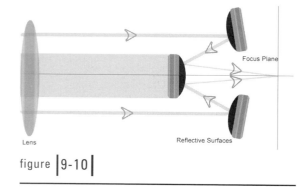

figure |9-10|

Simple reflective lens diagram.

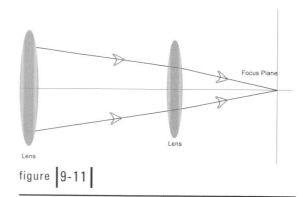

figure |9-11|

Simple refractive lens diagram.

LENSES

If the eyes are the windows to the soul, then the lens is the window to the vision of the director. Choosing the right lens for your shot is essential, both technically and aesthetically. Lenses come in two basic types, reflective and refractive. A **reflective** lens captures the light entering the front of the lens and reflects it off a mirrored surface at the back of the lens and then off another reflective surface, which finally deposits the image on the film or the CCD. The reflective lens is used rarely in standard film production except for shots with long **focal lengths**. One advantage of this style of lens is its compactness. Because the light is being bent internally within the lens itself, a larger focal length can be achieved within a smaller housing. One major disadvantage, however, is inherent distortion in the images. Reflective lenses try to correct this using a corrective lens just before the plate, but this does not always produce the desired image.

The second and more common lens type is the **refractive** lens. A refractive lens can have one, two, or several lenses built into the housing. The lenses control both zooming and focus. The advantage of the refractive system is the superior image quality produced.

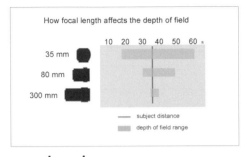

figure |9-12|

The effects of focal length on the depth of field.

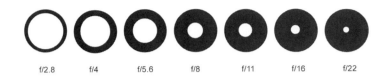

figure |9-13|

F-stop settings.

There are several types of refractive lenses. The first is a **fixed focal length** or prime lens. As the name suggests, this is a lens that is not adjustable in terms of the focal length. Before we continue, let's take a brief look at what focal length is. The focal length, often measured in millimeters (mm), is the distance from the center of the lens to the focus plane on the back of the camera. The longer the focal length, the shorter the depth of field; the shorter the focal length, the longer the depth of field. Figure 9-12 demonstrates varying focal length lenses and their depth of field. The depth of field is the area in focus in front of and behind the subject at the center of your focus.

The next aspect of a lens is the **f-stop**. In simple terms, the f-stop, depending on the number, either allows more or less light on the focal plane. The f-stop range is shown in Figure 9-13.

While it may seem confusing, the larger the number, the less the amount of light allowed into the camera lens. Not only does the f-stop affect the amount of light allowed into the camera, it also affects the depth of field. This is illustrated in Figure 9-14.

The last variable to take into account with the lens is the distance between the camera lens and the subject. This too will affect the depth of field range. This is important when dealing with miniatures and when shooting live talent to later be composited into a miniature scene. Figure 9-15 demonstrates how the distance from the lens affects the depth of field.

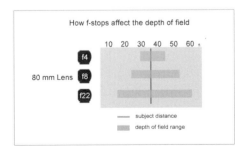

figure |9-14|

The effects of f-stops on the depth of field.

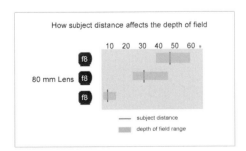

figure |9-15|

The effects of distance on depth of field.

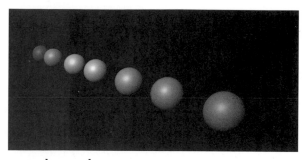

figure | 9-16a |

Image shot with a 35 mm prime (fixed focal length) lens.

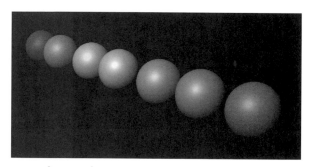

figure | 9-16b |

The same image shot with a 300 mm zoom lens.

figure | 9-16c |

The same image shot with a fish-eye lens.

Now that we have gone through the exciting world of f-stops, let us continue with the lens types. After the prime or fixed focal length lens, the next most common lens is the zoom. The zoom lens is usually defined as a range. For example, a 80–200 mm zoom will give you a range from 80 mm fixed to a 200 mm fixed and just about anything in between.

The next lens of mention is the macro. The macro lens is used for shooting very close up. Normal lenses cannot focus on objects that are directly in front of the lens. If it is import that you be able to do this, the macro lens allows for a very small distance between camera and subject.

The lens considered the most fun is the **fish-eye** lens, which distorts the image to look as if it were wrapped around a sphere. The following images demonstrate the different types of lens.

MOUNTS AND HEADS

Now that you have a camera and a lens, where do you put it? If you are David Letterman, you mount it to a small primate and call it a "Chimp Cam," but a **camera mount** would be a better idea. Just as with cameras and lenses, there are several types of camera mounts. The basic is the standard tripod. A tripod is a three-legged device with a mounting bracket at the top to hold the camera. This mounting bracket is called the head. Tripods vary in functionality and in price. You can spend as little at $20 or as much as $10,000 or more. The type of head you use for your camera can make or break a shot. If you are planning on having a lot of movement with the camera, you are going to want to make sure you have a good-quality head. A low-cost model is based just on friction. These heads can be jerky to stop and start and motion is not smooth. The next type, and more preferred, is the **fluid head**. The fluid head, as its name suggests, is constructed with a thin fluid layer within the movable joints. This allows for much smoother motion, starts and stops. They are usually a little more expensive, but well worth it. The next level up is the **Dutch head**. Just like the fluid head, the Dutch head has fluid dynamics for smooth motion. In addition to this,

the head is spring-loaded. This helps counter-balance the weight of the camera and lens, thus making the movement of the camera easier and smoother. The last and most expensive is the **film head**. The film head is the luxury vehicle of camera heads. The basic features are the same as some of the less expensive models, but the quality of the head movement is greatly improved. Film heads usually offer safety features that keep the camera from falling forward and damaging the camera or lens.

Another type of lens mount often used in miniature and effects filming is a **tracking head**. The tracking head is connected to a computer using specialized software that records all head movement of the camera. Some of the most advanced tracking heads record zoom and focus as well. With this information, the post-production team can match animated objects to the real-world camera.

© Snader Inc.

figure |9-17|

Platform dolly.

The next type of camera mount is the dolly. In simple terms the dolly is a tripod on wheels. In more practical terms, the dolly can be any device a camera sits on that rolls (Figure 9-17). Some dollies are locked to interlocking **tracks** or guides (Figure 9-18). Using a track allows

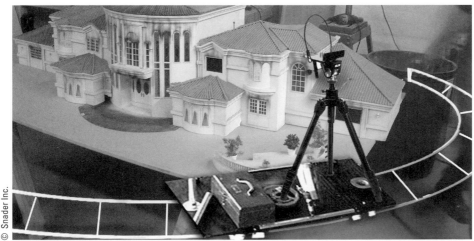

© Snader Inc.

figure |9-18|

Track dolly used for shooting miniatures.

© Snader Inc.

figure |9-19|

Crane dolly.

for superior smooth motion and a path that can be repeated over and over again. Lastly there is the crane or the **jib**. The crane is a combination of a dolly and an arm that can be extended and controlled remotely (Figure 9-19).

SUMMARY

The number of options available to you in terms of cameras, lenses filters, mounts, and so on, can be daunting. Luckily or unluckily as a student or independent filmmaker your options are usually limited in terms of these resources. The bottom line with dealing with this equipment is to always think ahead. Adding camera movement to a shot is a lot easier than trying to **stabilize** a shot that was shot without a tripod or Steadicam. Also, don't be afraid to ask questions. We can only cover so much in the pages of this text. Talk to your teacher and call the local camera supply store; you will be amazed how many doors may open when you mention you are making a film.

in review

1. What are the different types of cameras used in film production?

2. What are the differences between the digital formats?

3. What is the job of the DP?

4. How do aperture and depth of field affect your shot?

5. What are the different types of lenses?

6. What are the different types of mounts?

exercises

1. Shoot the same scene with varying depths of field and discuss the differences.

2. Shoot the same scene with different lenses and discuss how each changes your shooting technique.

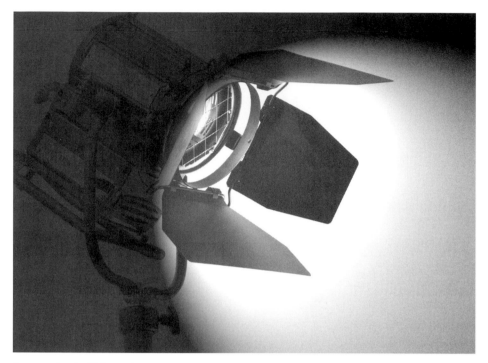

An example of a 6" Fresnel.

CHAPTER

10

Chapter Objectives

- **Understand the different types of lighting instruments used in production**
- **Know the properties of light and illumination**
- **Prepare basic lighting plans**
- **Know the best lighting for different cameras**

Introduction

You've got your camera, you've rehearsed the scene, and you are ready to go. Ready to make the next *Lord of the Rings,* right there in your garage. But something is still not quite right. Going back to the analogy of the artwork and the Mona Lisa: without light, the Mona Lisa is no more a piece of art than the hair on your head.

Lighting has two primary functions. First, to illuminate. You need enough light to be able to see your scene or to expose your film. Second, to set a mood. You could just light your entire set with one huge 10k lighting instrument, but what would that say about the scene?

A quick exercise: Go home and look at any of your favorite horror movies. Take note of the lighting during some of the scary scenes. Now imagine that same scene with every light you can find being on. Not as scary anymore, is it?

Before you begin the design of illuminating your set or miniature, it is a good idea to know what types of lights, or instruments, as they are usually referred to on the set, will be available to you. Having a working knowledge of the different types of instruments available to you and how they function is essential in the lighting of your miniatures or sets.

Beyond the creative aspect of lighting a set or miniature, you will also learn in this chapter the basics of lighting colored screens for shooting plates used for compositing. While many similar instruments can be used in both aspects of design, their placement and color play large roles in the final image quality.

LIGHTING INSTRUMENTS

Lighting instruments are broken up into the following categories: Fresnels, floods/scoops, cycloramas, ellipsoidal, and parabolic aluminized reflectors (PARs). While there are many variations of each of these, we will speak in general terms that should cover most aspects of the instruments discussed.

figure |10-1|

With a Fresnel lens, light is collected from the source and directed forward.

Fresnel

The **Fresnel** is made up of a lamp housing and a lens. What makes the Fresnel different is the type of lens, which is designed so that it captures more of the light from the lamp and directs it forward through the housing. In fact some of the initial uses for the Fresnel lens was for lighthouses. The lens's ability to direct more of the light in a certain direction was very attractive to those who ran and relied on lighthouses. Figure 10-1 shows how the Fresnel lens works.

The Fresnel produces a soft-edged spot that is ideal for both general lighting and special lighting. The most common lens sizes are three, six, and eight inches. You can focus the light to a tighter spot or a more flooded spot. Figure 10-3 and Figure 10-4 demonstrate the variation in the **throw** of a Fresnel.

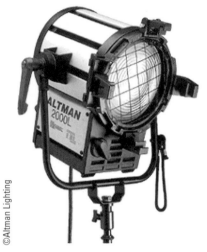

figure |10-2|

Altman Corporation's Altman 2000L Fresnel spotlight.

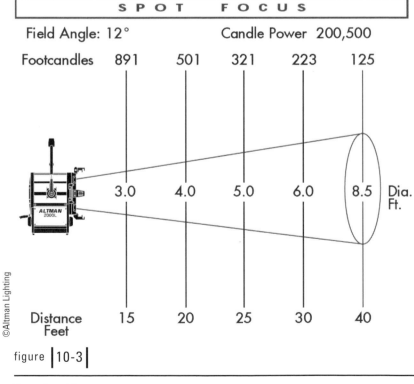

figure |10-3|

Fresnel spot focus.

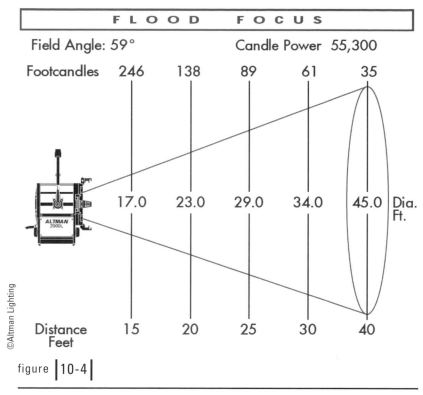

figure | 10-4 |

Fresnel flood focus.

Flood

Just as the name suggests, this instrument floods an area with light. One type of flood is called a scoop. A scoop normally consists of a reflective parabola with a light source in the middle of it. Unlike Fresnels, scoops have no lenses.

Floods are used when you need a wash of light. Often floods are used with filters, which we will discuss shortly. The filters help spread the light even more for a soft, even light on your set or talent.

Cyc-light

As the name suggest, the cyc-light is used often to light **cycloramas**. Cyclorama lights can be mounted on the floor or from the ceiling. The instrument is used to create an even wash of light on a cyclorama. This is ideal for lighting greenscreen stages. Usually the cyclorama light is composed of a bank of lights. Figure 10-7 and Figure 10-9 show two varieties.

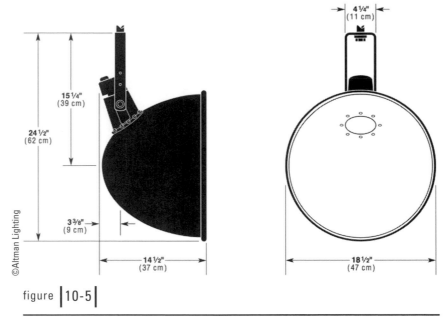

figure |10-5|

18" Altman Scoop.

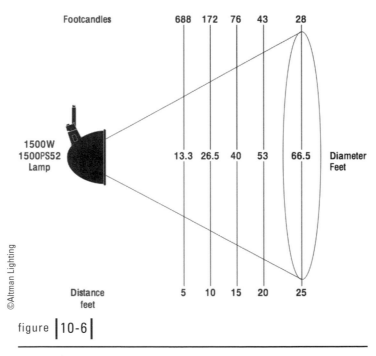

figure |10-6|

Scoop lighting diagram.

figure |10-7|

Cyclorama light bank.

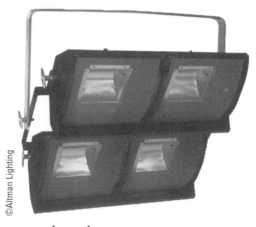

figure |10-9|

Ceiling-mounted cyclorama lights.

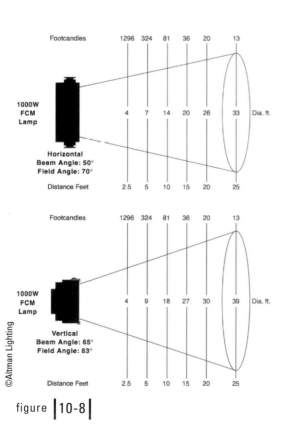

figure |10-8|

Cyclorama lighting diagram.

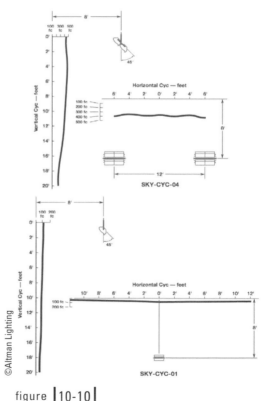

figure |10-10|

Ceiling-mounted cyclorama lighting diagram.

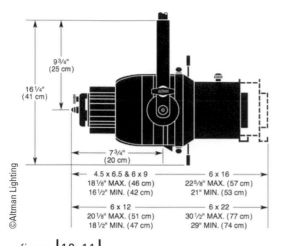

figure |10-11|

Elipsoidal.

Ellipsoidal

The **ellipsoidal** is the Cadillac of lighting. This instrument works in the same fashion as your zoom lens on your camera. Usually composed of two or more lenses, the ellipsoidal can go from a tight spot with a hard or soft edge to a wide spot with a hard or soft edge. While the instruments have a great range of flexibility, allowing them to cover a lot of options on set, they are usually the more expensive of the instruments available because of the number of lenses involved. Ellipsoidals come in a variety of sizes and strengths.

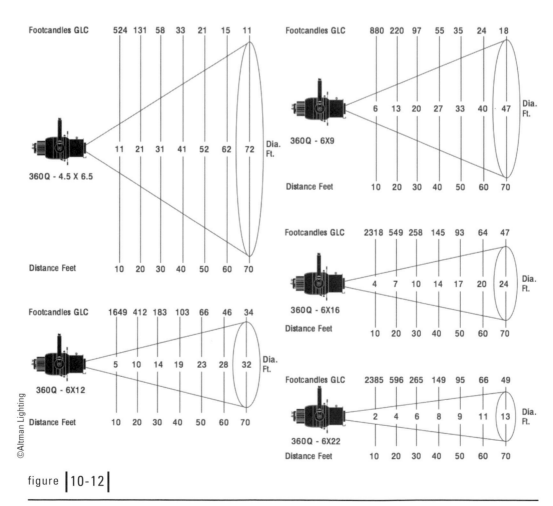

figure |10-12|

Elipsoidal lighting diagram.

PAR

If the ellipsoidal is the Cadillac of lighting instruments, the **PAR** is the rugged pickup truck. The PAR has more of an elliptical throw as opposed to the spherical throws of most of the other instruments. It is composed of a housing and just a lamp; the lens is built into the lamp itself. Adjusting the lamps forward and backward in the can changes the focus of the light. The PAR is used for area lighting or washes of color. Its low cost and ease of use make it a popular instrument.

figure |10-13|

PAR (parabolic aluminized reflector).

SET LIGHTING

Now that you have been well educated in several types of lighting instruments, let's venture over to practical uses for the lights when lighting a set. Unlike lighting for a stage, when lighting for a set you are lighting both for effect and for exposure. Not only must you be able to see the talent or the set pieces in person, but they must also be seen by the film in the camera or the CCD in the digital camera.

While there are some differences between lighting for film and for video, we will first discuss some basics of lighting. There are four categories that should be considered: visibility, naturalism, composition, and mood or atmosphere.

Visibility is one of the basic or fundamental functions of lighting design for your set. While the amount of light is important, other factors such as color, contrast, and movement play primary roles in visibility.

figure |10-14|

PAR lighting diagram.

Naturalism aids in setting the time and place. If your set takes place in the early evening, your choice of lighting colors and intensities should be much different from a scene shot in the middle of a sunny afternoon.

Composition in lighting is closely related to composition in a shot or in photography. You must think of the entire image, as it will be seen. There are many concepts to composition in regard to lighting they include symmetrical, asymmetrical, abstract, geometric, balanced, unbalanced. The list goes on.

Mood works beyond the eye and into the mind's eye. Lighting can lead a viewer toward a scary hallway or to a peaceful sunset on the beach. How do you want to make your audience feel with this light—happy, scared, sad, excited? Using the right instruments in the right way can be the difference between scenes that move your audience to scenes that just move by without emotion.

Okay, now that you have all you ever wanted to know about lighting under your belt, it is time to put some of this to use. In a basic lighting design the three areas of light that come into play are key, fill, and back. Figure 10-15 shows how the addition of each instrument affects the overall look and feel of the image.

The first image (Figure 10-15a), with just even front lighting, is very flat and lifeless. It looks like a painting or a still because there is no depth to the image.

In the second image (Figure 10-15b) we remove the front lighting and just throw in a **key** light. You can see already the changes in the quality of the image. The depth can now be seen within the image and it begins to come to life. The problem with just a key light, however, as you can see from the image, is the harsh shadows and darkened areas on the set. This shot is not composed correctly.

In the next image (Figure 10-15c) we add the **fill** light. As you can see, the addition of this light really brings the image to life. The glasses begin to "pop" out of the screen as the fill light gives even more depth and balance to the shot.

The final addition is the **backlight** (Figure 10-15d). The backlight is used to separate the talent or the object from the back of the set. It creates more depth and gives the shot that final element of realism.

figure | 10-15a |

Flat front lighting.

figure | 10-15b |

Key light only.

figure | 10-15c |

Key and fill.

figure | 10-15d |

Key, fill and back lights.

The lighting diagram in Figure 10-16 is very basic. It is only to show the concept of key, fill and back lighting. It is suggested that you find what instruments are available to you and practice with them. If you are shooting on video this is a very easy and cheap endeavor. You may find that you only have ellipsoidals available for your production. How do you get the more-even lighting you desire? Placing filters and break-up patterns in the instruments can help you achieve a multitude of results from a limited number of instruments.

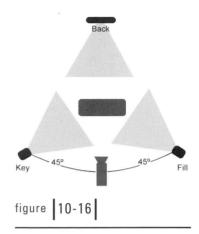

figure | 10-16 |

A diagram of a simple key, fill, and back layout.

In a more detailed and practical term, as the lighting designer for your effects shot you need to take into account the shots before and after the shot in question. For example, if you are shooting talent on a green-screen to be composited into another shot, you must take into account the lighting from that shot. Not that you have to match color per se, (we'll get into greenscreen lighting in Chapter 11), but you must at least match direction and intensity. This makes for a much easier composite during post-production, and trust us, the compositors really appreciate the attention to detail.

Oftentimes on a set you will have what is called a **practical**. This is an actual working light on the set itself, such as a table lamp or a streetlight, and it is there mainly as eye candy. Rarely is it ever enough to truly light the scene enough for the camera, video, or film. As the lighting designer you must take this into account and plan for **specials** in your design. Specials are lights that perform a more specific purpose. For example, you are designing the lights for a scene taking place in an alley. You have already created an ambient wash using a few cleverly placed Fresnels, but the scene calls for the primary light to be generated from a practical light hanging from an alley wall. While this may create a wonderful look, it will probably not be enough to light the face of the actors. Thus the special comes into play. You must add an instrument to accentuate the practical on the set, but do it in a way that it does not stand out. Placing a spotlight on the actors' faces will not look natural, but a Fresnel with a **gel** the same color as the practical that is placed high and in front of the actors will give you just enough light on the faces without destroying the mood of the scene.

COLOR TEMPERATURE

While we cannot do full justice to the science of the color temperature of light, we would be remiss, in not at least explaining portions of it that will aid you in your lighting design. A light sources color temperature is measured in **Kelvin**. The Kelvin unit is the basis of all temperature measurement, starting with 0 K (= –273.16°C) at the absolute zero temperature. The "size" of one Kelvin is the same as that of one degree Celsius, and is defined as the fraction 1/273.16 of the thermodynamic temperature of the triple point of water, which positions 0° Celsius at 273.16 K. (You will probably never need to know this.) Often when creating a lighting design you are trying to match either reality or some semblance of it. Thus if you were trying to

recreate the look of a room lit with candlelight, you would know that the color temperature of candlelight is about 1500 Kelvin, or 1500 K. The color temperature of a sunny room ranges from 9000 K to 15,000 K.

Color temperature is also important in matching shots. If you are shooting foreground elements to be placed later into a background, having the color temperature of the background handy when it comes time to light the foreground elements will make compositing of the two shots much more seamless in post-production. Some common color temperatures:

- 1500 K: Wax candles, hurricane lamps
- 2000 K: Early morning sunrise
- 2500 K: Standard 40-watt incandescent house light
- 2680 K: Standard 60-watt incandescent house light
- 3000 K: 1000-watt incandescent
- 3400 K: Approximately 1 hour before dusk
- 5000 K: Regular daylight or flash from your camera
- 5500 K: Midday sun
- 6000 K: Bright sun on cloudless days
- 7000 K: Some overcast
- 8000 K: Hazy day
- 9000 K: Shade under a tree on a clear day
- 10,000 K: Heavily overcast sky
- 11,000 K: Blue sky
- 20,000+ K: Shade in the mountains on clear days

The temperature of light is measured with a light meter. Light meters come in a variety of types and styles with different features and prices. Primarily you want one that will read color temperature accurately. There is no need to spend $1,000 on one.

While one of the main uses of the light meter is to determine if you have enough light to expose the film you are using, our primary use for it here is to match color temperatures. As you will likely be using a digital medium to capture your shots, exposure settings for film are not as important.

SUMMARY

Without light we cannot see. No matter how great the camera, how nice the shot, or how much time is spent on planning, a poorly lit shot will stand out as amateurish and weak. Taking the simple steps provided to ensure decent, effective lighting will help you present your shot in the manner it was intended. Do not be afraid to experiment, especially if you are using digital formats. With DV being so cheap, it is easy to experiment with your lighting.

in review

1. What are the different types of lighting instruments?

2. Which instruments use lenses?

3. What is a special?

4. What is basic three-point lighting?

5. What are the major differences between lighting miniatures and full sets?

6. What is the importance of the light meter?

exercises

1. Using the lighting icons on the DVD, create a simple lighting diagram for your effects shot.

2. Photograph the same object, model, or talent with different lighting configurations and discuss the differences.

3. Photograph a scene with different color temperatures and discuss the differences.

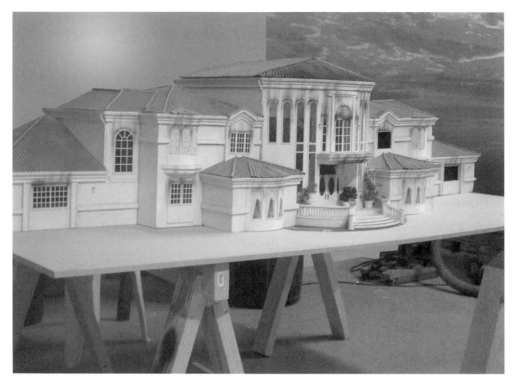

A miniature built by Unit 7 Studios in front of a green screen with a new sky background composited behind part of it for testing.

CHAPTER

11

Chapter Objectives

- **Know the different colors used in keying**

- **Understand when to use a certain colored screen**

- **Light your screen**

- **Light your talent or subject**

Introduction

While most of you are familiar with the notion of compositing with bluescreen/greenscreen as something done on the computer, it was originally developed as a film technique for separating actors from their backgrounds in order to composite them onto a new scene. The colors used were not chosen arbitrarily; blue was originally selected because the color of skin tones is made up of reds and greens. Technology has changed a great deal since the advent of this type of photography. The addition of new colors to the spectrum used for shooting these screens have increased as well as the types of materials used to create the screens. The primary focus of this chapter will be to teach you the basic techniques needed to shoot clean and effective footage to be used in your final composites. We'll walk you through several types of material and paints as well as lighting and the placement of talent or subjects in front of your screen. With the advent of modern software used in compositing, many cinematographers have become lax in their shooting techniques of screens. While it is true that most anything can be "fixed in post," the cost involved with fixing badly shot elements can quickly eat away at your budget.

COLORS

First things first: what color do you choose? As the title of this chapter suggests, you have four options: blue, green, red, and black.

As mentioned, blue is often used with actors because of the lack of blue in the skin tones of most actors; granted, if your actor is made up to look like he or she is not breathing and thus turning blue, a bluescreen may not be the best idea, so use common sense. Another advantage of using blue is that it is the sharpest color, but it is also the grainiest. Thus if you are shooting in video, blue will

figure |11-1|

A simple greenscreen.

have the most video noise and be rather difficult to use, especially if you are using a compressed DV format.

Greenscreens are usually used with set pieces or if the screen has to be located within an existing set. For example, say your shot calls for the actor to open a door to reveal a scene in the Australian outback, and you of course do not have that kind of budget to fly there and shoot it yourself. You can place a greenscreen on the other side of the door.

figure |11-2a|

With a greenscreen outside your door…

Thus, when the talent opens the door and reveals the screen, you can later in post composite in some stock footage of the Australian outback. This same technique is used to place video on monitors in scenes where you do not have practical working monitors or screens. Greenscreens are also used in miniature photography, but recently there has been a shift to redscreen for this. The redscreen is often used when using motion control rigs or with no camera movement. The idea is this: In the initial pass you light the miniature very brightly, more so than you would for the normal shot. This is the first pass or the matte pass. Second, you light the miniature with its correct lighting and shoot it over black; this is known often as the "beauty pass." Using the matte pass to create the **holdout matte** (discussed in the next chapter) you get a cleaner matte to composite your correctly lit miniature into its final scene.

The last color option is black. This is used for shooting atmosphere effects. Items like fog, smoke, fire, explosions, and so forth are shot on black. This allows for richer separation of the effect and allows for a cleaner composite in the end.

MATERIALS

Once you have chosen the color that will best work for your shot, you must now decide what material to use for the colored screen itself. The first is paint. **Rosco Inc.** makes several paints for your compositing needs: a line of products designed for video, the Chroma Key collection; one designed for digital called DigiComp; and a special paint called **Ultimatte**, designed specifically to work with Ultimatte hardware and software compositing systems.

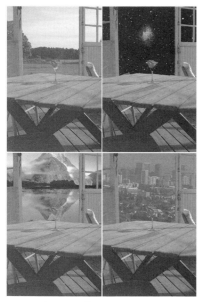

figure |11-2b|

… you can open your door to anywhere.

A second option is fabric. Just as with paint, we have several choices here as well. Several professional companies produce screens in cotton, polyester and foam, or foam-backed. Screens can range in price from hundreds to thousands of dollars. A less expensive option is to check your local fabric store for green or blue fabric. It is not always the best but can sometimes work in a pinch when the budget is tight. Some things to look for when choosing a fabric from the fabric store:

- Saturated colors. Gradations in colors are bad.

- Smooth surfaces. While that felt may look tempting, that furry surface may cause some problems.

- A matte finish. You do not want your fabric reflecting light.

- Seams. Is the fabric wide enough for your shot, or will you have to sew a seam into it to make it large enough?

The last two options are foamboards and paper. Both of these can be found at your local arts supply store and are usually inexpensive. One drawback is that they are not usually very large, but they can be used for miniature photography.

So what material do you choose? If you are using a floor that will be comped out later, it is best to use paint. It is easily cleanable and can be touched up quickly.

Paint should also be used if your wall or key surface is not "normal." For example, if you wish to use a cube to represent an object to be keyed later, it is best to used painted cubes instead of fabric that can rip or tear from being used.

If you are shooting on location or you must be mobile, fabric is certainly the way to go. The portability of the fabric compared with greenscreen walls makes it an attractive solution for location shooting.

| TIP |

Reflective Floors

If you are going to comp your talent into a scene with a reflective floor, you can cover your greenscreen floor with clear, hard plastic sheets that create a reflection on the floor. Thus when the final composite is created, the reflection is already there. You will most likely need to color-correct this reflection, but you already have saved a lot of time.

SIZE

Bigger is certainly not better when it comes to screens. Because foreground **spill** is such an enemy of compositors, using as small a screen as possible will help eliminate unwanted foreground spill. If you need to key out only the window of a car to place a street scene within it, there is no need to have a screen the size of the car. Make your screen just slightly larger than the window. The smaller screens will require less lighting and will be easier to deal with.

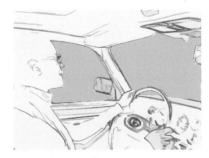

figure | 11-3a |

A typical car and greenscreen shot.

figure | 11-3b |

Too much greenscreen can spill onto your surface and create problems later in post-production.

figure | 11-3c |

Using just what you need makes life easier for your compositor.

As with every rule, there are exceptions. By using a large screen, you can back the screen up a larger distance, assuming you have the room, thus putting more room between the subject and the screen and cutting back the chance for green spill on the foreground.

LIGHTING YOUR SCREEN AND YOUR TALENT

You have chosen the color and the material. You have your screen. You are ready to go, except for one thing: lighting. When we speak of lighting your screen for a key shot, we cannot stress one phrase enough: *ample even lighting.* Having enough consistent, even light on your screen will save countless hours and headaches in post—not to mention money. There are of course several other factors that are important, which we will discuss next, but if you don't start out with a plan for ample even lighting, be prepared to hear your name cursed by the compositor at 3 AM. To ensure your lighting is as even as possible, your light meter will come in very handy. A quick pass of the screen after the lighting is in place will give you the information you need to illuminate your screen correctly.

| TIP |

Using a Spot Meter

Essential to creating an evenly lit green-screen is a spot meter. Spot metering spans a 1° to 5° angle of view and measures the light contrast on a surface. You will want to make sure your greenscreen does not vary more than one half stop.

When lighting talent and a screen it is important to keep enough separation between the two. If the talent is too close to the screen you will get spill on the talent. This again creates headaches for the composting artist. And while yes, it can be fixed in post, that is not the way to think about shooting your scene.

Figure 11-4 shows a simple layout for lighting a screen with talent.

One of the difficult aspects of lighting the talent in front of a screen is ensuring there is no spill on the screen. This is one of the reasons why the talent is moved forward, away from the screen. With enough separation you can light your talent accordingly without destroying the lighting on the background screen. At a minimum, 15 feet is a good number to work with. While this may be difficult in smaller venues, separation is key and some is better than none. If you continue to have problems with shadows being cast onto the screen you should add additional low-level lights directed at the shadow area. This will aid in returning the light levels back to the original values.

You must also make sure that your light sources match closely the source of the eventual background. For example, if the final shot has the sun setting to the right of the screen and your key light on your actor is on the left, this will break continuity of the shot and it won't look "real." Again, these things seem like common sense but they can be easily forgotten during the course of production. It is also important to reproduce any ambient and environmental light. If you light the talent with very flat lighting, once you cut them out for the composite they will look like

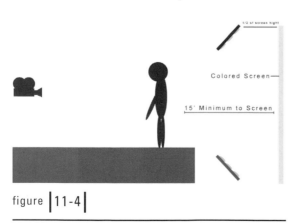

figure | 11-4 |

A basic lighting diagram for lighting your greenscreen.

cardboard cutouts instead of living, breathing beings. It is very difficult in post to replicate back-light. The highlights on the hair and the edges of the body really give the foreground great depth in the final composite. Ultimately the ideal methodology is to replicate what your background is going to be. So if your final shot is to be done outside, try to shoot your greenscreen shots outside.

SHOOTING ELEMENTS

The last items we will deal with are natural elements. You should never shoot your green/blue/red screen shots with natural elements in them. If your shot calls for fog or rain, those elements should be added later.

The simplest and cheapest way to shoot these elements is to buy some black fabric from your local fabric store. The key is to shoot these elements in complete, surrounded darkness. Lighting the element can be tricky because you are basically lighting particles of matter. Remembering your basic design for lighting will help you do this.

STOCK FOOTAGE

As a final note, do not be afraid to use stock footage when you can. Controlling natural elements for shooting can be a difficult task. Using stock footage from companies such as **Artbeats** can make this process much easier to deal with and get one more production shot off your plate.

Plus, many schools frown on students starting fires or exploding things on campus. Below are some examples of the elements available from Artbeats.

figure | 11-5 |

Some of the natural elements available from Artbeats.

SUMMARY

It is easy to shoot a bad colored screen shot. While it seems simple there are many factors at play. Don't forget to look for the "gotchas" such as unwanted shadows, hot spots, and dark spots on your screen. Don't forget the placement of the talent or subject in regard to the screen; too close and you will have green spill on your talent. Continuity of lighting is extremely important: To shoot an effective screen shot you must have knowledge of the direction and color of the light of the scene you will be compositing it into. Trying to match sunlight emanating from screen left onto actors who were lit from a key light from screen right is not fun.

in review

1. What colors are screens usually made of?

2. When would you use one color over another?

3. From what materials are screens usually made?

4. What is the primary type of light used in lighting a screen?

5. How do you help eliminate spill?

6. Why is continuity of light important?

7. When should you use stock footage?

exercises

1. Photograph the different color screens, examine the images close up on your computer, and discuss the differences in grain and noise of each color.

2. Shoot your study model on your screen.

3. Add reflective floors to your shot.

4. Try shooting the same shot with different materials for the background.

Digital matte painting of a new sky background with cutout for a house miniature.

| the scenic |

Section 5

SECTION INTRODUCTION

The scenic is all-encompassing in that it refers to many aspects of your scene or shot. Whether you are creating matte paintings or using rear projection with miniatures, "scenic" refers to the full view of the scene that you are shooting.

Take for example the closing shot in *Raiders of the Lost Ark;* you see a lone man push a cart with a box containing the lost ark. As the camera pulls out, it reveals a large warehouse filled with thousands of similar crates stacked as far as the eye can see. What you probably do not know is that the entire scenic, the shot of the warehouse, is a matte painting with the area of live action blacked out so that the actor with the cart can be comped in later.

The idea of the scenic is to create the illusion of more than what there really is. Whether it is an entire city in the desert as in *Star Wars* or a warehouse as in *Indiana Jones,* the scenic can help bring your imagination to the screen.

THE SCENIC

A digital photo converted to a matte painting for a more surreal look for this warehouse interior shot.

CHAPTER

12

Chapter Objectives

- Use matte photography to save construction and location expense

- Understand the importance of texture and lighting in creating mattes

- Use basic Photoshop tools to create scenics

- Add motion to your matte paintings

Introduction

One of the longtime art forms of the filmmaking process is that of **matte painting**. Matte paintings allow you, the filmmaker, the ability to create elaborate worlds and scenes with only a canvas, a brush, some paint, and of course, some good old-fashioned talent. In this chapter we discuss the basics of matte painting and digital matte photography. We cover options other than hand painting your mattes and discuss the tools needed. We also cover some Photoshop tools more in depth to give you a basic skill set for working with digital images.

MATTE PHOTOGRAPHY

The premise of matte photography is that only part of the visible area in front of the camera needs to be shot as it is. Using a two-dimensional painting of scenery can save a lot of construction and location expenses. It's the same "trick photography" approach that made techniques like miniatures and **double exposure** popular.

Double Exposure

Film responds to light by affecting the silver particles and layers of colored emulsion. The final image does not appear immediately, though. Before processing, the film retains what is called a latent image, which is the area of affected silver and colored emulsion. That image can be exposed again, for a variety of effects. If the entire frame is reexposed, the result will be degrees of transparency where the two images overlap. If one area of the frame is completely blocked from light, the emulsion in that area is not activated. For the second exposure, the previously exposed area is matted out and the unexposed area is now exposed to the shot. While this method works only on film, it is the foundation of digital compositing.

figure |12-1|

A double exposure of film.

Limitation of Fixed Perspective

Among the advantages of creating a still image instead of a miniature is the cost of materials. Once you have Photoshop you can basically create or import anything you need without significant expense. A drawback is that you are committed to a specific point of view, with a **fixed perspective**. Thus, any live-action footage that is to be composited within the painting must match the perspective of the background.

There are two basic approaches to creating a matte painting: traditional and digital.

figure |12-2|

Notice in this background image that the angle of the camera is looking down. You can actually see the tops of the trees.

figure |12-3|

This miniature of a Mayan temple could not be composited effectively at this angle. Notice here that the camera is looking up at the model instead of down.

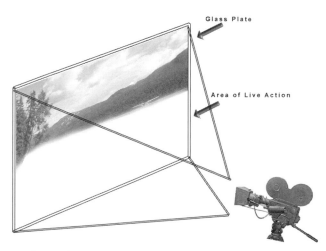

figure |12-4|

The matte painting of the background is painted onto a piece of glass with the area of live action left clear.

Traditional Matte Paintings

Traditional mattes are physical paintings or photo collages mounted on glass, with a specific window left clear to view action. There may be an entire painted landscape with only a small window for live action, or a small painted element with the majority left clear.

A glass matte is typically used in one of two ways. It can be suspended in front of the cameras while filming, for an in-camera composite. This produces a first-generation image with consistent grain and exposure. As with foreground miniatures, they require wide-angle lenses, long depths of field, and plenty of light.

A shot with many areas of activity may be filmed as a **rear-projection** matte. In that situation, the painting is filmed by itself, with the clear areas blacked out from behind. The black material is then replaced with a frosted sheet. Live-action is projected through the window from behind the glass, focused on the frosted sheet. This is repeated for each area of live action.

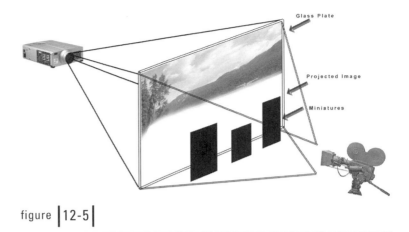

figure |12-5|

Rear projection with miniatures in front of the projection screen.

2-D and 3-D digital mattes exist only as data in the computer. Scenic elements are arranged in layers so they can be altered independently. There may be a need to add atmospheric layers or shift focus between layers of depth, and layers allow that flexibility.

2-D Digital Mattes

A Photoshop collage or painting is considered two-dimensional, because it is created from still images. These can be adjusted, even animated in other software, but since the perspective of a still image cannot be changed, it remains 2-D. These are well suited to stationary camera shots or to distant backdrops that are too far away to reveal perspective changes. These can be used in a digital composite or printed for use within a miniature.

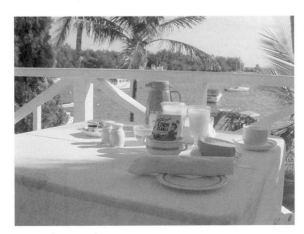

figure |12-6a|

Say you live in Hawaii but you need a shot of your terrace overlooking Los Angeles....

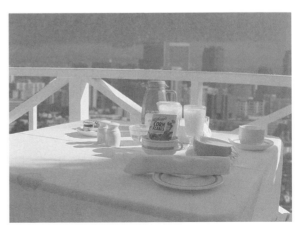

figure |12-6b|

You can take a digital still of downtown Los Angeles, have it printed onto a large format printer, and hang it as a backdrop behind your scene. The same thing can be achieved by using a greenscreen and compositing the image in, but there are always other options in case you don't have a compositor to work with.

figure | 12-7 |

A 3-D church created on the computer instead of a physical model.

figure | 12-8 |

A 3-D scene of an underground sewer.

3-D Digital Matte Paintings

Moving camera shots are more dynamic and interesting than static ones. The ability to navigate through an environment and see all the changes of depth cues are what make the 3-D digital matte painting such an advantage. "Virtual" sets and landscapes can be staged from any angle, or flown around within a shot. As different as the effect is from a still 2-D painting, so is the effort required to create one. Creating buildings entirely with software can be cost-effective, but there are numerous factors that are easily overlooked.

TEXTURE AND LIGHTING

Miniature sets have an advantage over 3-D digital mattes by virtue of their physical textures and variety of reflective properties. A completely digital structure has neither of those. Every surface must have an appropriate texture created or "mapped" to it. Those surfaces must be able to bounce, reflect, or absorb the virtual lighting in a realistic way. It's very easy to create a synthetic-looking virtual set, because of the many considerations of texture and lighting. Glass windows, rusted metal pipes, polished or raw wood, cement, and pavement all respond to light differently, and have to be modeled to do so. Without aggressive attention to those details, 3-D digital scenery can look like a video game, with flat, stretched surfaces. The attention to detail in making a 3-D animated set look real as compared to a miniature can be night and day. Realism can be achieved, but it does take some work.

2-D LAYOUT

One of the illusions of film is that it shows you something with depth. It does not. A filmed image exists on a two-dimensional plane, and we interpret the various depth cues (remember depth cues from Section 3) to gauge the space being described. Because everything the camera sees is condensed onto this one surface, it is possible to mix 2-D and 3-D scenery and have them fit appropriately.

Multiplane Animation

Before fully rendered CG characters and settings were available, animated films relied on innovative tricks to give their environments more depth. *Snow White* was the first to use a multiplane setup. Several glass sheets were arranged at various distances in front of the camera. Each was mostly clear except for a bit of painted trees or foliage, and one fully painted background sat at the farthest distance from camera. With the lens set for a low depth of field, the panes of glass were slowly moved toward the camera. As they neared the lens they would go out of focus, and when the painted section was out of frame the sheet would be removed entirely. The result was a remarkably realistic tracking shot through layers of 2-D scenery.

FOREGROUND PHOTOS

Any 2-D scenic element has, by definition, actual length and width, but no depth. The appearance of depth or perspective is a product of converging lines, focus, and other depth cues. Using a photograph of a building would appear to be a quicker and cheaper solution to creating an establishing shot than the creation of a foreground miniature. It can be just that; however, there is a catch. A photograph has no freedom to be rotated to match the alignment of the camera and background action. It was shot from a fixed point of view, with a certain amount of lens distortion, so it will look appropriate only if placed in the same context. This means the perspective lines in the photo must perfectly continue the lines in the rest of the frame or it will immediately look out of place. It is possible to use the existing photo to determine your production camera placement, if you can duplicate height, lens angle, and the other conditions of the photo.

To help ensure your foreground photo matches the background perspective, you can create a transparency with a printed grid. (Some of these grids can be found on the DVD.) By placing the center spot at the vanishing point, as seen by the camera, you can set the guidelines for horizontal, vertical, and converging line continuity.

BASIC PHOTOSHOP TOOLS

We will assume that if you have made it to a class like this that you have at least some basic Photoshop or other paint-system skill set. In the following paragraphs we cover some simple tools that are used often in creating scenics for pre-viz, composites, and final matte work. If you are completely new to Photoshop, Thomson Delmar Learning, the publisher of this book, has several titles available that can get you started. Check the Web site at http:// www.delmarlearning.com.

Selection Tools

The first tool we will discuss is not really a tool per se, in that it does not directly alter the image itself. Instead, the selection tool, as its name implies, is used to select areas, sections, or

figure |12-9|

For selecting areas that are less complex, the Marquee tools are simple to use.

figure |12-10|

The default Lasso, Polygonal Lasso, and Magnetic Lasso tools.

color ranges of an image to limit the area of manipulation of the other image altering tools available within Photoshop.

The selection tools are located in the upper left corner of the toolbox. The first are the Marquee tools: Rectangle, Elliptical, Single Row, and Single Column. These tools are best used for selecting symmetrical areas of your image. These shapes do not have editable points; thus, using them to select complex areas is very difficult.

For selecting areas a bit more complex, the Lasso tools may be the selection tools of choice. There are three: Lasso, Polygonal, and Magnetic.

The default Lasso tool allows you to create a freehand random shape on the image. When you connect the end of the shape to the starting point, Lasso closes the shape and selects the area within the shape as the area to be affected by you.

Masks

The first tool that is essential for creating the digital scenic is the masking tool. The mask is basically a device for cutting out or hiding a portion of an image by using a shape. We will go through a couple of methods of creating masks within Photoshop.

The first is by using the shape selection tools to create a shape you wish to use as a masked area of your image. Let's take the beach ball in Figure 12-11.

What we would like to do is create a matte for the beach ball so as to isolate it from the white background. Since the ball is round it will be simple to use a round shape to create this. With the elliptical marquee tool as seen in Figure 12-9, we can create a round shape like that of the beach

figure |12-11|

A beach ball with no matte over a white background, to be cut out for use in a composite.

figure |12-12|

The dotted line shows the selection of the beach ball using the marquee tool.

ball. By holding down the shift key while drawing your shape, you can create a perfect circle.

Next, in the layers menu select Add Vector Mask (Figure 12-13).

To demonstrate how the matte is affecting the beach ball, we have selected a brush that looks like an autumn leaf and we will paint just the ball with it (Figure 12-14). You will notice that the leaves do not paint on the outside of the beach ball because the mask is limiting the affected area of the brush. Once we remove the mask, as shown in Figure 12-15, the brush strokes can be painted on the entire image.

Lets say instead of painting, you want to use this mask as a cutout or **alpha** channel. Once you have created the matte layer, save the image into a format that accepts alpha channels, such as a **Targa**, **TIFF**, or **PICT** file. This will store your newly created matte information so that it can be brought into your compositing system for compositing.

figure | 12-13 |

The hand is pointing to the Add Vector Mask tool, which creates a mask from the selection shape.

Beyond using the selection shapes you can use the Magic Wand tool, the Lasso, or any selection tool you wish. Once you have the area selected that you wish to matte out, select Add Vector Mask and you are all set.

figure | 12-14 |

With the matte in place, the brush strokes are limited to the area of the beach ball itself.

figure | 12-15 |

Once we delete the mask we created, the brush can now paint on the entire image.

figure |12-16|

The transparency or opacity as shown here in Photoshop, can be adjusted using the slider or by typing in a value.

figure |12-17|

The castle stands out like a sore thumb because it is not blended with the atmosphere.

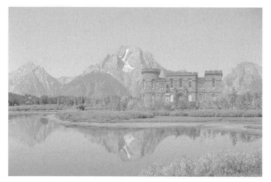

figure |12-18|

Selecting an area of atmosphere or haze. The selection does not have to be exact because you can blend away the edges.

Transparency

Transparency is a pretty simple term and tool. Within Photoshop, each layer or object has a transparency level or percentage represented with the values between 0 and 100, 0 being completely transparent and 100 being completely **opaque**. More than explaining how to use the transparency tool, let us explain why you would use it in creating a digital scenic.

When adding layers of elements representing wide-reaching views such as landscapes or city skylines, often you will be asked to add an atmospheric haze to blend your elements together. By combining elements together with a wide range of transparency levels, you can create a greater illusion of depth and a cohesiveness of elements used within your scene.

The quickest way to alter the transparency of an individual layer in Photoshop, is through the layer window.

In Figure 12-17 we have taken a background of a mountain scene and added in a castle. The castle looks as if aliens placed it there; it just doesn't fit.

Using your Lasso tool, select an area of the atmosphere. Draw a shape that is roughly the size of the object you are trying to match. Figure 12-18 shows a selection above the mountains that is roughly the size and shape of the castle.

Now that you have this selected, copy it and paste it atop the castle layer. It will look something like Figure 12-19.

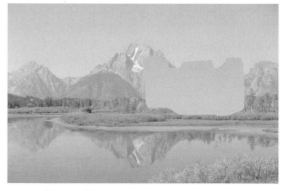

figure |12-19|

Now covered with the atmosphere, we have to adjust the transparency or opacity of the layer.

figure |12-20|

Using the slider you can adjust the levels or you can just type in values. Using the slider gives you interactive feedback of the results.

Now we adjust the atmosphere layer to an **opacity** of 16 percent.

Figure 12-21 shows the original shot at top and the shot with added atmosphere at bottom. You can see the difference in using this method to blend layers for your digital scenic. We will use a method very similar (if not identical in some ways) for compositing live action.

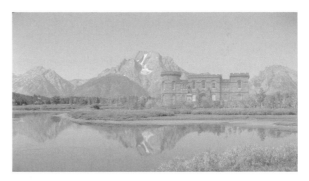

figure |12-21|

Adding a layer of semitransparent sky over the castle (bottom) helps to blend it into the background, thus aiding the illusion of one shot.

Blur

Blur tools are pretty self-explanatory in the sense that they blur things. But what is often confusing is defining the different types of blurs and how they might be used.

Within Photoshop you have several blur tools available just when you purchase the software; there are several others developed by third-party plug-in developers, but we will not get into those here.

The blurs can be found under the Filter menu. The types of blurs are Blur, Blur More, Gaussian Blur, Motion Blur, Radial Blur, and Smart Blur.

The Blur and Blur More tools remove noise where significant color transitions occur in an image. By averaging the pixels next to the hard edges of defined lines and shaded areas, Blur filters can smooth transitions between layered objects within your scenic. The Blur More filter increases the effect of the Blur by three or four times the original.

Gaussian Blur can quickly blur a section of your image, but unlike the Blur or Blur More tools, the Gaussian Blur is adjustable. A Gaussian Blur uses a bell-shaped curve to weight the average of the blur over the selection of the image. The Gaussian Blur is used to create a hazy effect.

figure |12-22|

Listed above under the Filter menu are the available Blur tools. Notice the ones with the ellipses (...) after them, indicating that they have user-editable properties for customizing your blur.

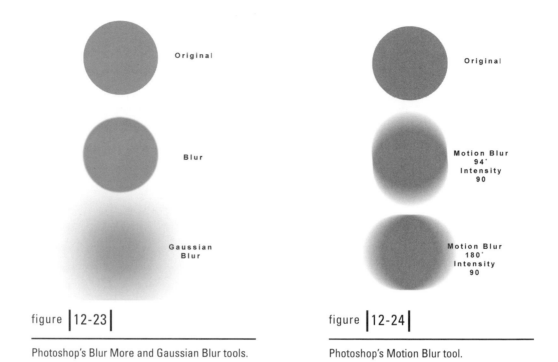

figure |12-23|

Photoshop's Blur More and Gaussian Blur tools.

figure |12-24|

Photoshop's Motion Blur tool.

Compare the images in Figure 12-23: the top is the original, the middle is blurred using the Blur, and the last one is blurred with the Gaussian Blur.

Motion Blur blurs your selection or image in a particular direction (from −360º to +360º). The intensity can also be adjusted (from 1 to 999). The concept of the motion blur is to simulate your camera catching a single frame of your subject in motion.

Radial Blur simulates the motion blur of a zooming or rotating. If you choose Spin, you will create a blur along concentric circular lines. Next you would specify a degree of rotation, or Zoom, to blur along radial lines, to simulate the zooming in or out of the image. There are three qualities of the Radial Blur. Draft for the fastest but a poorer quality result; Good for a midrange result; and Best for smoother, final result. Good and Best are almost identical except on a large selection. You can specify the origin, or center, of the blur by dragging the pattern in the Blur Center box.

Smart Blur precisely blurs an image. You can specify a radius, to determine how far the filter searches for dissimilar pixels to blur; a threshold, to determine how different the pixels' values should be before they are eliminated;

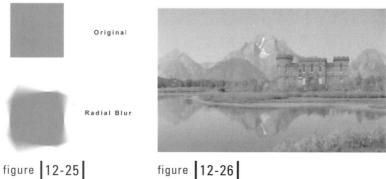

figure |12-25|

Photoshop's Radial Blur tool.

figure |12-26|

Photoshop's Smart Blur tool.

and a blur quality. You also can set a mode for the entire selection (Normal), or for the edges of color transitions (Edge Only and Overlay). Where significant contrast occurs, Edge Only applies black-and-white edges, and Overlay Edge applies white.

Clone

The Clone tool allows you to copy part or all of a piece of an image on top of another image. The sourced image is copied using paint strokes and pasted to the destination area almost as if you are revealing the image in the new area.

Adding Motion to 2-D Matte Paintings

The abilities of Photoshop to create believable backgrounds are continued and expanded in After Effects. While the program is useful for creating animated effects, it retains the basic stacked-layer arrangement of Photoshop. Two-dimensional images can be skewed, blurred, and otherwise adjusted over time to appear to move, but the environment is not a true 3-D space. And it doesn't need to be if you tailor your shot to the strengths of the software.

figure |12-27|

Photoshop's Clone tool.

Cloning in Photoshop

1. Select the Clone Stamp tool and do the following in the options bar:

2. Select your brush and set brush options.

3. Choose your blending mode, opacity, and flow.

4. Align the sampled pixels. With Aligned selected, you can start and stop the cloning without having to reset your sampling point. No matter how many times you stop and resume painting, the sampled pixels are applied continuously. If Aligned is deselected, the sampled pixels are applied from the initial sampling point each time you stop and resume painting.

5. To sample image data from all visible layers, select Use All Layers. To clone only from the current layer, de-select Use All Layers.

6. To set the sampling point, or the area you wish to start cloning, position the pointer in any open image and alt-click (Windows) or option-click (Mac OS).

7. "Paint"' the clone onto your new image using your mouse or Wacom pen.

Note: Cloning between two image types is not possible within Photoshop, thus your images must be in the same mode (CYMK, grayscale, RGB, etc.).

Lens Flares

Lens flares can be animated to change size, shape, and placement in the frame, to give the illusion that the camera is moving through the field of a light source. But as with any effect, it can easily be overdone. Subtle occurrences of lens flares in shots go a long way toward adding realism to your final shot.

Take two situations that involve a moving vehicle. Your talent sits in a car in front of a bluescreen. The view out the front would reveal changes in the size, blur, and **foreshortening** of objects as they approach and pass. Traveling into the depths of a space is perfect for miniatures or 3-D CGI, but would be difficult to simulate with After Effects' stacked-layer arrangement. On the other hand, consider the view out the side window. The horizon very slowly moves in a straight path through the frame, while layers of depth approaching the car move increasingly quickly through. The closest objects passed, including fences or lampposts (or even other cars), practically blink in and out of view. This arrangement of moving planes, none of which changes foreshortening, is perfectly suited to After Effects. Layers of diffusion and applied blur effects can enhance the realism of this kind of scene.

SUMMARY

The idea of matte painting has moved beyond the traditional of paint to canvas or paint to glass. As with most of the rest of this book we have tried to plant ideas on how to do the things done by the pros, but a little cheaper. Using the simple digital tools described here you can create some very realistic mattes for your miniatures photography or for your composite shots.

in review

1. What is matte photography?

2. What is a double exposure?

3. What is the present-day equivalent to double exposure?

4. What are the advantages of digital matte creation?

exercises

1. Create a matte "painting" using the digital collage techniques.

2. Print the convergence grids onto clear plastic sheets and use them to line up foreground and backgrounds.

3. Using Photoshop or whatever software you have available, create a matte background.

3-D modeled set extension work in progress.

CHAPTER

13

Chapter Objectives

- Gain a basic understanding of 3-D as it is used in scenic design

- Learn when it is advantageous to use 3-D rather than miniatures or matte paintings

- Learn about the applications available and in use today

Introduction

As film students, you may not have been exposed to the process of rendering digital 3-D objects. It is a completely different discipline from the shoot-what-you-see school of filmmaking. It is just as difficult to do well, though, and even easier to do poorly. There are no givens, no "happy accidents" as FX artists refer to them, to help them blend in with the rest of the shot. Every solid plane, every texture, every reflection has to be specifically programmed to respond to light as it would in the real world. But there's no light, either! You create the qualities of the source, the fill lights, bounce, color, and diffusion that will cause your CG building to look as though it's just sitting in the sunlight. Sound like a lot of careful observation and modeling? Maybe foamboard and balsa are not so tough by comparison.

It may seem out of place to describe 3-D to a film student at this stage, but a solid foundation of all aspects of filmmaking is essential to becoming a great filmmaker.

If you're not likely to create your own 3-D CG effects, why are they included in this text? The ever-growing popularity of and demand for that skill increases the chances of your needing to know someone who does create them. Time to dust off those networking skills, but this time you'll want to have a plan before you solicit volunteer help.

WHAT IS 3-D?

3-D, in regard to this chapter, is referring to the craft of creating three-dimensional imagery on a computer using software designed specifically to build in a virtual 3-D world. But it did not start out as easy as it is today.

The 1980s saw the surging use of computers for creating effects or imagery on the screen. In 1982, *Star Trek: The Wrath of Kahn* used computer animation to create the "Genesis Effect" in the film. During this time it would take a warehouse filled with computers and drives to render the frames needed for the film. By the 1990s, computer animation had made leaps and bounds in functionality and reality on the screen. This led to the first fully computer-animated feature film, *Toy Story,* by Pixar and Disney. Artist now are creating 3-D images at costs that are a mere fraction of what they used to be.

INTERVIEW

Visual Effects Veteran Bill Taylor

Physical and Digital Effects Today

Fortunately, the best effects creators have not forgotten that there are alternatives to digital models. Traditional miniatures give you a lot of bang for the buck and allow multiple-camera shooting and retakes. Digital enhancements can substantially improve the integration of models into the real world. In *The Core* (supervised by Greg McMurry) the space shuttle crash landing uses a real riverbed as background plates, shot on a camera car or helicopter. A CG shuttle was used for wide shots, which would have been much more difficult in miniature due to the size of the run. Close-up shots of wreckage and impacts were done with models because the splintering and fragments would have been very tough to animate. Intelligent choices.

Jurassic Park killed stop-motion for creating fantastic, photo-real animals, because CG animation is too clearly superior. Just to start, you can edit and polish CG animation, while stop motion is by its nature linear. The day will come when CG physics are good enough to be convincingly real for complex crashes and explosions, but miniatures still have too many happy accidents that occur in-camera. There are no happy accidents in computer graphics. And the best computer graphics for water or environments are not going to be affordable to students or low-budget filmmakers.

Software Choices

Photoshop is the world standard for image editing, but our artists prefer it for creating paintings from

The uses for 3-D are infinite, from creating worlds that exist only in the minds of madmen to creating something as simple as a street sign where there wasn't one before.

An advantage today to those in need of 3-D work for their film project is that the 3-D artist, in general, has become a commodity—meaning that they can be found relatively cheaply if you need to hire them. Many high schools now teach 3-D animation as an elective, thus the pool of available talent continues to grow. Combine that with the low cost of 3-D software today and you have a recipe for good, cheap labor.

HOW DOES 3-D WORK?

We will keep it simple here. The mathematics and algorithms behind creating 3-D images on the computers is best left for that rare breed, the programmer.

scratch. Other paint programs are useful, but in visual effects you aren't trying to imitate brush strokes. After Effects is tightly integrated with Photoshop, with similar commands and terms. Since it's a layer-based compositing tool, it's easier to understand for people like me who have traditional backgrounds than node-based software, especially for novices. Seeing the graphic layer presentation always helps. After Effects over the last several versions has become tremendously powerful. Ninety-nine percent of Illusion Arts' finished comps are done with After Effects.

It's all there in After Effects: rotoscope and vector paint, motion tracking and 3-D camera moves, and motion math editor. Even though a given tool might not be the absolute best available (I still like Commotion for roto, for example), you can get the job done with After Effects, right out of the box. You can easily stabilize a shot, composite elements into it, and add back the original camera motion. Since there is such a huge user base, there are also many competing plug-ins.

Node-based compositing does have advantages once you climb the learning curve. Though we have a couple of Shake licenses, we really haven't scratched the surface yet. There are major areas like motion control in which it is far advanced over After Effects, and there are Foundry plug-ins exclusively for Shake that are pretty awesome.

As for bluescreen and greenscreen software, Ultimatte, Primatte, and Keylight are available as plug-ins for every major compositing package.

Keying software is built into the later-generation editing packages, so that editors can make a pretty decent temp composite [usually limited by the quality of the digitized footage they're working with].

Also, it's a tremendous help to have rough-compositing equipment on set for shooting, especially if the background has already been rendered from a certain point of view. ■

But we can give you a basic idea of how it works so that when you are talking with your 3-D artist, who is creating your great background plate, you don't feel totally lost.

The 3-D artist, using software like Maya or **Softimage XSI**, uses one of many available construction tools or building blocks to create the scene. The tools can be made of predefined shapes such as cubes, cones, and spheres, or the objects can be built by creating several curves that represent the edges or cross sections of the model. These curves are then skinned to create a solid surface that looks like the object they are trying to create.

figure |13-1|

The primitive shapes in a typical 3-D application.

figure |13-2|

An advantage of doing your scenery in a 3-D application is the ability to move your camera anywhere without it ever being seen.

figure |13-3|

A fully 3-D-animated building and location.

Once the model has been built, the next step is for the artist to create the materials or textures for the object. In larger production houses, these jobs are usually divided up between specialists in their fields. The final steps are atmosphere and lighting. Often some of these elements are added later in post-production in the compositing stage.

One more aspect is animation. One of the biggest advantages to 3-D-animating your background plates is the element of a virtual camera that can go anywhere within your scene without being seen.

In 2-D matte paintings you are stuck with limited camera moves; with miniatures you are limited by the size and space available to move equipment through your model. With 3-D animation your camera can start on the roof of a building, fly down the side, zip back up just before hitting the ground and proceed to wind its way through the city or whatever environment you have created. This flexibility opens up the world to you as a filmmaker. No longer are you limited by real-world limitations.

THE SORE THUMB

Student films have to come together fairly quickly. Ideas shift on the fly, and designs frequently change over the course of production. Having CG-savvy artists on hand may seduce you to build elaborate shots or sequences to show off the effects. Here's a word of advice to help you with that: *don't*. An isolated all-digital effect leaps off the screen, especially if inexperienced hands put it there. Think in terms of the particular strength of CG that would compel you to use it, and try to blend in other methods that lend themselves. For example, most geographic landscapes are easier and more convincing to carve from Styrofoam and cover with scenic materials. For the purposes of this book, the best use of 3-D graphics is construction of solid geometry, namely architectural modeling and texturing.

Ask yourself, are you doing it because you can or because it lends itself to the story and the shot? You will often hear the film snobs complain about effects-driven films, how they lack story, depth, or meaning. When deciding to create that shot, become that snob. Will the shot make you question, "Why did they do that?" Or will it make you just marvel in the overall completeness of the scene?

WHEN DO WE USE 3-D?

We touched on this above but here we will elaborate just a bit and give some specific examples in films you may have seen that illustrate the ideas we will speak to.

To answer this question of when to use 3-D and when to use another method, we must first revisit Section 2 of this textbook, Previsualization. What does the storyboard call for? What are the options for creating the shot? Are there options that the director is willing to consider?

Let's take for example the storyboard plate shown in Figure 13-4. This shot requires the camera to do a slow push into a background of a mountain range. While this shot can be done in 3-D or with a miniature of a mountain range, the best idea here is to create or acquire a 2-D matte painting of the mountain range and create the camera push within the computer.

figure |13-4|

This storyboard calls for a push-in on a mountain range. This shot can be accomplished with a 2-D image, either a matte painting or stock photos or, of course, by going on location and shooting the real thing.

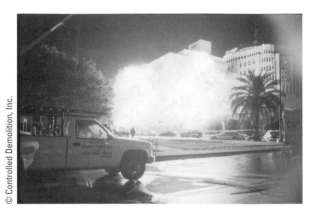
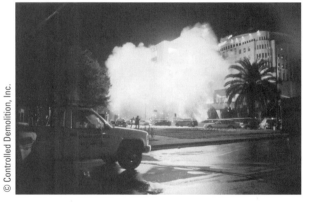
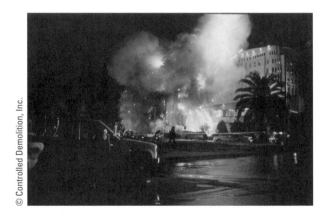

© Controlled Demolition, Inc.

figure | 13-5 |

Sequential shots of Orlando's city hall being imploded with added effects for the production of the film *Lethal Weapon 3*.

Figure 13-5 shows the street-level point of view (POV) of a building that explodes. You could try to find a real building to blow up, but those are rare. Sometimes you are lucky, as the film crew of *Lethal Weapon 3* was. The film required an opening shot of the lead actor rushing out of a building just before it exploded. Well, as luck would have it, the city of Orlando had planned to implode their old city hall building and the city allowed the crew access to film and enhance the implosion to be used in the film.

Since this probably will not be available to you for your project, what is your next option: miniature or 3-D? Elements such as fire and explosions often seem "rendered" when created in 3-D applications; thus the level of realism may be compromised. Here building a miniature of the building and using practical pyrotechnics would be the better solution. However, if you don't

figure |13-6|

A storyboard calling for the implosion of a building.

have anyone in your circle of filmmaking buddies who is licensed to create these effects, 3-D may be the only alternative.

Figure 13-7 shows the path of a camera as it flies through several buildings in a cityscape, dodging and turning as if it were the POV of a superhero flying through the city looking for the bad guy. Of course this shot cannot be done with a 2-D matte painting. Building miniatures is a possibility but because of the amount of camera movement required and the amount of space spanned over the course of the shot, the best option is a 3-D environment of the cityscape.

figure |13-7|

POV of a flight of a superhero through a cityscape.

SUMMARY

The 3-D scenic has come a long way in the last five years. Realistic scenes and locations can be created beyond one's wildest imagination. But that creation does come at a cost. Individual frames of animation for your scenic can take hours to render if they are very complicated, and you may not know the visual appeal of the scenic until you get it on a larger screen. At this level of your film career in effects, the digital scenics you will probably be doing are digital mattes. But that alone can save you a ton of time and money. However, if realism is not key to your film, you can get away with a more stylized scenic that is created entirely in 3-D and still save time and money.

in review

1. What is 3-D?

2. What are primitive shapes in a 3-D application?

3. What are some inherent problems with the 3-D scenic?

4. What are the advantages of the 3-D scenic?

5. When is a good time to use 3-D?

exercises

1. Find shots from films that use 3-D models for environments or backgrounds and discuss them.

2. If available, create your study model as a simple 3-D study model in the computer.

A miniature of an illuminated sign being composited in front of a new background.

| compositing |

Section 6

CHAPTERS IN THIS SECTION

- From Camera to Computer

- Concepts of Compositing

SECTION INTRODUCTION

A composite. What exactly is a composite? The dictionary tells us a composite is "made up of distinct parts or elements." That's fine if we are making some new chemical or a cure for baldness, but how does this relate to film and effects? Read on and you will see.

Compositing in the purest sense is the combining of multiple images to create a new seamless image. Take for example your local news station. Jane is announcing the weather while standing in front of what looks like the state of Kansas with little animations of tornadoes, thunderstorms, and rain dancing all around. As most people know, Jane is not really standing over Kansas, and clouds don't have little mouths to blow wind across the country. No, Jane is standing in front of a greenscreen and she is composited over the image of Kansas.

If we take this out of the newsroom and into the movie theatre, our composites become a bit more complicated. Sometimes a composite can be as simple as two layers, or, as in the case of a film like *Lord of the Rings,* layers can run into the hundreds, even thousands.

Interestingly enough, it is not the number of layers that make the composite successful or not. It is the *artistic and scientific integration* of all the elements in a combined shot in such a way that the shot looks as if it were captured with one camera, at one moment in time.

That's right: artistic *and* scientific. There is much more to the final composite than just the artistic eye. Having a knowledge of gamma, luminosity, bit depth, lookup tables, and so much more is essential to creating a final composite that looks amazingly lifelike as opposed to one that looks like Jane standing in front of Kansas.

COMPOSITING

Using software like Apple's Final Cut Pro you can upload your images for editing and effects from your camera.

CHAPTER

14

Chapter Objectives

- **Digital formats**
- **The different types of compositing software**
- **Image resolutions and formats**

Introduction

In this chapter we take you through the process of getting your footage from your camera to your computer to get it ready for your effects shots. We take you through the most commonly used image formats and discuss some of the wide array of software products available to you in the market today.

While there may not necessarily be a right or wrong way to choose a format or a software package for your project, each come with a set of pluses and minuses that can aid or hinder your post-production environment.

We also discuss the several image resolutions that are commonly used in production. The resolution of your image is very important because it represents the amount of image data captured in each frame. The more data you capture at the onset, the more flexibility you will have later when it comes time to edit that image.

A great analogy is to think of it as if you are going to re-cover a sofa. If you buy just enough fabric to cover it and decide that a change needs to be made, suddenly you may find that you are literally cutting corners to make it fit. If you instead give yourself added room by getting a little more coverage than you think you may need, you will find it easier to cut away excess than to try to make fabric from thin air.

FILM SCANNERS AND DIGITAL CAPTURE

Once the shots have been filmed or recorded to video, the next step is to get them to the computer for the compositing artist to work with. But how does that happen? With traditional film you must take your film to a scanning facility. The scanning facility takes your film and runs it through a film scanner. Film scanners range in function and type, and of course cost, but in general the film scanner takes each frame of film and projects light through it so that a computer chip captures the image and saves it as a digital file. That file format can be one of many different types, which we will discuss shortly. There are many other variables to consider when using film, such as aspect ratio for the scan, color levels compared to your **film out facility**, and a variety of color and contrast issues. Once the frames have been scanned they are usually stored on one of several media types: for example, a DLT, a computer hard drive, or DVDs.

The process for transferring your digital media from your camera is a little easier. Since the frames are already in digital format on the tape from your camera, what is needed is a method to transfer those frames from the tape to the computer. Most consumer and pro editorial software packages contain what are called capture tools. These tools allow you to hook your computer to your camera or video deck to transfer your frames from your camera to your hard drive. You do not need to deal with color correction yet because you are bringing in exact copies of what you recorded from your digital camera. Just as with the film scan, however, you do have a choice of image file format, which we discuss shortly. A new technology that is starting to get wider use is the hard drive–based video deck. This looks like a video deck with controls on the front of the device like play, pause, rewind, etc. But instead of using tapes, the unit is housed with one or more hard drives. The drives capture the images from the camera and when you get back to your edit bay, you just plug the deck into your computer as if it were a regular hard drive.

IMAGE FORMATS

It seems that almost every year a new and improved image format is created for storing media for film and video. From the workhorse file format Cineon to the more common Quicktime, there are many choices for your image format needs. In simple terms, most of the image formats keep track of three color channels (RGB) and a single alpha channel (RGBA). We will explain more about the alpha channel shortly. Some formats are compressed and some are not. Ideally you will never want to work in a compressed format for visual effects. Compression removes some of the image data and this can make your job as a compositor a true headache. Take a look at the puppy in Figure 14-1 and the close-ups of its eye in Figure 14-2.

figure |14-1|

The original shot.

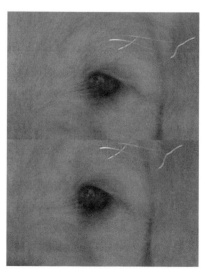

figure |14-2|

Close-up of the puppy's eye saved in two formats. Top: Uncompressed and saved as a TIFF file. Bottom: A compressed JPEG file.

You will notice in the close-up comparison of the puppy's eye the effect compression has on an image. You can imagine now the increased difficulty in color correcting, tracking, or any number of other digital corrections that need to be made on compressed images. Table 14-1 lists some of the most common images formats used today and their compression, if any.

table | 14-1 |

Image Formats

Extension	Image Format	Channels	Compression	Bit Depth
.als, .alias	Alias/Wavefront	RGB		8
.alsz	Alias/Wavefront	RGB(AZ)		8, 16, float
.avi	Microsoft Video	RGBA	Lossy	8
.bmp	BMP	RGB		8
.cin	Kodak Cineon	RGBA		16, 10
.dpx	Derived from Cineon	RGBA		8,16
.gif	GIF	RGB		8
.iff	Apple Shake	RGB(AZ)		8, 16, float
.jpeg	JPEG	RGB	Lossy	8
.mov	Apple Quicktime	RGBA	Lossy	8, 16
.mray	Mental Ray	RGBA		8, 16, float
.pic	Softimage	RGBA		8
.png	PNG	RGBA		8,16
.psd	Adobe Photoshop	RGBA		8,16
.rgb, .sgi	Silicon Graphics	RGBA	Lossless	8, 16
.rla	Alias/Wavefront	RGB(AZ)		8, 16, float
.tga	Targa	RGBA		8
.tif	TIFF	RGBA	Optional	8, 16, float
.yuv	YUV 10-bit	RGB		16, 10

COMPOSITING SOFTWARE

Just as with image formats, there are many different options for creating your effects shots. They range from the very low cost to the very expensive. In general most of these software packages do the same thing. They may take different approaches to tackle a task, but the tasks remain consistent from software to software. While one software may offer tools that allow you to do something faster and easier than another software, it usually comes at a price. While we will make this section as general as possible in terms of covering the art and science of compositing, we will discuss some products more directly since they will probably be accessible to you as a student.

 Two of the higher-end products are Flint and Flame from Discreet (http://www.discreet.com) and Shake from Apple Computer Inc. (http://www.apple.com/shake). A trial version of Shake

is included on the DVD. The prices range from just several hundred to hundreds of thousands of dollars. The learning curves can be a little steeper on these types of packages but their power is usually unmatched. At the time of this writing Shake has been used at the compositing solution for the last seven Academy Award–winning films for special effects.

Another software available to almost all students is Adobe's After Effects. After Effects, while lower in cost, is rich in tools and functionality. It is relatively simple to learn and easy to find a good artist if you do not wish to do the work yourself. There are many packages available; Table 14-2 gives a rough idea of the most popular packages and some of their features and costs at the time of this printing.

RESOLUTIONS

There are several resolutions you can work with in regard to compositing. The resolution is the size of a single frame of footage. For example, a frame of NTSC footage is 720 pixels wide by 486 pixels high, and a full aperture frame of film is 2048 pixels wide by 1556 pixels high. Table 14-3 lists the most popular formats and their resolution. The term that describes this pairing of numbers is the aspect ratio. Simply put, the aspect ratio is the ratio between the width of the image or picture and the height of the image or picture. Thus the normal aspect ration for NTSC is 4:3 (1.33:1) and HDTV's is 16:9 (1.85:1); this is the same ratio for Academy Flat. Anamorphic Scope (Panavision/Cinemascope) has an aspect ratio of 2.35:1

When working with film resolutions you have another option, and this is the resolution of the film scan. The frames can be scanned at 1k, 2k, 4k or even higher. The larger the "k" value of the frame, the larger the number of pixels sampled in the scanning process. The higher the sampling, the more information you have to manipulate your final image. This can be very important if you are dealing with severe color correction or other image manipulations.

STORAGE AND BACKUP

Needless to say, all this material you have been digitizing and putting onto your computer can quickly eat up your disk drive space. Thankfully drives have been getting exponentially cheaper and by the time this text is printed you should be able to purchase a terabyte of disk storage for less than $500. Not only will the price be small, so will the drive itself. A terabyte of disk storage used to take up an entire closet that needed special air conditioners to keep the room cool; now all this storage fits nicely on your desktop taking up maybe a few inches of desk space. While this all sounds great there is one little "gotcha" that you have to be prepared for, and that is disk failure. With disk drive capacity becoming so large it is possible to store almost your entire project on one drive. Because of this, if just one drive fails, you can lose everything. But here within these cheap drives is your answer. Tape drives are not large enough or fast enough to do backups of such large drives. Instead, buy a second drive that works as your backup drive. Using backup software like Retrospect allows you to create automatic

table |14-2|

Common Compositing Packages

Software	Manufacturer	Price	Platforms	Resolutions	Features	Web Site
After Effects 6.5	Adobe	$999 Pro; $699 Standard	OSX, Windows	Resolution Independent	Motion Tracker, Network Rendering, Keying & Matte Tools, Warping & Morphing, Particles, 3-D effects, 16-bit Color Support, more	http://www .adobe.com
Avid IDS	Avid Technology	$134,800	Windows	Resolution Independent	Keying, Color Correction, Paint, Editing, Audio, Text, Text Paths, Tracking, Time Effects, Transitions, more	http://www .avid.com
Combustion	Discreet	$999 Software Only	OSX, Windows XP & 2000,	Resolution Independent	Paint, Animation, Editing, 3-D Compositing, Text, Keying, Color Correction, Particles, more	http://www .discreet.com
Digital Fusion 5.0	Eyeon	$4,995	Windows XP	Resolution Independent	Paint, Tracking, Keying, Macros, Text, Cache, Particles, Color Correction, Network Rendering, Scripting, Grid Warping, more	http://www .eyeonline.com
Flame 6.0	Discreet	$275,000 Includes Hardware & Software	SGI Tezro	Resolution Independent	3-D Compositing Environment, 2-D & 3-D Tracking, Advanced Keying, Advanced Retiming Tools, Color Correction, Warping & Morphing, Paint & Text, Rotoscoping, more	http://www .discreet.com
Flint 9.0	Discreet	$94,995 Includes Hardware & Software	Linux IBM Intellistation, SGI Octane2	Resolution Independent	3-D Compositing Environment, 2-D & 3-D Tracking, Advanced Keying, Advanced Retiming Tools, Color Correction, Warping & Morphing, Paint & Text, Rotoscoping, more	http://www .discreet.com
Inferno 6.0	Discreet	$439,995 Includes Hardware & Software	SGI Onyx 350	Resolution Independent	3-D Compositing Environment, 2-D & 3-D Tracking, Advanced Keying, Advanced Retiming Tools, Color Correction, Warping & Morphing, Paint & Text, Rotoscoping, more	http://www .discreet.com
Shake 3.5	Apple Computer Inc.	$2999 OSX; $4999 Linux	OSX, Linux	Resolution Independent	3-D Compositing, Tracking, Warper/Morpher, Scripting, Macro, SDK, Paint, Color Correction Tools, Keylight, Primatte, Rotoscoping, more	http://www.apple .com/shake

table | 14-3 |

Aspect Ratios

Type or Format	Aspect Ratio W:H	Aspect Ratio W/H
Square	1:1	1
16 mm	1.33:1	1.338028
8 mm	1.358:1	1.358209
Academy	1.37:1	1.370432
Academy Flat	1.85:1	1.857
Anamorphic	2.2:1	2.2
D-1 NTSC	1.58:1	1.58
D-1 NTSC Square	1.333:1	1.33
D-1 PAL	1.48:1	1.48
D-1 PAL Square	1.333:1	1.333
EDTV	1.775:1	1.775
HDTV (1280 x 720)	1.77:1	1.777
HDTV (1920 x 1080)	1.77:1	1.777
IMAX	1.43:1	1.434555
NTSC	1.33:1	1.33
PAL	1.58:1	1.58
Super 8	1.36:1	1.36079

scripts that will back up your data daily at whatever time you want. Or if you prefer the manual method, just copy your project folder from one drive to the backup drive every night.

It is also important that you remove your backup drive after your backup is complete. Not only remove it, unplug it. This is to remove any possibility of power surges or shorts from destroying not only your main drive but also your backup. There is nothing worse than having all your hard work just zapped away in a moment; it is so heartbreaking it may make you go back to delivering pizzas for a living!

SUMMARY

The process of getting your images to the computer for editing and manipulation has certainly changed a great deal over the last five to ten years. We expect this trend to continue. Recently at a trade show in Los Angeles we were treated to an early look at one-terabyte solid-state drives. This means no moving parts and all in a package about the size of a saltine cracker. As with each section and chapter of this text, the foundation is planning. Decide early what formats you will work in, what resolutions, and which software. The sooner you get these issues worked out the better.

in review

1. How is film taken from the camera to the computer?

2. How do you move digital media from your camera to the computer?

3. What is the significance of the resolution of images?

4. What are the different methods for backing up your media?

exercises

1. Compare images of different resolutions and discuss the differences.

2. Create different image formats of the same images and see if there are any differences and discuss them.

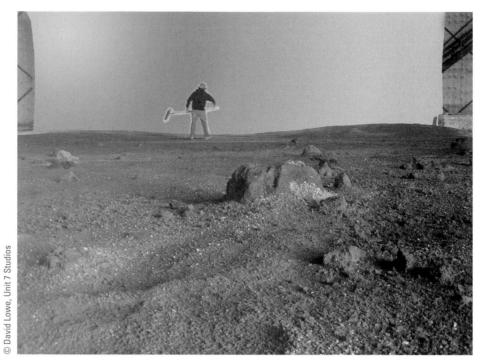

© David Lowe, Unit 7 Studios

Miniature set of Mars surface in front of a greenscreen.

CHAPTER

15

Chapter Objectives

- Know when to use keying to complete an effects shot
- Use rotoscoping to isolate an object
- Understand how to use camera tracking and match move
- Use color correction to seamlessly combine images
- Use math ops to match grain

Introduction

 Within this chapter we will take you through the basic concepts of compositing. While there are almost an unlimited number of choices of software available to you as a compositor, the basic technology or ideology of compositing is pretty much the same in each. Because of this we will cover the concepts and ideas used in compositing that are found in almost all software packages. On the DVD that accompanies this text we have some actual demonstrations of compositing some shots and you will see specific software products in use. But just as we discussed earlier in the text, the software packages are but a tool in your toolbox. Once you learn the basic idea of what that tool does, it is easy to pick up the same type of tool made by someone else and still be very productive.

KEYING

Why do we want to use keying, which is the process of isolating the foreground from the background, to complete an effects shot? This can depend on many factors; budget, time, danger of the shot or practically is it easier. There are several ways to approach every shot of a film. Let's takes for example the cobra shot from the first *Indiana Jones* movie, *Raiders of the Lost Ark*. In this scene the main character, Indy, falls to the ground only to be confronted face to face with a cobra. Knowing that Indy is afraid of snakes, this makes for a great moment in the film. Looking at that same shot today we can come up with several options as to how to complete that shot. In the original film the shot was all done in-camera with no compositing. The snake was placed behind a very clean piece of glass; Indy falls to the ground on the other side of the glass and thus is safe from being struck by this deadly animal.

Today however, we have several other options. Say the budget of the film did not take into account the insurance needed to have a live cobra on set and on top of that, your talent refuses to work with a snake. Instead of going the practical route of shooting it all live you come up with other options. Option one: shoot the talent in front of a greenscreen and later comp in stock footage of a cobra. Option two: your prop department creates a

CONCEPTS OF COMPOSITING

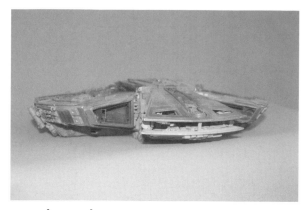

figure | 15-1a |

A miniature spaceship over green.

figure | 15-1b |

Matte created from removing the green.

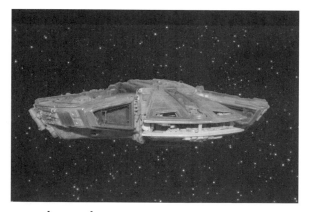

figure | 15-1c |

Using the matte, the foreground is cut out of the old shot and composited onto the new background plate.

fake cobra with simple animatable controls. Option three: re-create the cobra as a 3-D computer model to be composited in later. Be creative, but always be aware of what is available to you. In general a good portion of these shots are done by means of some sort of compositing of several shots to make one. Keying is the method of choice for compositors. Keying allows you to create a matte, or cutout, of your foreground and background. The term *matte* comes directly from traditional filmmaking. If the cinematographer wanted to block out part of the film from being exposed so that he or she could later add in a new background or foreground, a physical matte cut out of heavy paper or cardboard was used to block, or matte-out, part of the lens, thus limiting the area of the film that was exposed to light. Later that same matte, only reversed and mirrored, was used to protect the already exposed film and the new elements were shot and added to the already exiting shots. The examples in Figure 15-1 demonstrates the concept of a matte.

Chroma Keying

Chroma keying gets its start from video, where signals are broken up into chrominance and luminance.

Chrominance is the color part of a video signal or image relating to hue and **saturation**. Whites, grays, and blacks are excluded from this signal. **Luminance**, which we will discuss later, is brightness of the video signal; thus it tracks the black, white, and gray signals of an image.

Since the chroma keyer is based on hue and saturation, it has the ability to isolate a certain color and replace that color with another image (remember Jane and her greenscreen weather map?). The chroma keyer in your software takes your image, typically stored as RGB information, and converts it into **HSV** (hue, saturation, and value). This gives the keyer a larger range of colors to work with. Not only will we be selecting the color green but also a range of that green color, as demonstrated in Figure 15-2.

figure |15-2a|

A poorly lit greenscreen with obvious gradients in the color range.

figure |15-2b|

Notice already the difficulty in the early stages of creating a matte out of this greenscreen by just using the chroma.

Luma Keying

The **luma keyer**, like the chroma keyer, sets out to isolate the foreground. Whereas the chroma keyer uses the red, green, and blue color values to select the area of the image to remove, the luma keyer uses the luma values of the image to isolate the foreground. The luma keyer, like the chroma keyer, comes to us from the video world. Unlike the chroma keyer, which uses the information contained in the chrominance values of the image, the luma keyer works with the luminance values. The luminance values of the image are the black, white, and gray levels, or brightness of an image. Luma keyers analyze the image and break it down into values between 0 and 100 percent. As the artist you select what are called thresholds.

figure |15-2c|

The same matte after adding in the luminance and saturation to the mix.

After you set your threshold, any part of the image that is above this threshold is set to 100 percent white while anything below it is set to 100 percent black. Setting a single threshold, however, will give you a very hard-edged matte, which is often not desired. Thus many software packages with luma keys have the ability to set a range for the threshold. Anything outside of this range is still either black or white, but everything within the range is gradiated to create a softer-edged matte. Figure 15-3 demonstrate the luma keyer.

Difference Keying

The **difference keyer** works by detecting the difference between two image plates. One plate is the "target" plate; it contains the item or foreground you wish to isolate. The second plate

figure | 15-3a |

Fire shot over black.

figure | 15-3b |

Matte created using a luma keyer to isolate the fire.

figure | 15-3c |

The fire is composited over a new background using the luma matte.

figure | 15-4a |

The clean plate.

is the **clean plate**. The clean plate is a shot of the same image as the target plate minus the foreground element. For example, if you isolate an actor in a scene to add an effect only to him or her, you first shoot the scene with no actors and then shoot it again with your actors. This technique does require some planning. If the shot is locked off, meaning the camera is not moving, you only need to remove the talent from the foreground and shoot a clean plate. If the camera is moving, the only way to accomplish a difference matte is to shoot the scene with a motion-control camera, thus ensuring identical movement in both the target plate and the clean plate. Figure 15-4 shows a clean plate, a plate with a foreground and the resulting matte from doing a difference key.

figure | 15-4b |

Shot with foreground element in place.

figure | 15-4c |

Resulting cutout using a difference keyer.

> ### ▶ Where Did Rotoscoping Start?
>
> Max Fleischer invented rotoscoping around 1915. With a passion for cartoons and a job as art editor at *Popular Science* magazine, Fleischer began to conceive the idea of using mechanics to make easier the work of creating animated cartoons.
>
> Fleischer, along with his brothers, experimented to see if his theories were correct. Together they built the machine necessary for the new process of rotoscoping. One of the brothers dressed as a circus clown for the reference footage, this was the birth of "Koko" the clown.
>
> In simplest terms, the rotoscoping machine traces or outlines the subject from the live action and draws it onto animation paper.

ROTOSCOPING

The rotoscope artist is tantamount to the army grunt. You do a good deal of the work but get very little recognition. But what is rotoscoping? As with keying, **rotoscoping** is used to isolate an object or talent from the foreground or background. Unlike using the keyers, rotoscoping is a painstaking frame-by-frame process that has driven more than its fair share of artists to become chain smokers and caffeine addicts.

While we said rotoscoping is considered grunt work, it can also be the knight in shining armor. When all of your keyers just won't work or the greenscreen is so poorly lit that you just cannot pull a key, the rotoscope tools allow you to go into each individual frame and by hand draw shapes around the objects you wish to isolate from your scene. These shapes are called **splines**. A spline is made up of at least three points and is a closed shape. By adding and moving points around on your screen, you can manipulate the points and the shape to outline an object in your scene and thus cut it out from the shot. The most popular splines in compositing systems are **B-spline**, **Bezier**, and **Hermite**. B-spline curves are manipulated by control points. The control points can either be on the spline or off. The spline moves toward the control points, so as you move a point farther away, the spline moves toward that point. The second type is the

figure |15-5a|

B-Spline. Notice that only the first and last point actually touch the curve.

figure |15-5b|

On the Bezier curve, the points rest on the curve itself while the points of the handles do not.

figure |15-5c|

The Hermite curve looks very similar to the Bezier, but notice the difference in the handles.

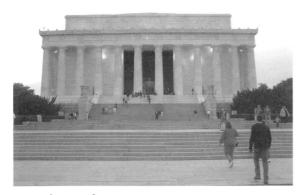

figure | 15-6a |

Stock plate of the Lincoln Memorial.

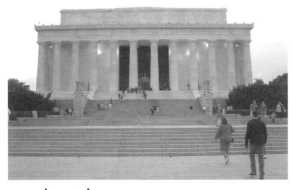

figure | 15-6b |

After getting the images into the computer, you will want to create a shape around the staircase. Here we have isolated the staircase using a Bezier roto.

Bezier. Unlike the B-Spline, the control points of a Bezier are directly on the spline. For more control, the points have handles that control the ease-in and ease-out. The handles can be broken to control each side of the control point individually. Similar to the B-Spline, the hermite curve is defined by at least two points and each point has it's own single handle.

Theses splines can be seen in most compositing software packages, although they may limit you to using just one or two of them.

Now that you know what rotosplines are, when do you use them? One example of when a rotospline can be used is to remove something from a scene that was not designed for that purpose. Say for example you need to take the stairs from in front of the Lincoln Memorial and place them in front of a new structure. Since it is not practical to place a large greenscreen in front of the memorial to just remove the stairs, another option is to roto out the stairs to use in the new shot (Figure 15-6).

Rotosplines have many uses. Going back to the stairs in front of the memorial, we want to get rid of the two people in the foreground. The background may not matter, but if it does, this same trick can be used. Taking your image over black, make a copy of it and flop it over the vertical axis so it looks like Figure 15-6e.

figure | 15-6c |

The resulting roto matte.

figure | 15-6d |

The final cutout over black, ready for your comp.

The next step is to layer the two frames on top of each other using one of the layering tools in your software. Now that the layers are on top of each other, we still have to matte out the people. Since the shot is flopped all we need is to matte out the half with the people thus revealing the half from the lower image that does not have any people.

Another place where rotos are used are with **garbage mattes**. Garbage mattes are shapes used to matte out areas of a scene you do not want to use. For example, as we mentioned before, when shooting a greenscreen you want to use the smallest screen possible to

| TIP |

Flopping an Image
If your software does not have a flop tool you can easily flop it with your scale tool. To flop an image around the vertical axis, scale your image by −1 in the X. To flop around the horizontal, scale the Y instead.

figure | 15-6e |

The final cutout flopped on its vertical axis.

figure | 15-6f |

Notice the roto is set in the visual center and over the people you wish to remove.

figure | 15-6g |

The resulting matte from the roto shape.

figure | 15-6h |

The resulting image is a clean set of stairs. If you need to remove the people at the top of the stairs, the same basic process can be used.

figure |15-7a|

A greenscreen that needs to have the ceiling garbage matted out.

figure |15-7b|

A garbage matte selects the areas to keep or remove.

figure |15-7c|

The resulting area after cutting away the excess with the garbage matte.

keep from having too much green spill. This will often leave nongreenscreened areas of the shot to key out. The easiest thing to do is a garbage matte.

The last term we will deal with in regard to rotosplines is the **traveling matte**. The traveling matte is just like any other matte except that it is animated over a sequence of frames. This process can be tedious if animated over many frames; thus it is best to animate several key frames only and then go back and tweak the in-between frames as needed.

CAMERA TRACKING AND MATCH MOVE

When your camera is locked down and not moving, it is simple to work with the resulting images in terms of matching in the movement of other objects you wish to composite into your scene. But what do you do if your camera is moving or you have to pan or tilt your camera? You have to track the shot. Tracking is the recording of any movement from within a shot. That movement can be the camera's pan, tilt, zoom, or dolly or it can be the tracking of the talent or some other object within the scene.

Tracking is accomplished by using tracking points. Tracking points search a small area of the frame and look for that same area in the following frame. In each frame the tracker creates a point that represents the movement at that time. Eventually you will have created a motion path that your computer can follow.

When would you use tracking? Say the shot you are working on requires that you composite a miniature of a barn into your scene. This of course would be simple if the camera were not moving. But in this shot the camera is on a car, heading toward the barn through an open field, to simulate a horse riding in

that direction. If you just composited the miniature onto the background plate of the open field your barn would be in one place as the rest of the scene moved around it.

What you need to do is track the movement in the scene and apply that movement to the miniature so that it matches.

Hopefully your production crew was diligent and placed **tracking markers** in the field. A tracking marker is any brightly colored object that easily stands out in a scene. Often in a scene like an open field, an orange cone or brightly colored triangle on a stick mounted securely into the ground is used. You will want to have at least two markers placed on either side of the shot. If the shot is going to cover a great distance, several markers should be used so that when one marker leaves the view of the camera, another is coming in.

Using the same shot, let's say the scene was actually supposed to be a smooth motion dolly in shot, but due to the rough terrain, the shot is filled with a lot of camera shake. What you need to do then is stabilize. Stabilizing involves using the same tools as a tracker, but instead of taking the tracking information and applying it to a new object or frame, we use the tracking information to reposition the background so that it is in the same position as in the previous frame, thus stabilizing the shot.

figure |15-8b|

Markers tracked using Shake's tracker system.

figure |15-8a|

Open field with cones as tracking markers.

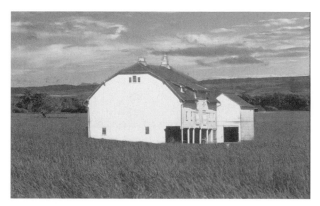

figure |15-8c|

Using the tracking information we can start the composite of the new barn in the field.

Cheap Tracking Markers

Just as with building your models and miniatures, there are cheap ways of doing just about everything, including using tracking markers. Here are some cheap items that can be used as tracking markers:

- White or orange Ping-Pong balls
- Tennis balls
- Styrofoam balls from a craft store
- Colored tape

Adhering these objects to the surface you wish to track is simple. You can use double-sided tape, push pins, Velcro or even glue.

Working with trackers can be tricky. Most trackers are set up with three on-screen components. The first is the **search area**, the area of the tracker where it will look for the tracking point from frame to frame. The outer box of your tracker usually represents this. The smaller inner box is the track area. This area is "photographed" by the tracking software and is searched for in the following frame within the search area. The reason we use a search area is to limit the amount of frame space the tracker uses to search for the track area, thus making the process faster and more accurate. The last component of your tracker is the crosshair, or center. At each frame the tracker will place a point, or a **keyframe**, to represent the X and Y position on the screen of the tracker. This allows you to go back into your track later and tweak individual frames.

Each software package will give you many options in regard to the tracker; be sure to read the manual a bit first and really learn how to use their tracker correctly. There are often several tools in each that can be tweaked to allow for tighter and smoother tracks.

COLOR CORRECTION

The reason we color-correct in compositing is to fool the eye into thinking that two images photographed in different locations were in fact photographed not only in the same place but at the same time.

There is a process and a sequence of steps you should follow. Just adding a color corrector to your shot and playing with the levels will give you a result that may be a little less than desirable.

The first step in the process is to analyze the images. You are looking for where the light sources are coming from. After that, what is the quality of the light? Is it a hard light with harsh edges, or is it soft? Is the light scattered by haze or dust in the air?

One method of working this through is to create a lighting diagram of the shot on paper. This does not have to be anything fancy, just some scribble will do. But sketch into place the light sources, where light is being reflected and mark the hard lights and soft lights.

figure |15-9a|

You need to match the lighting in this background plate for your foreground image.

figure |15-9b|

By increasing the contrast you can get a better look at the highlights and shadows. The arrows show the direction of the light source. Pay particular attention to the arrow at the top that shows that the light source is coming from above.

The next step is to create a luminance version of your composite. By doing this you can deal only with correcting the brightness and darkness of the images. Making sure the blacks and whites match in both the foreground and background elements is essential in creating the illusion that the entire scene was shot once with one camera. You can see the results in the following comps. Figure 15-10 and Figure 15-11 demonstrate the visual differences in black and white values in the foreground and background plates. Figure 15-12a shows a comp using the unadjusted images and Figure 15-12b is the comp with the black and white levels matching.

A great tool available in most packages is the **histogram**. A histogram creates a graphical representation of the distribution of pixels in the frame. This representation is based on the brightness

figure |15-10|

Make note of the darkest darks and the lightest lights.

figure |15-11|

By removing the color and just working with the mono-chrome image we can begin to compare the black and white levels of the foreground and background images.

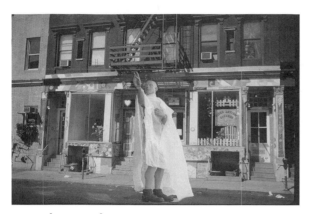

figure | 15-12a |

Notice, regardless of final tweaking of the image, that the black and white levels of the foreground and background do not match. This subtle difference can easily make this image stand out as a composited scene instead of one shot with a single camera at one moment in time.

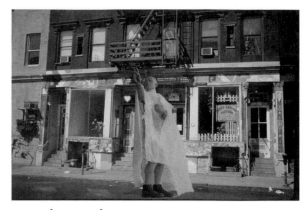

figure | 15-12b |

In this comp we have matched the black and white levels of the background to that of the foreground and then created the comp of the two images. You will notice now that the two images blend together more as one.

figure | 15-13 |

This histogram represents the black and white levels of the background plate. Notice the intensity of the blacks shown on the left side of the chart.

of each pixel, or the luminance value of each. The two histograms below represent the luminosity values of the uncorrected foreground and background images from the previous comp.

In the histogram shown in Figure 15-15 we have taken only a section of the foreground around the darkest area (the shoes) and adjusted its levels to meet that of the background. Notice the increase in the level of the blacks in comparison to that in Figure 15-14.

The histogram can also be used for matching your RGB levels. Utilizing the same concept as the luminosity, the histogram creates a graphical representation of the different color channels. Matching

figure | 15-14 |

This histogram represents the black and white levels of the foreground plate. Notice in this histogram that the black levels are nowhere near the black levels of the background plate.

figure | 15-15 |

Selecting on the darkest area (the shoes) we adjusted the black and white levels to match that of the background. You would do this same process for the midrange and the highlights of the images.

figure |15-16|

Red levels from the background plate.

figure |15-17|

Green levels from the background plate.

subtle overall tones in composited images is essential in creating the illusion of one camera, one moment in time. The histograms in Figure 15-16, Figure 15-17, and Figure 15-18 demonstrate the RGB color channels of the background plate used previously.

The next trick in color correction in compositing is matching **specular** highlights. Specular highlights are the hot spots of light you will often see on the edges of objects and sometimes people. These hotspots are great representations as to the source and intensity of light. Notice in Figure 15-19a the arrows that point out the highlights or specular regions of the image.

figure |15-18|

Blue levels from the background plate.

The reason this is of concern is that we often need to match the highlights from the foreground and the background. This again continues the illusion of the multiple images being taken at once instead of separately. One way to handle highlights is with your luma keyer. Using the luma keyer you can isolate the hot spots, or speculars, in your shot. By doing so you

Corel Stock

figure |15-19a|

Notice the arrows pointing to the hot spots on the jeep. What do they tell you as to the source and direction of the light?

figure |15-19b|

Here we have created a matte channel based on the luminosity of the image. We can use this to isolate a color correction to that of the highlighted areas.

have created a matte channel that will allow you to perform color corrections only on the highlights of the image.

This can be important because the color of the specular is often the color of the light source and not the object itself. Thus if you have someone in sunset lighting and you need to match the highlights on the miniature to that of the foreground, changing the highlight colors to match the sunset colors will go a long way to meshing your images together to a final composite.

While this next trick may not seem like a color correction tool, it actually is. That is adding fake shadows to a scene. A shadow is of course the absence of, or reduction of, light being cast upon a surface. If you add an actor to a background of a miniature and you fail to add the appropriate shadows, the foreground will look flat and fake. Figure 15-20a minus the shadows looks flat and somewhat fake whereas Figure 15–20b, with shadows added, has more depth and realism.

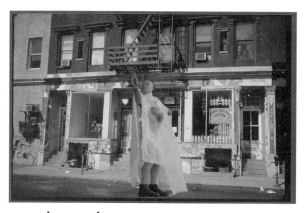

figure |15-20a|

This is the same comp from earlier with the adjusted black and white levels but minus any shadow passes.

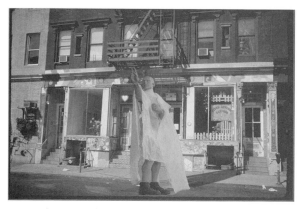

figure |15-20b|

Now with a simple shadow pass added that matches the direction of the light sources of the background plate, we begin to create an image that is more seamless.

Lastly, let's talk about haze. Yes, that horrible crud you see when you fly into Los Angeles on a hot summer day. Haze is basically any particulates in the air. One sure way to seam together a composite is to match the atmospheric haze in the foreground and background elements. Haze adds depth to the image as well. Imagine you are on a boat looking out at New York City. If you snap a picture and look at it later, you will see a slight haze, or noise, in the image. This is from the camera picking up particles in the air between you and your subject; usually the greater the distance, the thicker the haze. Thus adding some haze or noise to the objects that are supposed to be distant will add greatly to the realism of the final shot.

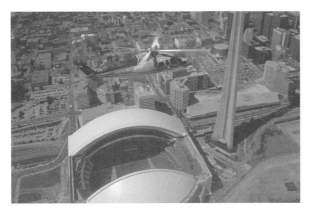

figure |15-21a|

Comp of a helicopter over a background plate with no added haze to blend the elements.

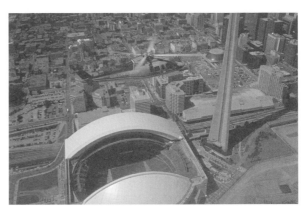

figure |15-21b|

The haze matched from the background, applied over the foreground at an opacity of about 15 percent, helps the image blend into the background and creates a more seamless comp.

GRAIN

What is grain? For our purposes, grain is an unwanted characteristic of film. A film frame is comprised of red, green, and blue grain that is either more or less sensitive to light. The more sensitive to light your film is, or faster the speed, the larger the grain structure of the film. Conversely, the slower the film stock, the less sensitive it is to light, and the smaller the grain structure of the film. Grain is what differentiates film from video and it is what gives film its warmth and depth.

Grain is something you will have to deal with if you are mixing computer graphic (CG) elements or mixing video and film or mixing two types of films together.

CG elements have no grain structure; thus adding a CG element to a shot with grain structure will create an image where the CG element will look like it doesn't fit within the scene. But before we get into dealing with fixing this issue, lets learn a bit more on how grain works.

Film grain is broken up into the three primary colors: red, green, and blue. In the context of film production grain is described in two ways, size and amplitude. Size describes the physical size of each grain while amplitude describes brightness variation between grains. The size of the frame can affect the size of the grain. In NTSC images a grain can be the size of a single pixel, whereas in 2k images it can be the size of several pixels. There is yet another caveat: the size and amplitude of the grain are not consistent between color channels. Red and green are similar in size and amplitude while the blue channel is larger in size. Because of this, when adding or trying to match grain in a shot, it is best to add it to one channel at a time. In most software packages you can view one color channel at a time. By zooming into an area so that you can see the grain and then switching between color channels, you can see the difference in grain structure.

figure |15-22a|

Close-up of grain showing the red, green, and blue color channels combined.

figure |15-22b|

Red channel only.

figure |15-22c|

Green channel only. Notice how much softer the grain is.

figure |15-22d|

The grain pattern is much noisier in the blue channel.

Most software packages have the ability to add grain. They may or may not have some predefined film stocks available to you. Once you select the appropriate film stock, the computer simulates the size and amplitude of the grain so that you can add it to pieces of your composite that need it. There is also the option of purchasing grain stock from different manufacturers. This is usually sequence of frames with animated grain that you can comp into the frame.

Another potential problem to look out for is **grain freeze** or **grain lock**. This happens when you cut an element out of a single frame and you use that element over multiple frames. The grain of the cutout element is frozen, since it is a single frame, while the grain of the rest of the shot continues to move. This frozen grain stands out like a sore thumb. Adding moving grain to this element will help make the element fit in with the final composite.

Depending on your software package you will use different tools to do this, but typically this is done using a mathematical operation, or **math op**.

MATH OPS

A math op is usually defined as add, subtract, divide, multiply, max, and min. Typically an add is used to add grain to your shot if you are using grain that comes from stock footage. An example of this can be found on the DVD.

The next figures are examples of math ops and how they each affect two images in your comp.

The last questions to be answered are: does it look good and does it look real? Don't trust your own eyes. You know the elements of your composite already; ask others who are unfamiliar with your shot to look at it. Play it for them and ask them what stands out. You may think something you have comped stands out while nobody can tell except you.

Test often. Render tests of your composite to test your shot along the way. Catching problems early with tracking, lighting, mattes, and grain saves time and money, which as we all know, is pretty scarce in most productions.

figure |15-23b|

Add or +.

figure |15-23a|

These two images will be run through the most common math ops.

figure |15-23c|

Subtract or −.

figure |15-23d|

Divide.

figure |15-23e|

Multiply.

figure |15-23f|

Max or maximum.

figure |15-23g|

Min or minimum.

SUMMARY

The compositing of your image along with the color correction and other tweaking is the final step before your shot goes to editing and into its final stages of print. The attention to detail is very important in the world of compositing. While your image may look wonderful on the small screen in front of you as a still, once it is blown up to a screen that is 30 feet wide, suddenly that rotomatte you made does not look nearly as tight on subject as you thought. All that **chatter** around the hair of your talent now screams out as a bad key because you did not play the clip during the process of creating your composite.

The bottom line is to check and recheck. Get a fellow compositor or, better yet, get people who have no clue about compositing, and have them watch your shot over and over. Tell them to let you know about anything that stands out. Don't forget, a room full of noncompositors will be watching your shot, so who better to look for glitches?

1. What is a keyer?

2. What is rotoscoping?

3. What are the different types of splines used in roto work?

4. What is camera tracking?

5. What is the difference between match move and stabilization?

6. Why is it important to match blacks and whites?

7. What is a histogram?

8. What is grain lock?

9. Which color channel has the largest grain?

exercises

1. There are several tutorials for Shake included on the DVD. Try them out and discuss them.

2. If time and resources are available, create final composites of your miniatures.

glossary

A

Aaton A manufacturer of professional film cameras for feature films. http://www.aaton.com

Accelerator Used to help superglues cure faster.

AD Abbreviation for art director.

Aerial perspective The bluish color and blurring of objects seen in the distance.

After Effects A software package manufactured by Adobe for creating effects and composites. http://www.adobe.com

Airbrush A tool connected to compressed air that is used to distribute paint onto models and miniatures.

Alpha The color channel in image formats that determine the transparency of each pixel.

Alpha cyanoacrylate A professional adhesive used in model making.

Arri A manufacturer of professional film cameras for feature films. http://www.arri.com

Art director The task of the art director is to analyze the cosmetic or visual requirements of a script in regard to the set.

Artbeats A manufacturer of royalty-free stock elements used for filmmaking. http://www.artbeats.com

ASA A rating system of film stock sensitivity or emulsion speed as defined by the American Standards Association and combined with the American National Standards Institute.

ASA/ISO American Standards Association/International Organization for Standardization.

Atmospheric haze Particles of dust and pollution in the air that when artificially added to a composite help to blend the entire scene together.

Autodesk Parent company of graphics and effects software Flint, Flame, Alias, and 3D Studio Max. http://www.autodesk.com

B

Backlight A light placed behind an object to help separate it from the background.

Balance From the rule of thirds, creating a shot that is not heavily weighted to one extreme or another.

Bashing The process of taking parts or pieces from existing model kits to create a new model that was not originally intended.

Bezier A curve created by connecting the end points of a line, in the direction of the handles as it passes through the end points.

Bluescreen A colored screen used to separate the foreground from the background in order to composite into another scene in post-production.

Breakaway Sections of a set that are designed to be removed so that cameras and other equipment can have access to the set.

B-spline A curve with multiple control points that are not located on the curve itself.

Burn The opposite of dodge, burning is the equivalent of adding more exposure time to the development of film to brighten the areas affected by the burn.

B-Y The blue color channel in a YUV color format minus the luma value.

C

Camera mount The piece of the tripod that attaches to the bottom of the camera.

Casting To form into a shape using a variety of materials such as plaster or latex.

CCD Charged coupled device. An electronic device that converts light into electricity for digital images. CCDs are found in digital still and video cameras.

Chatter The blinking pixels around the edges of bad keys.

Chroma keying A compositing method that originated in the analog video world. The keying is based on hue differences.

Chrominance The color part of a video signal or image relating to hue and saturation.

Cineon A compositing system originally developed by Kodak. Also an industry standard for image format.

Clean plate A shot of the background without any foreground elements.

Color correction The altering of the colors of an image to change the mood or to match the color of another image.

Color depth Refers to the number of pixels used to store the information about an image. Color depths are usually referred to as 8, 10, 16 or float.

Color negative The resulting image on film after being exposed and developed. The colors are the opposite of their original.

Color space Refers to the range of colors available for an image and how those colors are represented.

Compositing The layering of images on a computer using compositing software to create a final image.

Composition The combining or arranging of elements to compose a whole.

Continuity The art of making sure elements from one scene or shot are the same in preceding and proceeding shots.

Contrast The range of values between the lightest or whitest pixels and the darkest or blackest pixels.

Craig's List An online community where you can find crewmembers and equipment for your productions. http://www.craigslist.org

Crane A weight-balanced rig that can lift and carry a camera and cameraman over large distances and great heights.

Cyclorama A curved wall or fabric that encompasses the entire background of a set.

D

D-1 An 8-bit video recording format, it is based on the 601, 4:2:2 format.

D-5 Similar to the D-1 video recording format but is based on 10-bit color.

Depth cue An element in a shot that is designed to fool the eye into thinking objects in a scene are smaller or larger than they really are, or an object in a scene that is designed to make something appear to be in front of or behind something else.

Depth of field The distance in front of and behind the object in a scene that appears to be in focus. There is only one spot that is truly in focus at a time in any given lens; the area that remains acceptably in focus during the falloff is the depth of field.

Difference keyer By comparing two images, the difference keyer isolates objects that are different in each image and then creates a matte of that image.

Director of photography A cinematographer who is responsible for capturing a scene on film as required by the director. The DP is also responsible for deciding what film stock, camera, and lighting to use in a particular scene.

DLT Digital linear tape, a storage medium often used to record scanned film so that is can be delivered to post houses.

Dodge Used in conjunction with burn, dodge limits the amount of light or exposure and thus keeps the affected portion of the image darker.

Dolly A small cart or truck that runs along a track. It can carry just a camera or an entire camera crew and director. Dolly also refers to the movement of a camera to and away from a subject.

Double exposure The art of exposing the same piece of film multiple times to create a new image.

DP Abbreviation for director of photography.

Drafting paper A heavy stock paper used to draw set plans for construction.

Dutch head A spring-loaded camera head that aids in counterbalancing the weight of the camera and the lens.

DV Digital video.

E

EI Abbreviation for exposure index.

Elevations Front or side plans of model construction diagrams.

Ellipsoidal A lighting instrument comprised of two or more lenses that can be focused to a tight or large spot or to a soft-edged light.

EP Abbreviation for executive producer.

Executive producer The executive producer is not normally involved in the day-to-day technical aspects of the production, but rather the business and legal issues.

Exposure index The optimal speed for a particular stock of film being used in a particular environment. This is often interchanged with film speed.

F

Fill Part of the basic three-point lighting setup, the fill is set up opposite the key in front of the talent and is usually a soft or flood rather than a spot.

Film head The removable top of a tripod that connects to the camera.

film out facility A company that takes your source footage, usually regardless of format, and creates an output on film for projection.

Film scanner A device used to scan film into a digital format.

Filters On a camera, filters are placed in front of the lens to alter the color or sharpness of a shot. In software packages filters do basically the same thing but offer many more options, and these alterations to the shots are done in postproduction instead of "in-camera."

Fish-eye A very-wide-angle lens that will distort the image so that it has a curved look.

Fixed focal length A camera lens with no zoom.

Fixed perspective A lens that is locked at a certain zoom, pan, and tilt.

Flame Post-production compositing and effects software developed by Autodesk.

Flint Post-production compositing and effects software developed by Autodesk.

Floods Lighting instruments used to cover a large area in even lighting.

Fluid head A camera head that uses fluid instead of friction for smoother movement.

Foamboard A board filled with foam and covered in a thick paper. This can be used for creating models and miniatures.

Focal length The distance from the center of a lens to the point at which an object or a subject in the distance is in focus.

Forced perspective The art of using different scaled objects in order to convey more height, more distance, or more space.

Foreshortening The process of applying linear perspective to the figure in order to create a more dramatic look or feel to an image.

FrameForge 3D Studio A software program for creating storyboards digitally.

Framing The art of using objects or elements within a scene or a shot to frame the focus of the shot.

Fresnel A lighting instrument with a stepped lens that can cast light over large areas.

Front elevation The construction plans from the front perspective of a set, model, or miniature.

F-stop Represents the aperture of a lens. The larger the number, the less light that is allowed to hit the film or the CCD.

G

Garbage matte A digitally created shape in just about any post-production effects software package that cuts out or blocks unwanted areas of a shot.

Gatorfoam An extruded polystyrene foamboard bonded between two layers of Luxcell wood-fiber veneer. Gatorfoam is used in model building and frame construction for molds. http://www.gator foam.com

Gels Heat-resistant sheets of colored plastic that alter the color and shape of light.

Grain The small, light-sensitive chemicals on film that when exposed to light capture the color information from the focus of the lens.

Grain freeze The resulting effect when a single frame of film is used in sequence such that the grain no longer moves about the screen. This can happen often in post-production if the artist is not careful.

Grain lock See Grain freeze.

Ground plan A top, or bird's-eye, view of the construction plans of a set or model.

Guerilla-style A type of film shooting where an entire crew may rush into an area, film a shot, and rush back out without getting permits or paying fees. There are no trailers or amenities.

H

HD Abbreviation for high definition.

Hebco's Tenax 7R Permanent glue for plastic models.

Hermite A curve between two control points with a directional control for each control point.

Histogram A graphical representation of each color channel.

Holdout matte In compositing, the area that is "cut out" of a background as a placement for a foreground element.

Hot wire blade A heated blade used to cut foam.

HSV Abbreviation for hue, saturation, and value.

Hue The red, green, and blue values of a color regardless of saturation or value.

Hydrocal A brand of plaster used in mold making. http://www.gypsumsolutions.com/htmlID/hydrocal.asp

I

In-camera An effect that is done entirely in front of the camera as opposed to added in post-production.

Interlaced The separation of an image into even and odd fields.

Invert To obtain the opposite values.

J

Jib An extension arm on a tripod to create a small crane.

K

Kelvin A unit of measurement for temperature.

Key In the video world, the term for matte.

Keyframe A point along a timeline that records data for animation.

Keying The process of creating a matte or a key.

Kodak Manufacturer of film and cameras.

L

Latex A liquid made of rubber or plastics that can be used in the creation of textures and molds.

LazerCA+ A superglue used to glue wood to styrene.

Light meter A device used to measure the brightness of light and the temperature.

Linear perspective The illusion of parallel lines converging over a distance. This technique is used to simulate more depth than what is actually there.

Luma Short for luminosity or luminance.

Luma keyer A matte creation tool that uses the luma values of color to separate the foreground from the background.

Luminance The measure of brightness of a color.

Lycra An elastic material often used for green-screens or bluescreens.

M

Macro lens A lens used for close-up photography.

Mask Protects a portion of your image from being exposed or affected by the lens or an effect.

Masonite A type of fiberboard used for construction of miniatures or sets.

Math op A mathematical operation used to combine multiple elements in a composite.

Matte painting A digital or traditionally painted background plate used in compositing.

MDF Abbreviation for medium-density fiberboard. A flexible construction material used for building models and sets.

MiniDV Miniature digital video format.

Mode An option in Photoshop to select from RGB, CYMK, or one of several other color spaces.

N

Negative Developed film that contains a negative image. Negative film is usually used in the first stages of film capture.

NTSC Abbreviation for National Television Standards Committee. Standard for video in the United States.

O

Opacity (Opaque) refers to the level of transparency. If something is more opaque it is less transparent, if it is less opaque, it is more transparent.

Overlap The placement of one object or image in front of another.

P

PAL Abbreviation for phase alternation line, the standard for video in most European countries.

Panavision A manufacturer of feature film cameras.

PAR Abbreviation for parabolic aluminized reflector, a lighting instrument in which the light and lens are self-contained.

Partial set When only part of a set will be seen on camera, only that part of the set is constructed to save time and money.

Photoshop A software paint system manufactured by Adobe. http://www.adobe.com

PICT An image format for storing frames on the computer.

Plaster A compound of lime or gypsum plus water and sand, used for mold and texture creation.

Plaster of Paris A type of plaster.

Point of contact Where the talent or subject physically touches its environment.

Practical A light on a set (such as a lamp or streetlight) that must function as a real light.

Previsualization The art of creating images or models to be used in the planning of camera shots and angles.

Pre-viz Abbreviation for previsualization.

Prime lens A fixed-focus lens.

Production designer Another name for art director.

Progressive In broadcast, the sequence of images are played back one frame at a time instead of interlaced with fields.

PVC Abbreviation for polyvinyl chloride, a plastic used in model making.

Q

Quicktime A video format developed by Apple Computer Inc.

R

Rear elevation A view of a plan or model from the rear.

Rear projection An alternative to matte painting. A screen is placed behind the foreground and a projector is used to place the background behind the scene.

Reflective A lens that captures the light entering the front of the lens and reflects it off a mirrored surface at the back of the lens and then through another reflective surface, which finally deposits the image on either the film or the CCD.

Refractive The refractive lens uses several glass lenses to concentrate and bend the light toward the film or CCD.

Relative motion The perceived motion of an object in relation to the viewing source.

Relative size A technique for creating greater apparent distance between objects with miniature scenes.

Renderings Full-color drawings of storyboard panels.

RGB Abbreviation for red, green, and blue.

RGBA Abbreviation for red, green, blue, and alpha.

Rosco Inc. A manufacturer of theatrical and film supplies, including paints and gels.

Rotoscoping The manual creation of mattes using splines.

Rule of thirds The division of an image into either three horizontal or vertical areas of interest.

R-Y The red color channel in a YUV color format minus the luma value.

S

Saturation The value representing the amount of a given color.

Scale To stretch the object's width or height or change its size proportionally.

Scale model A model or miniature created at a percentage scale of the original.

Scanline One line of video information in interlaced video.

Scenic fog The artificial addition of atmospheric haze or smoke.

Scenics The crew in charge of the set for film shoots.

Scoop A lighting instrument designed to throw ambient lighting that cannot be focused.

Script analysis The locating of all effects shots required in a film by going through the script and making notes of all potential effects shots needed.

Search area In a tracking system on a computer, the area the computer looks into in order to find the same area to track in the proceeding or preceding frame.

Section A sliced view of a construction plan.

Set dressers Those on the film crew in charge of making the set look real.

Shake Compositing software created by Apple Computer Inc.

Side elevation A side view of construction plans.

Sight lines A graphical representation of the areas in and out of view of the camera.

Sketches Simple drawings or storyboards that represent planned shots.

Softimage XSI A 3-D animation system developed by Avid.

Specials Lighting instruments that have a very specific purpose in a scene.

Specular The highlight seen on an object from a light source.

Spill The unwanted casting of light or color.

Splines Curves used in animation and compositing software packages.

Stabilize Removing unwanted shake or movement from a camera.

Standard definition The bottom end of digital television, 480i.

Steadicam A device worn by the cameraman that keeps the camera smooth while the cameraman moves around.

Sticks A single-legged, counterbalanced attachment for a camera that helps keep the shot steady.

Stock footage Footage shot, created, or collected by a third party and sold for use in your production.

Storyboards Panels created to represent the action in a film to help communicate the shot to the crew and the talent.

Study model A simple model used in the planning stages.

Styrene A type of plastic used in model making.

Styrofoam A type of foam made up of small foam beads.

Subtractive modeling Carving; the removal of pieces to "reveal" a model or sculpture.

T

Targa An image format used to store film digitally.

TD Abbreviation for technical director.

Technical director Person in charge of the post-production crew that will be adding any elements that require digital creation, such as CGI or digital compositing.

Testors Liquid Plastic Cement A type of cement used in model making.

Texture gradient The eventual fading of texture over a large distance.

Throw The qualities of a light from a particular lighting instrument.

Thumbnails Small sketches done in the early stages of pre-viz.

TIFF An image format used to store film digitally.

Track Used with a dolly to create a smooth shot with the camera.

Tracking head A special attachment on a camera that feeds information about the camera's position, zoom, tilt, and rotation.

Tracking markers Items placed in a scene that can be tracked later using a computer in order to aid in the compositing of multiple elements.

Traveling matte A matte that is animated over time.

Tripod A three-legged device used to hold cameras, lights, and other objects.

T square A tool used to draw or cut straight lines.

U

Ultimatte A type of paint used for painting green-screen walls.

Ultraboard A plastic-coated foamboard.

Ultracal A type of plaster.

Underpainting Scraping away a top layer of paint to reveal the underlayer, to simulate weathering.

Unit production manager Responsible for administrative duties on the film.

UPM Abbreviation for unit production manager.

Urethane A type of flexible plastic used in model making.

V

Vacuform A device used to vacuum air from a heated sheet of plastic to create a model from a mold or form.

Value The brightness of a color.

VFX Visual effects.

Visual FX supervisor The person in charge of the effects crew.

W

Wash A thin layer of paint.

Weathering Making something look older and more weathered than it actually is.

X

X-Acto Manufacturer of cutting tools and other tools for arts, crafts, and model making.

Z

Zoom Using the lens only to bring the subject closer or farther away from the lens.

index

INDEX